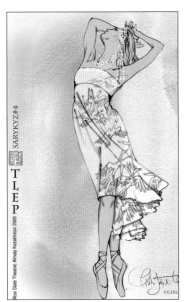

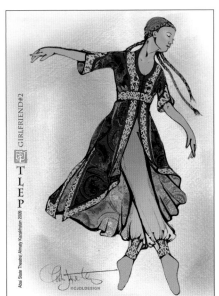

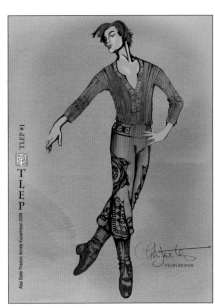

Digital Costume Design
& Rendering

PENS, PIXELS, AND PAINT

Digital Costume Design
& Rendering

PENS,
PIXELS,
AND
PAINT

Annie O. Cleveland

**COSTUME & FASHION PRESS /
QUITE SPECIFIC MEDIA**

An Imprint of
Silman-James Press
Los Angeles

Credits:
Designer: Jeffrey Cohen
Editor: Judith Durant
A Pat MacKay Project

Cover: Design by Annie O. Cleveland. Madame Ranyevskaya in *The Cherry Orchard* for Colorado State University, Ft. Collins, Colorado, 2001. Costumes courtesy of Janelle Sutton.

Half title: Designs by Christine Joly de Lotbiniere. Sarykyz, Girlfriend, and Tlep in *Tlep,* Abai State Theater, Almaty, Kazakhstan, 2009. Sketches executed in Photoshop.

Title page: Designs by Carrie Robbins. Flower Girl in *George Gershwin's American in Paris,* the Alley Theatre, Houston, Texas, 2008. Sketches executed in Painter.

Author photograph: Ken Howard
Cover photograph: Eddy Espina

Corel® Painter® is a registered trademark of Corel Corporation and /or its subsidiaries in Canada, the United States and/or other countries.

Adobe® Photoshop® is a registered trademark of Adobe Systems Incorporated in the United States and/or other countries. Macintosh, Mac, and MacOS are trademarks of Apple Inc., registered in the United States and/or other countries.

Wacom®, Cintiq, Intuos, and Bamboo™ are registered trademarks of Wacom Technology Corporation.

Library of Congress Cataloging-in-Publication Data
Cleveland, Annie O., 1950–
Digital costume design & rendering : pens, pixels, and paint / Annie O. Cleveland.
 pages cm
 Includes bibliographical references and index.
 ISBN 978-0-89676-271-8 (pbk.)
1. Fashion drawing. 2. Adobe Photoshop. 3. Corel Painter. 4. Costume design—Digital techniques.
5. Fashion design—Digital techniques. I. Title.
 TT509.C54 2014
 792.02'60285—dc23
 2013047006

Resources and ongoing discussion are at Annie Cleveland's dedicated
Website: www.quitespecificmedia.com/digitalcostumedesign

Log on and join the community for access to updated information as software upgrades are released. Tips, tricks, and techniques from both Annie and the readers will be posted at
www.quitespecificmedia.com/digitalcostumedesign

Your log on ID is: **xG5y76**

Costume & Fashion Press/Quite Specific Media

An Imprint of
Silman-James Press, Inc.
www.silmanjamespress.com
info@quitespecificmedia.com | info@silmanjamespress.com

Table of Contents

Foreword

It's about time someone wrote this book! And thanks to Annie Cleveland for being the one to finally do it. What a gift to all of us!

I had been thinking about using Painter to draw directly on the computer since about 1994–95; I dared to design my first full show on the computer in 1997, a production of Rostand's *Cyrano de Bergerac* produced by the Roundabout Theatre Company, starring, directed by, and co-adapted by Frank Langella. It was on this show I discovered one of the computer's greatest boons to the costume designer: the Layers Palette. Yep, as you might imagine, there were numerous iterations of each sketch required before the design was done. And the computer made it painless.

In the olden days (BC—before computers), one might spend anywhere from one hour to a collective eight hours on a single sketch, drawing the rough, showing the director, adjusting (or re-drawing the sketch from scratch), showing the director again, adjusting the sketch once more, adding color, showing the director again, showing the star, the choreographer, the writer—the ever-widening circle of folks with whom we interact. And each interaction might result in further changes in the sketch, because each costume sketch must ultimately become a real-life document for bidding. As we costume designers do not have any equivalent to the set designer's drafting, the simple costume sketch becomes a contract between the final shop chosen, the designer, and management as to the actual nature and specifics of the ultimate product to be built.

Clearly, if one must create several hundred designs for a show, time becomes a major factor. As it is, costume designers often don't get a lot of time for this drawing part of our process, this crucial collaborative back-and-forth. As I said, in my own case, development of an agreed-upon, bid-ready sketch would often take me eight hours. Do the math. Consider 100 sketches. That's a healthy 800 hours. And that's before a single hunk of muslin has been unfurled.

With the discovery of the computer and its facility with layers, I quickly learned how to organize my sketches so that the figure is on the bottom layer (but not on the canvas layer so that I could easily change the nature of the page's color and texture as I clarified my thinking and feelings about the piece and learned what the set designer was planning), and each part of the finished costume lives on its own separate transparent layer. This gives me the ultimate flexibility when I show sketches to the director and whoever else is in the mix. If someone wants to make a change, or just see what the frock will look like in a different color, or what a different hat will look like, or what no hat will look like, no problem.

And then wonderful surprises began to happen! Painter has lots of tricks up its digital sleeve. And sometimes, one just pushes a key and makes a fabulous discovery! Painter invites you to experiment, and it's so much fun to see what you have wrought after only a few exploratory clicks that one stays at the computer much longer than necessary—which may or may not be an advantage! Painter encourages experimentation. And since there are several ways of "undoing," the fear factor of ruining a sketch is totally non-existent. Mistakes become new discoveries.

When I first picked up Painter, it was produced by a company called Fractal and came packaged in a darling paint can (which I still have). When I began to teach this business of drawing directly on the computer at NYU just a few years later, Fractal had gone the way of dinosaurs. I think its replacement was called something like "Meta-Creations." Now Painter is part of Corel, and the computer-jock-artists there bring us new iterations regularly. And herein lies the problem. *Computer programs are ever-changing beasts.* Just when you think you have crawled up the learning curve and mastered the program, it is replaced by a newer "better" program that thrusts us back to the bottom of the mountain. What can I say but "Stick with it."

And here to help you out, better than a *Painter for Dummies* book, is Annie Cleveland's *Digital Costume Design & Rendering: Pens, Pixels, and Paint.*

And what's so welcome about the book is that it is *not* by a computer nerd. It's by someone who uses Painter for her own design work. So she knows what we need to produce in our work. I wish this book had been around when I was learning. But since it didn't exist, I had to figure ways to adapt graphic and photographic design ideas to costume design needs. It can be done, but it is ever so much easier to have a book that is "species-specific!" Intelligently arranged and presented in clearly titled chapters, with the specific lesson points to be tackled per chapter listed at the top of each chapter, the book is easy to navigate. The steps of each procedure are clearly numbered or bullet-pointed, the directions concise and easy to follow, and the accompanying illustrations straightforward, well-chosen, and, of course, directly related to problems "costumic."

In some cases, Annie will even point out some traps we all have fallen into, so that you can avert them.

When I was a kid learning watercolor, I was taught that there are no errors; there was no eraser allowed. Every blob that went down on the page was "useful," in

fact "artistic," but *only* if the person behind the blob knew how to use it. When I made a real mess, I was taken to the sink in the far corner of the room. The teacher turned on the water full force and thrust my hand, wielding the offending piece of paper, under the faucet (in view of all the class of course) to wash off all the offensive marks. Perhaps a bit harsh, but that's how much of art teaching was handled "in the day." (One day I remember visiting the sink seven times. To this day I'm not very good at watercolor.)

By contrast, it's comforting to remember that with the computer, there are always at least three ways of achieving something you have dreamed up, probably more. And there is an "undo" or a "step backward" function. I set my Painter "undo" function at five, figuring that if I can't fix whatever I don't like by going back five steps, I probably should cast around in my mind and look for a way to make the mistake "artistic," or at the very least "useful." So have courage, jump in, open up Painter, open up *Digital Costume Design & Rendering: Pens, Pixels, and Paint* to Chapter 1, and give it a shot. Read through Chapters 1 and 2. Make yourself a blank page. And promise me you'll stay with it for a couple of hours. You don't need to have a particular costume sketch due. I prefer to have my students start by drawing any photographic portrait they're drawn to, a film icon, a pet, a family member. It doesn't matter. *Just draw.* Grab a pencil tool and draw. Then (on another layer of course), try some color. "Chalk" is easy. "Airbrush" is lovely. Put down another layer and try something for "hair." Experiment a bit. There are fabulous novelty brushes to give you "hair" you never dreamed you could draw! Go back and change the ground or "paper" color. See the difference it makes. Watch the image of the face coming alive as you work. Put down another layer and work on bringing out the eyes. I promise you, time will fly by and you won't believe what you've achieved. When you finally put that tiny highlight in the eyes, what looks back at you will be quite wonderful! Truly. And think of it—not a thing to clean up! What could be more convenient?

ALERT: Painter (as well as Photoshop) is a very dense and powerful program. I've been using it at least 15 years and I still haven't used every tool. I probably use less than 50% of its total offerings. This book is amazingly complete, so don't expect to make your way through all of it in a few sittings. Be patient. Start in, and if you think of something you'd like to do, and you don't know how to do it yet, check through the Table of Contents and/or the index and find out where that particular idea might be explained. Remember how long it probably took you to feel comfortable drawing on a piece of paper. Remember how many classes you might have taken, how many hours you spent in Life Drawing. Calligraphers do pages and pages of Os and Ls before moving onto full words. Doing anything well

takes practice, and I don't think there's any way around that! Practice when you can. Don't give up. You will get better, and you will become more comfortable with the technical aspects of the program. (A number of very important people told me I was wasting my time with this computer business when I already drew well. But given how long it took me to learn to draw, it seemed unlikely to me that I would learn to draw with the computer as my tool in a week, or a month, or even a year.) So stay with it. I've found the advantages far outweigh the initial discomfort. And anything new is discomforting (disconcerting?) in the beginning. But sooo exciting once you see what you can achieve. Enjoy!

—Carrie Robbins
 New York
 April 2013

Tony Award nominated costume designer Carrie Robbins has spent most of her career designing costumes for Broadway and Off-Broadway. In May of 2012 she received the Irene Sharaff Lifetime Achievement Award for Excellence in Costume Design.

Introduction

More and more professional designers are seeing the advantages of using computers in their design process. Currently, many position announcements in the field of costume design are listing computer proficiency as a requirement for the job. The powerful editing tools in computer software enable designers to explore more sophisticated design options than they would if faced with having to create each new sketch from scratch. This book is written specifically for costume designers and will focus on using Corel's Painter software with references to using Adobe Photoshop. The question always arises "What is the difference between Painter and Photoshop?" Briefly, Photoshop was designed by photographers as a tool to enhance existing images. Painter was designed by artists who begin with a blank canvas and terminology used is closely related to the terminology of fine arts media. Photoshop uses terminology that one needs when editing photographs. Both of the programs seem to recognize certain valuable aspects of the other. Painter software designers developed the layer function to more closely replicate the layers in Photoshop. Photoshop software designers, on the other hand, have gradually added more brush variations to their libraries in order to gain some of the versatility of Painter. The important goal of this book is to enable costume designers to embrace digital media no matter which program they choose to use. Most of the exercises can be accomplished with either program. If the tools or techniques are vastly different in Photoshop, a Photoshop specific section is added to the relevant chapter. When you see the 🅟🅢 symbol, it indicates that there are Photoshop notes at the end of the chapter.

Software companies are constantly creating new versions and updates and keeping your system up-to-date can be difficult. This book was written using Painter version X3 and Adobe Photoshop Creative Cloud. Most of the revisions in Painter X3 are additions of new and powerful tools, but the essential function of the program remains the same. There was a major update between versions 11 and 12; in version 12 the workspace was significantly reconfigured. There were not many visible changes from 12 to X3, so users of version 12 should have no problem using this book. Photoshop has recently inaugurated the Creative Cloud. Instead of buying individual software, users now buy a license that gives them access to the entire Adobe suite of software. This license can be renewed monthly or every 99 days depending on the type of membership. The overall workspace arrangement and functions remain the same for Photoshop CS6 and the Creative Cloud version. It is a good idea to investigate the online information regarding Creative Cloud and to weigh the membership costs against the price of Painter.

The chapters covering each aspect of Painter are organized to give an overview of the opportunities available but are in no way meant to be a definitive examination

of each function or tool. Digital rendering programs are highly complex, and as such they contain very deep menus, many of which are of no use to the traditional costume designer. The basic tools and procedures will be identified and exercises will be given to allow you to explore a range of adjustments or variations for each tool or process. Some of the more advanced features may be mentioned, but the primary purpose of this book is to give beginners enough understanding of the versatility of the program so that they may be inspired to further investigate how to customize the tools and applications to meet their own specific needs.

Although there is a "magic wand" tool in Painter, computer software is not the answer to all design problems. This is not a drawing book and the exercises in this book will not turn you into a gifted sketch artist if you have not already achieved some degree of sketching ability. The exercises are designed to familiarize you with the program. If you are is accustomed to the nuanced flow of watercolor off the tip of a brush, trying to duplicate that same feeling with a stiff digitizing pen against a slick tablet will seem awkward and frustrating. Artistic skill will improve, however, with consistent practice whether the work is done digitally or by more traditional means. It is hoped that once you discover the power of computer programs, you will be able to envision things you may not have thought possible and be able to communicate your ideas to the rest of the design team in an exciting, dynamic, and efficient way. This exploration is meant, above all, to be fun and enlightening and, hopefully, the experience will stimulate the creativity in all those who are willing to put in the time.

Digital Costume Design & Rendering Website

When you are ready to begin the exercises, open your copy of the book to the copyright page. There you will find Your Log on ID code. Go to www.quitespecificmedia.com/digitalcostumedesign, and register using your code.

Once on the website you will find a wealth of information:

- In **RESOURCES** you will find the images you need to complete the exercises in the book. These images are arranged by chapter and labeled with the corresponding exercise number. Select the image specific to the exercise that you are working on and then **DOWNLOAD** and **SAVE** the image on your computer where you can find it again. The images are **JPEG** files and are not excessively large. Open Painter or Photoshop and then open the image in that program. Note: The examples in this book and the sketches for the exercises come from actual costume renderings that were created with specific theatrical intention, but it should be very easy to substitute your own drawings.

- Under **TIPS & TRICKS** you will find a reader/user forum where you can post questions or problems and give feedback to other users. Here too you will find links to other sites for more information as well as the latest on software updates and additional tutorials.

- And most importantly there's the **GALLERY**: here you can share your work and see the work of others.

Our goal is to create a strong community of digital costume designers. Please join us at www.quitespecificmedia.com/digitalcostumedesign.

The influences that helped to shape this book go back many years. I would like to thank Robert Braddy and Barry Cleveland for having the foresight, in 1993, to develop the Interactive Digital Design Studio at Colorado State University and for insisting that I join them in their research into computer aided design for the theatre. Many students struggled through my early lesson plans in digital design. Their persistence produced remarkable results, validating my commitment to developing a digital design curriculum. Mark Shanda invited me to The Ohio State University to conduct the first of my Computer Design Workshops which formed the foundation for the exercises in this book. Professor Wei-Jan Chi confirmed that the ability to teach computer-aided design was a valuable attribute and was responsible for my securing a Fulbright grant to teach at National Taiwan University. My Taiwanese students made me rethink and simplify my lesson plans to make them clearer, more precise, and direct—an approach that I have tried to continue throughout this book. A special mention goes to Melissa and Pilar Patterson-Kling and Nacho for opening the ancestral home to help make this publication happen.

I met some resistance from costume designers who claimed they would never be able to replicate with the computer what they could create by hand. Carrie Robbins proved that even an established artist can flourish and grow if they have the courage to adopt new media. True artistry can be produced when talented hands are holding that Wacom pen. Her generous support and enthusiasm for me and my work is much appreciated. She introduced me to photographer Ken Howard who I want to especially thank for revealing the Santa Fe in me.

I am sincerely indebted to USITT and the Publications Committee, specifically Bobbie Owens, David Rogers, and Deborah Hazlett, for their faith in my writing ability. Without their encouragement I would not have considered myself an author. I appreciate the technical support given to me by California State University Northridge and Garry Lennon. Sincere thanks go to Jeffrey Cohen for designing an elegant layout and to Judith Durant for her diligent editing. I am especially indebted to my publishers, Pat MacKay and Ralph Pine, for their patience, guidance, and some really terrific meals.

And finally back to Barry Cleveland, who spent countless hours resizing images, frequently laid healing hands on the laptop when it refused to cooperate, certified that the work was backed up, and made sure my operating systems, both technological and physical, were in optimum condition. For over forty years he has been an inspiring colleague, intrepid traveling companion, stimulating co-author, savvy advisor, and most of all, loving husband and dedicated father to our three wonderful children, Simon, Julie, and Vincent, without whom I would be less of a person.

(feet)

8

7

6

Costume Notes
and Swatches

5

4

3

2

1

0

Scale 1inch:1foot

Name:
Role:
Production:
Designer:

Chapter 1
Getting Started

- Opening Painter
- Saving a File
- File Formats
- Opening a New Document
- Paper Color and Texture
- Photoshop Notes

Design by Catherine
Bradley, McGill
University, Montreal,
Canada. Demonstration
project showing the
design process from
photographing the actor
to final rendering.
Sketches executed in
Photoshop.

Imagine starting your new costume design by walking into one of the finest fully stocked art supply stores you have ever seen. You walk through the aisles thrilled by the array of materials before you. Your fingers glide across the luxuriously textured, very expensive watercolor paper and you think, "How fabulous it would be to buy as much of this paper as I want for those heavily textured sweaters I need to render." Cruising by the art markers, you linger to draw a few strokes on the scrap paper available, just to get a feel for the flow of the tool in your hand, but recognize buying a whole set of colors would probably be a wasted expense given the number of times you might use them. You admire the elegance of the high-end watercolor brushes but pass them up because you share your studio and know that at some point someone will leave them warped and splayed in a jar of dirty water. Although you would love to experiment with the richness of oil paints and you know they would be the perfect medium for capturing the jewel-toned costumes you envision for your next Shakespearean production, you move on with a sigh and pick up a few small tubes of watercolor to replace the dried up twisted ones on your table back home. You no longer have to pass up all those opportunities. Having bought Painter, you have already invested in that entire art store and you do not need to worry about paints drying out, brushes getting damaged, or paper being wasted. What are you waiting for? Let's get started!

Opening Painter

This exercise is designed for the first time you open Painter with the default settings. The program retains the settings of the most recent user, so if you are using the program in a computer lab where someone may have changed the settings, you might get unexpected results, including being unable to see what you are marking on the paper. In this case go to Chapter 2, Exploring the Workspace, and see the section on Painter terminology.

EXERCISE 1-A

Warm Up 🅿️

1 Open Painter. You will see a dialogue box asking if you want to create a new image or open an existing document. Select **CREATE A NEW IMAGE**.

2 A new window will open showing the size of the document. For now, because we want to get started, just click **OK**.

3 In the white drawing area, drag your mouse across the surface of the paper and make a mark. Do not try to be fancy, just get a feel for putting marks on the paper and learning to draw while looking at the screen.

Figure 1.1

Painter's opening screen. The image will change every time you open the program.

4 Make long smooth strokes to see what happens when you layer one stroke over another. Try some details like writing your name. You have just made your first step toward becoming a digital designer.

5 If your drawing gets too crowded, use the top menu bar to clear the page. Go to the tab labeled **SELECT** then choose **ALL** from the drop-down menu. A blinking dashed line will appear around the borders of your drawing. Go to the word **EDIT** and scroll down to the bottom to select the word **CLEAR**. Your drawing will now be blank and you can continue practicing.

6 Close your document by clicking on the red **X** in the upper-right corner of the drawing window. In the dialogue box you can choose to save your file as a **JPEG** or just delete it.

Saving a File

Anyone who has worked with computers should be familiar with the **SAVE** and **SAVE AS** options located under the **FILE** drop-down menu. Selecting **SAVE** rewrites the file with any changes you have added and permanently changes the original look of the file when you opened it.

If you create a pencil sketch to start your rendering, it would be a good idea to preserve a clean copy of that sketch so that you can refer back to it if necessary.

Figure 1.2

The list of file types in the **SAVE AS** dialogue box.

When the pencil sketch is complete, use **SAVE** and give the file a distinct name. Once you begin to apply color or make changes, you should use the **SAVE AS** function and give your file a slightly different name so that it does not completely overwrite your original pencil sketch file. Go to **FILE > SAVE AS**. In the dialogue box, locate the folder or location where you want to save the file. Give the file a distinct name. In the space labeled **SAVE AS TYPE**, click the small black arrow to see the dropdown menu listing the various types of file formats.

File Formats

All computer files have particular **FORMATS** that are indicated by the three-letter file **EXTENSION** following the dot in the file name. These extensions tell what kind of file it is and which program to use to open it.

- **RIFF** (*.RIF, *.RIFF) is the native file format for Painter. This is the best format to use while you are working on a rendering because it contains all the information about the file, including the various layers you may have created, the types of media you have used, and whether or not that media is "wet" or "dry." For this reason, **RIFF** files can get very large. It is a good idea to save your file as a **RIFF** so that you always have a copy that you can reopen and continue to make changes to. If you need to send your file to someone who does not have Painter, you should do a **SAVE AS** and convert the file to a **JPEG**.

- **TIFF** (*.TIF, *.TIFF) is a common file type. It is an uncompressed file so is just as large as a **RIFF** file but may not have the separate layers or other specialized features of a **RIFF** file. This is a good file format to use if you are planning to print your sketch and want to have the clearest detail possible.

- **JPEG** (*.JPG, *.JPEG) is one of the most recognizable image file formats. This file can be opened by most computers and, because it is a compressed file, it can be a smaller size than some other file formats. If you **SAVE AS** using a **JPEG** file, you will have an opportunity to adjust the degree of compression to reduce file size.

- **PSD** (*.PSD) is the native format for Photoshop. Painter can open **PSD** files and retain all their layers and information. Photoshop cannot open Painter's native **RIFF** format.

More information about the other file formats can be found in the Painter help menus.

Note

Keep in mind that if you continually save a file as a **JPEG**, the file is compressed each time. At some point, you will begin to lose quality. That is why you should make your changes in your **RIFF** file and use the **JPEG** file just to show samples of different iterations.

Opening a New Document 🅟🅢

When you open a new document, a **NEW IMAGE** dialogue box will appear, giving you the opportunity to name the file and set the size, resolution, and paper color and texture. The canvas size is shown in either pixels or inches. To change the size to another measurement unit, simply click on the small black arrow next to the word "pixels" or "inches" and then type in the dimensions that you want to use. If you are going to print out your drawings, think about what size you want the finished product to be.

The default setting for the resolution is 150 pixels per inch. The higher the resolution, the larger your file will be. It will also take more time to process your image when you are saving or making major changes such as changing the background color. A resolution of 72 ppi (pixels per inch) is useful for costume renderings, particularly if you will be communicating with your design team

Figure 1.3

When you open a new image you can name the file, change the size and resolution, and change the paper color and texture.

New Image	
Image Name:	Untitled-8
Canvas Preset:	Painter12 default (modified)
Width:	38.889
	inches
Height:	20.833
Resolution:	72.0 pixels per inch
	Color Paper
	OK Cancel

digitally. At this resolution the files will stay at a manageable size but still clearly show details. If you plan to display your renderings in a large format, you might consider using 150 or higher resolution. If the images will be used in printed materials, you will also want to save as 300 PPI.

Paper Color and Texture

When you click on the **COLOR** square, a new window opens showing various color swatches as well as a color scale. This will change the color of the canvas or paper on which you will be sketching. Move the cross hairs in the color scale to pick the basic hue you want to use for the paper color and adjust the value on the vertical scale to the right. Click **OK** to go back to the **NEW IMAGE** dialogue box. More on using background colors will be discussed in Chapter 7.

Figure 1.4

Select a color swatch or move the crosshairs in the color range box to select a custom color.

If you click on the **PAPER** square, a library will open showing all the paper textures available in Painter. Some media will reveal the texture of the paper while other media do not react to paper texture at all. It is important to know that you can change the paper texture at any time as you are working on a sketch. Learn more about using paper textures in Chapter 2.

Figure 1.5

Click on any icon to select the paper texture.

Keep in mind that these settings will be retained the next time you open a new document. This is convenient if you are planning to do a series of sketches that are all the same size with the same paper color and texture. It is a good idea, however, to make a habit of checking all these settings before you begin a new sketch.

Opening a Document and Choosing Paper Color and Texture

1 Go to the **FILE** tab on the top menu bar.

2 Select **NEW** from the drop down menu.

3 In the dialogue box type the name *First Practice.*

4 Change the unit of measurement to inches and make the new drawing
5 × 7 inches.

5 Change the resolution to 72 ppi.

6 Click on the **COLOR** square and select a color for your paper then click **OK**.

7 Click on the **PAPER** square and select a texture for your paper then click **OK**

8 In the **NEW IMAGE** dialogue box click **OK** to open your new sketch.
It should have the color you chose, but you will not see the paper texture until
you use a particular kind of media on the paper.

9 **SAVE** your file as a **JPEG**. You may use this document for the exercises in
Chapter 2 on Brush selection.

Photoshop Notes

Warm Up

Because Photoshop was designed to be used with existing images, a brush is not automatically selected when you open the program as it is in Painter. To begin painting, you must first select the **BRUSH** tool from the **TOOLS PANEL**. Go to Chapter 2 on Exploring the Workspace to learn about finding and selecting various tools.

Opening a New Document

The **NEW IMAGE** dialogue box in Photoshop is very similar to the one in Painter. The size and resolution function in the same manner but you are not able to choose a specific background color or paper texture. You can, however, select the **COLOR MODE**. For most print applications, the **RGB COLOR MODE** is the best choice. Photoshop opens the new document window so that it fills the entire workspace. Like Painter, these settings will be retained for the next time you open the program. Complete Exercise 1-B on Opening a New Document.

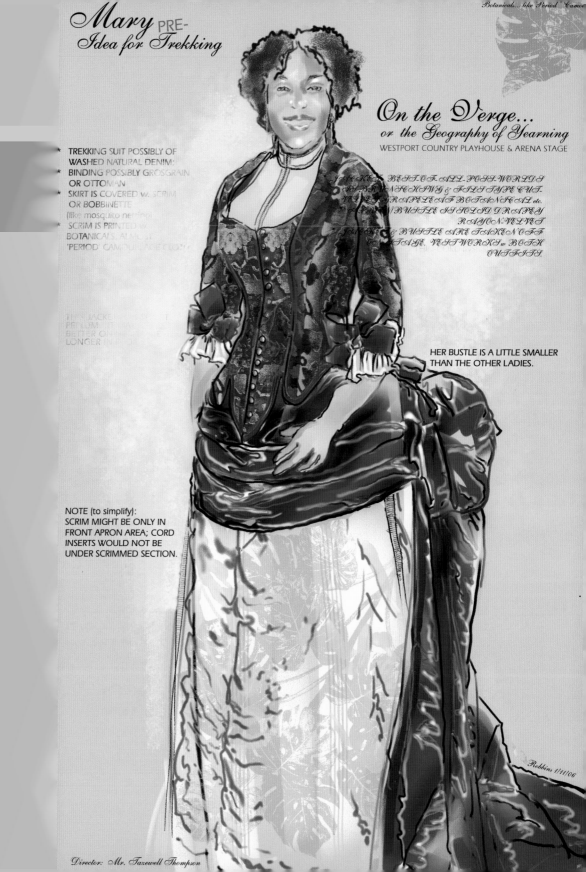

Mary PRE-
Idea for Trekking

On the Verge...
or the Geography of Yearning
WESTPORT COUNTRY PLAYHOUSE & ARENA STAGE

* TREKKING SUIT POSSIBLY OF
 WASHED NATURAL DENIM:
* BINDING POSSIBLY GROSGRAIN
 OR OTTOMAN
* SKIRT IS COVERED w. SCRIM
 OR BOBBINETTE
 (like mosquito netting)
* SCRIM IS PRINTED w.
 BOTANICALS, ALMOST
 'PERIOD' CAMOUFLAGE CLOTH

HER BUSTLE IS A LITTLE SMALLER
THAN THE OTHER LADIES.

NOTE (to simplify):
SCRIM MIGHT BE ONLY IN
FRONT APRON AREA; CORD
INSERTS WOULD NOT BE
UNDER SCRIMMED SECTION.

Robbins 1/11/06

Director: Mr. Tazewell Thompson

Chapter 2

Exploring the Workspace

- Workspace Overview
- Painter Terminology
- Toolbox
- Menu Bar, Property Bar, and Brush Selector Bar
- Color Palette
- Property Bar in Detail: Straight and Curved Lines, Size, Opacity, and Grain
- Erase and Undo
- Navigation Tools: Grabber, Magnifier, and Rotate
- Media Selector Bar
- Photoshop Notes

Design by Carrie Robbins.
Mary in *On the Verge*,
Arena Stage, Washington,
DC, 2006. Sketch
executed in Painter.

Workspace Overview PS

All of the exercises in this book can be accomplished using a mouse, but accuracy and control will be significantly enhanced with the use of a digitizing tablet and pen. Before beginning this chapter, it is worthwhile to review the information in Appendix A regarding digitizing tablets.

This chapter will introduce you to the general layout of the workspace. If you have already used Painter to some degree, consider skipping ahead to more detailed discussions of the different tool bars, menus, and palettes.

Most computer processes can be activated in several different ways. Some people are more comfortable seeing words in a drop-down menu in order to fully understand the process. Others like the visual recognition of graphic icons. More

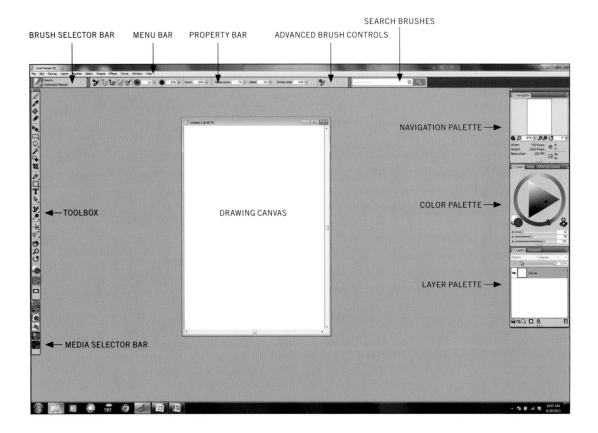

Figure 2.1

The default workspace usually has the
NAVIGATION PALETTE, the **COLOR WHEEL** on the
COLOR PALETTE, and the **LAYER PALETTE** open on
the right side.

advanced computer users like the speed of keyboard commands. This book will primarily use button icons or drop-down menus. The keyboard commands will be in parentheses when applicable.

Painter Terminology

- **ICON** refers to any button that has a picture on it. As you explore the work-space, move your cursor over an icon and leave it there. In a moment, the name of that icon should appear. If you are taking notes, this is an opportunity to record the accurate name of the icon for later reference either when looking it up in an index or when following exercise instructions.

- **PANELS** is the term is used by Painter to refer to small windows that open up to perform specific functions. These panels generally have more information and options than a simple button icon can provide.

- **PALETTE** refers to two or more panels that are grouped together. One of the default palettes is the color palette, which includes a **COLOR WHEEL** panel, a **COLOR-MIXING** panel, and **COLOR SET LIBRARIES**.

Figure 2.2

Use this menu to search for **BARS**, **PANELS**, or **PALETTES** that are not open.

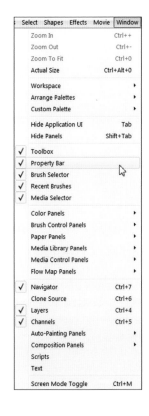

If any of the boxes or bars mentioned below is not visible on your screen, go to the word **WINDOW** on the top menu. Scroll down the drop-down menu to find **TOOLBOX**, **PROPERTY BAR**, **BRUSH SELECTOR**, and so forth.

Click on the name to make the bar visible. If there is already a check mark by the item you want to select, that means it is already open but may be hidden under another palette. You can move palettes or the **TOOLBOX** by clicking on the top blue bar and dragging it around the screen. You can close any unwanted palettes by clicking on the small dot in the upper left corner, which should turn red when your cursor passes over it.

Toolbox

On the left side of the screen you will see a vertical **TOOLBOX** (see 2.3 on next page). This contains most of the frequently used tools. These tools basically tell the program what task you want to perform, whether it is putting a mark in the drawing space, pouring paint with a paint bucket, cutting something out, or moving an object you have drawn. Look carefully at some of the icons and you will see a small black triangle in the lower right corner. This indicates that there are more tools hidden beneath this icon. To access those tools, simply click and hold on that small arrow and the hidden icons will appear. The tools are grouped by similar function.

Figure 2.3

Refer to the Painter Help menu under Exploring the Toolbox for a comprehensive list of all the tools in the **TOOLBOX**.

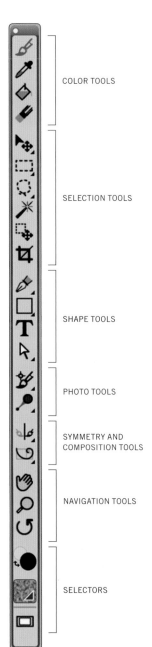

COLOR TOOLS

SELECTION TOOLS

SHAPE TOOLS

PHOTO TOOLS

SYMMETRY AND COMPOSITION TOOLS

NAVIGATION TOOLS

SELECTORS

The four **COLOR TOOLS** at the top are used when working with color media, followed by **SELECTION TOOLS**, **SHAPE TOOLS**, and **PHOTO TOOLS**, **SYMMETRY AND COMPOSITION TOOLS**, **NAVIGATION TOOLS**. Color and paper texture identifiers are at the bottom. An illustrated list of all the tools in the **TOOLBOX** and a description of their function can be found in Appendix B or in the Painter help menus. Take time to click on a few of the icons to reveal some of the other tool options.

Figure 2.4 Use the **BRUSH** tool when you are ready to put a mark on the paper.

When you open Painter, the top icon, the **BRUSH** tool, should be selected by default. The term "brush" is used for any tool that will put a mark on the paper, whether it is a pencil, a paint brush, a sponge, or a stamp, just to name a few. By clicking on this icon you are telling the program that you are ready to put a mark in the drawing space.

Menu Bar, Property Bar, and Brush Selector Bar 🅿️

Across the top of the screen is the horizontal **MENU BAR** where you will find some common drop-down menus as well as those specific to Painter. The **FILE** and **EDIT** menus may already be familiar to you. Directly below the menu bar is the **PROPERTY BAR**. This bar changes depending on which tool or brush you are using. Common uses for this bar are to change the size or opacity of a particular brush.

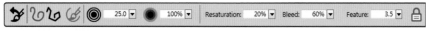

Figure 2.5 The **PROPERTY BAR** changes when different media is selected.

To the left of the **PROPERTY BAR** is the **BRUSH SELECTOR BAR**. This is one of the most powerful, exciting, and inspiring aspects of Painter. You will find any type of art media you can imagine and several you never dreamed of using. They are all referred to as "brushes" in Painter. Be fore-warned: It is easy to be drawn deeply into exploring different brushes and find yourself emerging several hours later not having accomplished the specific task you intended to do. I will suggest some of the brushes I have found most useful as a costume designer and you will discover many on your own as you strive to solve specific rendering problems.

The **BRUSH SELECTOR BAR** is divided into two parts. The icon and the name at the top of the **BRUSH SELECTOR BAR** identify the **BRUSH CATEGORY** you are using. This is where you select the specific media you want to use. The second name is the **BRUSH VARIANT**. For every media you select, there are multiple variations of that media.

Figure 2.6

The **BRUSH SELEC-TOR BAR**. The name at the top indicates the type of media you have selected and the name at the bottom tells the specific variant of that media.

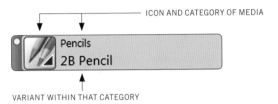

ICON AND CATEGORY OF MEDIA

VARIANT WITHIN THAT CATEGORY

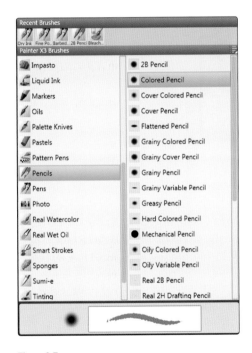

Figure 2.7

The **BRUSH LIBRARY PANEL** showing of Pencil Variants. The scroll bar on the right allows you to see all the variants available. The **DAB** and **STROKE** example at the bottom will change as different variants are selected.

Click on the small arrow in the corner of the icon to open the entire **BRUSH LIBRARY PANEL**. Across the top, you will see the brushes you have recently used. Below the recently used brushes are two lists (in Painter 12 and older versions this list is a collection of icons the one on the left represents every type of media). You will notice that the list is arranged in alphabetical order with a slider at the side to scroll up or down. As you click on a specific media, the list to the right changes to show all the **VARIANTS** of that media. For example, click on the Pencil icon in the **BRUSH CATEGORY** and you will see 2B pencils, mechanical pencils, as well as more bizarre variations such as greasy or grainy pencils. At the bottom of the library you can see visual representations of the "dab" size and "stroke" quality. Once you select a media and its variant, the library closes to save space in your document window. A new feature of Painter 3X is the **SEARCH BRUSHES** box in the upper right of the workspace. Type in the kind of media and a drop-down menu will appear showing the list of **VARIANTS**. If you know the specific **VARIANT**, type the name there and the program will locate it.

On the right of the screen are several **PANELS** or **PALETTES** that can be opened or closed. In the default setting the three windows that are open are the **NAVIGATOR PANEL**, a **COLOR PALETTE** made up of three different color panels, and the **LAYERS PANEL**, which also includes the **CHANNELS PANEL**. Because color is so important to costume designers, we will begin our discussion with the **COLOR PALETTE**. The **NAVIGATOR PANEL** will be discussed later in this chapter and you can learn about the **LAYERS PANEL** in Chapter 4.

Figure 2.8

The **COLOR WHEEL** is the default panel. Use the tabs at the top of the Palette to select the **COLOR MIXER** or **COLOR SET LIBRARIES**.

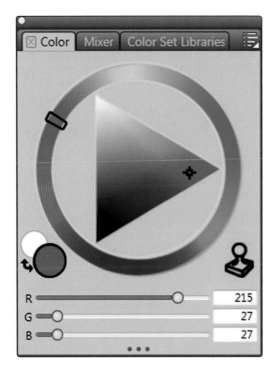

Color Palette

The **COLOR PALETTE** is made up of three **COLOR PANELS:** the **COLOR WHEEL**, **COLOR SET LIBRARIES**, and the **COLOR MIXER**. Select the hue you want to use on the **COLOR WHEEL** by moving the small black box around the outer circle. Select the saturation or value by moving the small black circle in the center triangle. The color you have selected will be displayed in the small circle in the lower left corner of the palette. Note that it is also displayed at the bottom of the **TOOLBOX**.

If you prefer to select colors from a set of color swatches, you can click on the tabs at the top of the **COLOR PALETTE** and select **COLOR SET LIBRARIES** or **MIXER**. These two options will be discussed in more detail in Chapter 3.

When working with color, an important tool to recognize is the **DROPPER** tool. The **DROPPER** icon looks like an eyedropper and is located just below the **BRUSH** tool in the **TOOLBOX**. The **DROPPER** can be used to select or sample an existing color in an image. Simply select the tool and click in the area of color you want to sample. Notice that the color wheel will change to reflect that selection. Each time you click in the image a new color is selected, so it is important to get into the habit of picking up the **BRUSH** tool as soon as you have made your color selection.

EXERCISE 2-A

Having Fun

Warning! Set a timer and discipline yourself to play and explore for a specific period of time. You might consider giving yourself a ten-minute "play" session as a warm up when you start each "work" session. That way you will begin to explore a range of tools without jeopardizing either the project that needs to get done, or the time you have available to complete that project.

1 Open a new document if you do not already have one open; you may use the file created in Exercise 1-B.

2 Make sure the **BRUSH** tool is selected at the top of the **TOOLBOX**, then go to the **BRUSH SELECTOR BAR** and begin exploring the different **BRUSH SELECTIONS** and **VARIATIONS**. See what happens as you layer one color over another using different media.

3 If your page gets too crowded and you want to start with a blank page, go to the top **MENU BAR** and the tab labeled **SELECT**. Choose **ALL** from the drop down menu. Notice the dotted line around the border of your drawing.

4 Go to the **EDIT** tab and choose **CLEAR**. You should now have a blank page.

5 Some media will respond to varying pressures with the digitizing pen. Some variants produce an uneven stroke. Look at what happens when you select **FELT PENS** and the variant **DESIGN MARKER** and make a stroke that changes direction.

6 You might pick up a brush that does nothing on a blank page. Some of the brushes work with the color that has already been applied. Take some time to explore the **FX** brushes on top of the drawing you have already done.

7 Above all, enjoy yourself. To quote one of my teachers, "This is a non-judgmental place." The purpose of this exercise is to get you excited about using the program. If you strive too hard to achieve a particular result, you may get frustrated too early.

8 When the timer stops, close your drawing. You may save it as a **JPEG** if you like.

A More Disciplined Approach

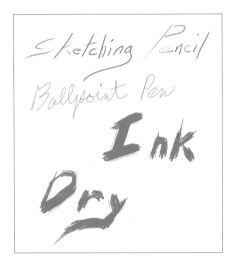

Figure 2.9

Examples of different media using varying pressure with a pen and tablet.

1 Use the **PENCIL** with the **SKETCHING PENCIL** variant to explore pressure and speed on your tablet.

2 Switch to a **BALLPOINT PEN** and note that this variant does not respond as much to pressure and speed.

3 To further refine your sensitivity to the pressure of the tablet, select the **CALLIGRAPHY** brush and the **DRY INK** variant. Try to create a smooth transition between thick and thin lines.

4 **SAVE** your file as a **JPEG**.

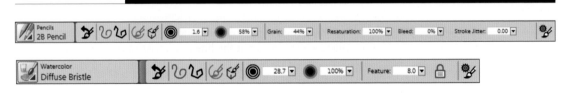

Figure 2.10

Notice the different adjustment categories in these two examples of the **PROPERTY BAR**. The first is for a simple **2B PENCIL** and the second is for an **AIRBRUSH**.

Property Bar in Detail PS

The **PROPERTY BAR** controls various aspects of the brushes you use. Not all bushes have the same properties. When you select the **PENCIL** brush and the **2B PENCIL** variant, you will see percentages for **SIZE**, **GRAIN**, **RESATURATION**, **BLEED**, and **STROKE JITTER**. If you switch to a **WATER-COLOR** brush and the **DIFFUSE BRISTLE** variant, the properties are **SIZE** and **FEATURE**. You no longer have to worry about **RESATURATION**, **BLEED**,

and **STROKE JITTER**. Take a deep breath and relax. While writing this book and in most of my work as a costume designer, I have never considered resaturation or bleeding, and rarely used stroke jitter. When you become an accomplished digital artist, you can explore these properties. The last icon (new in Painter X3) opens several complex menus for **ADVANCED BRUSH CONTROLS**. These will be briefly dicusses in Chapter 8. Short vertical lines divide the **PROPERTY BAR** into sections. We will start with the first section showing line direction.

EXERCISE 2-C

Exploring the Property Bar

1 Open a new file that is 5 × 7 inches (working small keeps the file size small) with white paper. Select the **PENCIL > 2B PENCIL** variant and let us take a closer look at the **PROPERTY BAR**.

2 Use this file to make experimental brush strokes as each part of the **PROPERTY BAR** is discussed.

Figure 2.11

The first icon resets the selected brush to its default settings. The next section of the **PROPERTY BAR** deals with line direction.

Straight and Curved Lines

The first icon is a brush **RESET** tool, which will take the brush back to its original properties. This **RESET** button is extremely useful, especially when you are doing a lot of experimenting. Next are two icons that determine if you are going to create a freehand **CURVED LINE** or a **STRAIGHT LINE**. To use the **STRAIGHT LINE** option, you select the starting point and either drag to the ending point or simply click at the place where you want the line to end. After the first line is drawn, the program will continue to connect straight lines when you click in the document window until you tell it to release the line. One option after drawing a straight line is to hit **ENTER** (**RETURN**) and the final line will connect back to your original starting point, thus closing the polygon. Another option is to simply select the **CURVED LINE** icon if you have finished drawing straight lines and do not want to close the polygon. This is a point where I find keyboard short-cuts to be a bit more helpful. You can toggle between straight and curved lines by hitting **V** on the keyboard for a straight line and **B** for a curved line. If you are drawing a series of stripes on a garment, you do not want to have your straight lines connected. In this case, draw the first line then hit **V** on the keyboard. This disconnects your line and allows you to continue to draw another straight line

starting at a different point. When you have finished drawing your stripes, you can select **B** on the keyboard to go back to drawing a freehand style. Practice switching from straight to curved lines.

The final two buttons in this section are **ALIGN TO PATH** and **PERSPECTIVE-GUIDED STROKES**. **ALIGN TO PATH** is used when working with shapes or **BEZIER** lines created with the pen tool. **BEZIER** lines are made with beginning and ending points and the program uses an algorithm to ascribe a path between the two points. For the most part, **BEZIER** lines will not be used in the exercises in this book except in the discussion of using and applying text in Chapter 7. **PERSPECTIVE-GUIDED** strokes is new to Painter X3 and is used for perspective drawing, which will not be discussed in this book.

Size, Opacity, and Grain

The next three icons are the ones that will be used frequently. In previous versions of Painter, icons were conveniently labeled. In Painter X3 you have to rely on two somewhat vague and strangely similar icon pictures. The icon with concentric circles is **SIZE** and it refers to the size in pixels of the line you are going to draw. Although it is possible to simply type in a value in the small window, it is easier to click on the small black arrow to the right of the number to open the sliding scale. As you move the slider, your cursor will change dimension and you can make a couple of test marks on your canvas to see if it is the size you want.

Figure 2.12

The **SIZE**, **OPACITY**, and **GRAIN** adjustments on the **PROPERTY BAR**.

Figure 2.13

Clicking on the percentage box opens a sliding scale below the icon.

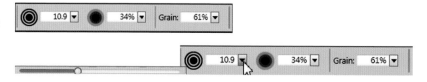

Note

The size of the brush stroke is relative to the size of the paper. If you have a document that is 5 x 7 inches and use a brush stroke that it 3 pixels wide, it will look very different on the page than if you used the same brush size on a document that is 8 x 10 inches. Consequently, if you are doing a series of sketches of different sizes, you may not be able to maintain a consistent brush size for all of the drawings. The important thing is to focus on which brush size looks appropriate for the drawing on which you are working at the time.

The **OPACITY** icon works the same as the **SIZE** icon. As with traditional media, markers or watercolors will have a lower percentage of opacity in the default setting than a pencil or a crayon. But in Painter you can control the opacity of any media and can make a crayon look more transparent than an art marker.

GRAIN, the final button we will discuss, only appears when a media is selected that responds to paper grain. The best way to see the results of the **GRAIN** icon is to use a **PASTEL** brush and one of the **SQUARE HARD** variants. The **GRAIN** slider works the same as the **SIZE** and **OPACITY** icons. The lower the number, the more apparent is the grain of the paper. The higher the number, the smoother the paper looks. If you want to change the **PASTEL VARIANT** back to its default setting, click on the **RESET** tool on the **PROPERTY BAR**.

At the very bottom of the **TOOLBOX** is the **PAPER LIBRARY**. Click on this icon to open a library of various paper textures that have been pre-loaded into Painter. Before completing the next exercise, take some time to explore the different paper textures by making some test strokes in your practice document. Whichever paper texture you choose will stay loaded as the active texture even if you close the program, so it is a good idea to check the **PAPER LIBRARY** before starting a new drawing.

EXERCISE 2-D

The First Costume Sketch

1 Start with a blank 5 × 7-inch drawing. Use the **BASIC PAPER** texture setting.

2 Choose a color and **PENCIL > 2B PENCIL** variant.

3 On the **PROPERTY BAR**, set the size at 2, the opacity at 50%, and the grain at 50%.

4 Draw a simple straight skirt.

5 Change to the straight-line mode.

6 Reset the size to 1.5 and the opacity to 20% and draw the two side front seams. Do not forget to release the **STRAIGHT-LINE** tool before making the second line.

7 Select **THICK HANDMADE PAPER** and switch to a **PASTEL BRUSH** and the **SQUARE HARD PASTEL** variant. Go back to the curved-line function.

8 Adjust the grain to 5% and adjust the size so that you can comfortably fill the skirt with the pastel stroke.

9 Give the skirt an overall texture. Change the grain to 7% to add shadows. The grains are closer together so it looks darker.

10 Use the **RESET** tool to return the pastel brush to its default settings.

11 Go to **FILE > SAVE AS** and save your file as a **JPEG** in a folder where you can find it again. If you are going to keep on working, do not close the file.

Figure 2.14

Use both the **STRAIGHT** and **CURVED** line function as well as **GRAIN** adjustments to create a simple tweed skirt.

Erase and Undo 🅟🅢

You have learned how to clear an entire drawing but, of course, there are many ways to erase or correct unwanted parts of a drawing. The easiest way to erase is to pick up the **ERASER** tool from the **TOOLBOX**. Once you do, you can adjust the size and the opacity of the **ERASER** so that you have complete control of the tool. The back end of the some digitizing pens is also an eraser, but once you get used to picking up tools from the Painter menus, it is easy to forget to turn the pen over.

Figure 2.15

The **ERASER** tool in the **TOOLBOX**.

In the **BRUSH SELECTION BAR** you will find an **ERASER** brush and its many variations. The variants list includes **BLEACH**, which can produce interesting effects on colors, as well as **DARKENERS**, which work the opposite of erasers. These are important to know if you are trying to achieve specific effects. Keep in mind that even if you have **DARKENER** or another specific **ERASER** selected in the **BRUSH SELECTION BAR**, the **ERASER** tool you pick up from the **TOOLBOX** will override those settings and revert to being a traditional eraser.

UNDO is another feature that is incredibly valuable. Painter has a default setting of 32 steps that can be undone. You can change that preference to a maximum of 256 steps, but a higher setting will interfere with the performance of your computer as it is processing image files. If you are sketching an object and a pencil stroke does not fall exactly where you want it, you can **UNDO** it and try again. If you put down several strokes of paint to check the color and decide you do not like it, you can repeatedly select **UNDO** until you get back to your clear canvas. But, as Carrie Robbins said in her foreword, a lower **UNDO** setting will provide some artistic discipline and force you to utilize your mistakes. To change the number of **UNDO** steps, go to the **EDIT** tab on the top menu bar and select **PREFERENCES > PERFORMANCE**. In the dialogue box that will open is a sliding scale to adjust **UNDO** steps.

This is another instance where the keyboard command is the easiest way to access the **UNDO** feature. Simply hit **CTRL+Z** (Windows) or **CMD+Z** (Mac). If you undo too many steps, you can **REDO** by selecting **CTRL+Y** (Windows) or **CMD+Y** (Mac). If you prefer words, you can go to the top menu bar and select **EDIT > UNDO** or **REDO**.

Navigation Tools 🅟🅢

Now that you are beginning to draw actual costume pieces, you will find a need for some navigation tools. There are three navigation tools in the **TOOLBOX**: the **GRABBER**, the **MAGNIFIER**, and the **ROTATE** tools. There is also a **NAVIGATION PANEL** on the right side of the screen.

The most convenient way to zoom in or out of a drawing is to use the **MAGNIFIER** icon in the **TOOLBOX**. By selecting this icon and clicking in the document window, you can zoom in on the drawing by incremental steps. To zoom back out, Hold the **ALT** key (Windows) or **OPTION** key (Mac) and notice how a little "minus sign" appears in the magnifier cursor. When you click in the drawing window you will progressively zoom out. If you want to zoom in to a face or specific costume detail, you can use the **MAGNIFIER** icon to draw a box around the part of the drawing you want to see more closely.

Figure 2.16

The **GRABBER**,
MAGNIFIER, and
ROTATE tools
in the **TOOLBOX**.

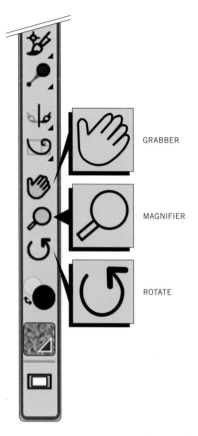

GRABBER

MAGNIFIER

ROTATE

Another useful navigation tool is the **GRABBER** tool. It looks like a small hand above the **MAGNIFIER** in the **TOOLBOX**. You can use this tool to move your canvas around within the drawing window. Notice that the scroll bars on the right and the bottom of the document window move in conjunction with the **GRABBER** tool.

Below the **MAGNIFIER** tool is the **ROTATE** icon. This tool allows you to rotate your canvas to facilitate your sketching technique. Click and drag in the drawing window to rotate the canvas to the desired angle. This does not permanently rotate the canvas. The actual file keeps the canvas in the vertical position, so if you close the document and reopen it, the canvas will be back to vertical. One instance when rotating the canvas is a convenient option is when you are drawing stripes on a garment. It is often easier to align the stripes if you can rotate the drawing area slightly to fit a more comfortable angle to your hand.

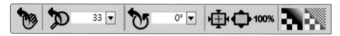

Figure 2.17 The **PROPERTY BAR** showing the controls for the Navigation Tools.

Once you select any one of these tools, the **PROPERTY BAR** will change so that you can zoom in or rotate the canvas using sliding scales. Each navigation tool also has a reset button to reposition the **GRABBER**, take the magnification back to the default, or reset the **ROTATE** tool back to zero. The next two icons to the right on the **PROPERTY BAR** allow you to center your drawing within the document window and **FIT TO SCREEN**, which will automatically zoom out so that you can see your entire drawing within the document window. The final two checkerboard icons are advanced functions having to do with the quality of the display and the drawing speed. Refer to the Painter help menu to learn more about these two functions.

Figure 2.18

The **NAVIGATION PANEL** showing the thumbnail of the *Basic Skirt*. The red box shows what is visible in the drawing window.

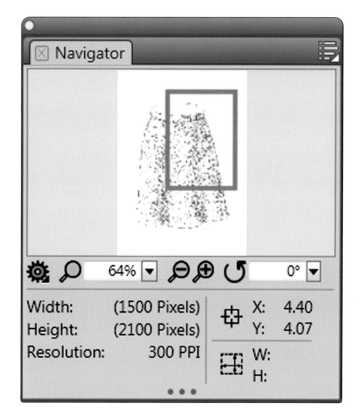

Navigation Panel

The **MAGNIFY** and **ROTATE** tools are also found in the **NAVIGATION PANEL** on the right side of the screen. This panel augments the quick adjustments that can be done by using the tools alone. In this panel is a small thumbnail version of your drawing so that you can dynamically see exactly where you are in the drawing. Below the thumbnail are a sliding scale for zooming in and out of the drawing, individual **MAGNIFIER** icons that will zoom in and out incrementally, and a **ROTATION** scale. A red box will appear in the thumbnail view that indicates to which part of the drawing you are zoomed. If you want to move to another area of the drawing while staying zoomed in, you can simply drag this red box to a new area.

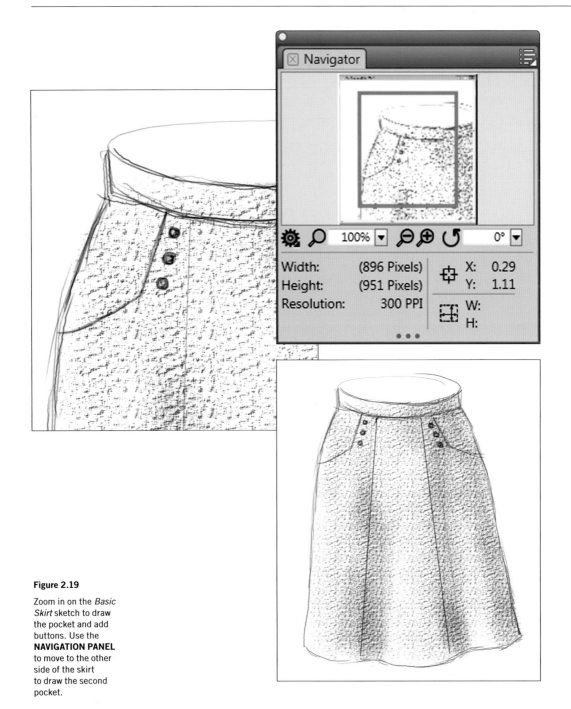

Figure 2.19

Zoom in on the *Basic
Skirt* sketch to draw
the pocket and add
buttons. Use the
NAVIGATION PANEL
to move to the other
side of the skirt
to draw the second
pocket.

EXERCISE 2-E

Magnify

1 Go back to your sketch of the straight skirt.

2 Use the **MAGNIFIER** tool in the **TOOLBOX** and drag a box around the left hip and waistband area.

3 Use the pencil (adjust the size to 1.5 and opacity 50%) and draw a shaped pocket.

4 Use the slider on the **PROPERTY BAR** to zoom out and check your result. Slide back in and draw three buttons as decoration along the edge of the pocket.

5 Use the red box in the **NAVIGATION PANEL** to move to the right hip and waistband while staying zoomed in on the drawing.

6 Draw another pocket and three-button trim in that area.

7 Select the **MAGNIFIER** from the **TOOLBOX** and, holding down the **ALT/OPTION** key, click in the drawing window until you can see the whole skirt.

8 Use the **GRABBER** tool to move your drawing to the center of the drawing window.

9 **SAVE** your file as a **JPEG**.

Figure 2.20

Each of these icons opens a library of various **PATTERNS, GRADIENTS, NOZZLES, WEAVES**, and **BRUSH LOOKS**.

Media Selector Bar 🅿

The last area of the workspace layout is the **MEDIA SELECTOR** bar located beneath the **TOOLBOX**. This bar will give you access to several **PALETTE LIBRARIES** of patterns and textures similar to the **PAPER LIBRARY** that you have already opened. The icons in this bar will change when different selections are made from the individual libraries. Here is what you will find:

- **PATTERNS** uses ready-made patterns or ones that you create to fill a selection.

- **GRADIENTS** controls gradient fills. A gradient is a gradual shift from one color to another.

- **NOZZLE** is a library of images that can be used by the brush called the **IMAGE HOSE**.

- **WEAVES** uses weave textures to fill a selection.

- **BRUSH LOOKS** is a library of images that correspond to specific types of brushes.

Each icon opens a menu of preloaded images in Painter. **PATTERNS**, **GRADIENTS**, and **WEAVES**, as well as **PAPERS**, also have **CONTROL PANELS** that can be opened by going to the **WINDOW** tab on the top menu bar and choosing **MEDIA CONTROL PANELS**. Once the **CONTROL PANEL** is opened, you will have the ability to adjust various aspects of the patterns, gradients, or weaves. **PATTERNS**, and **GRADIENTS** will all be discussed in later chapters. **WEAVES** is a special category that has more to do with defining a weave structure as if you are designing your own fabric. This along with **NOZZLE** and **BRUSH LOOKS** are advanced techniques that are best explored once you become more versed in other aspects of Painter.

Photoshop Notes

Workspace Overview

The general information about activating commands and terminology is also applicable to Photoshop. The Photoshop workspace has many similarities to the Painter workspace. The most obvious is the general layout. The **TOOLS** bar is on the left, there is an **OPTIONS BAR** across the top, and a variety of control panels appear at the right.

Figure 2.21

The full Photoshop workspace.

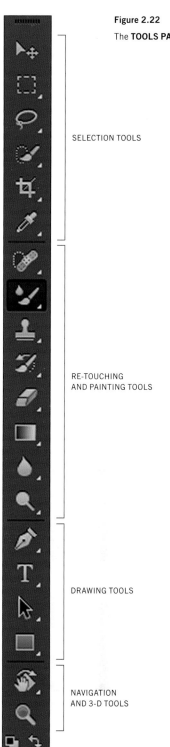

Figure 2.22

The **TOOLS PANEL** showing how the different tools are grouped together.

SELECTION TOOLS

RE-TOUCHING
AND PAINTING TOOLS

DRAWING TOOLS

NAVIGATION
AND 3-D TOOLS

Although Photoshop tools are arranged in a different order and the icons may be slightly different, there is a certain degree of similarity between Painter's **TOOLBOX** and Photoshop's **TOOL PANEL**. The grouping of tools under individual icons can be different, however, and it takes some exploration to become familiar with either program. The Photoshop **TOOL PANEL** begins with **SELECTION TOOLS**, followed by **RETOUCHING** and **PAINTING TOOLS**. The next section contains what the program refers to as **DRAWING TOOLS**, which differ from **PAINTING TOOLS** in that **DRAWING TOOLS** manipulate **BEZIER** lines (See Chapter 7 for more information about **BEZIER** lines). In this Photoshop section, the word "painting" will be used even when the bush that is chosen is a pencil or other hard medium. Keep this in mind when working through the exercises. The final section of the **TOOLS PANEL** contains **NAVIGATION** and **3-D TOOLS**.

Menu Bar, Options Bar, and Control Panels

On the top **MENU** bar the **IMAGE** tab corresponds to the **CANVAS** tab in Painter and the **FILTER** tab has similar special effects as those under the **EFFECTS** tab in Painter. Photoshop also has a discrete tab for working with text or **TYPE** as well as one for creating 3-D effects, which Painter does not have. Painter does have a separate **TEXT PANEL** (see chapter 7).

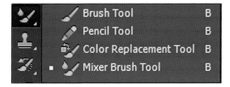

Figure 2.23

BRUSH selection from the **TOOLS PANEL**.

The **PROPERTY BAR** in Painter is called the **OPTIONS BAR** in Photoshop. As in Painter, this bar changes when different tools are selected. The icon on the far left indicates what tool is being used. The major difference between Painter and Photoshop is how brushes are selected. In Photoshop the **BRUSH** tool is located in the center of the **TOOL PANEL**. The hidden icons under that tool are the **PENCIL** tool, a **COLOR REPLACEMENT** brush, and a **MIXER** brush. Once one of these tools is selected, the **OPTIONS BAR**

Figure 2.24

The **OPTIONS BAR** when one of the **BRUSHES** is selected.

OPENS THE BRUSH CONTROL PANEL

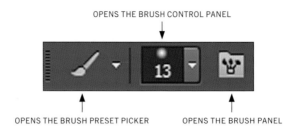

OPENS THE BRUSH PRESET PICKER OPENS THE BRUSH PANEL

Figure 2.25

The **BRUSH PRESET PICKER**. Click on the gear shaped button on the top right to open the menu of brush commands.

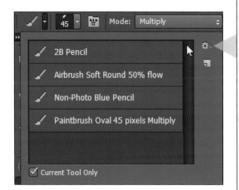

displays several icons that contain variations of brush styles. Under the **BRUSH PRESET PICKER** is a short list of pre-designed brushes including a **2B PENCIL**, an **AIRBRUSH**, an **OVAL PAINTBRUSH**, and a **NON-PHOTO BLUE PENCIL**. The addition of a **2B PENCIL** in this list is an example of the redundant systems contained in these two programs. On the top right corner of the **BRUSH PRESET PICKER** is a pop-up menu button. This will open a list of commands for customizing the panel, changing the brush library of presets, or resetting the tool back to the default. This menu is similar for all the painting tools, although there are some variations in the types of brush libraries available.

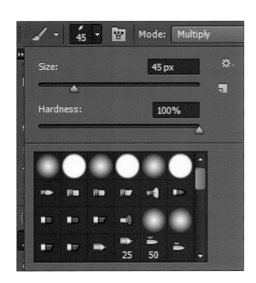

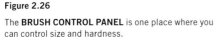

Figure 2.26

The **BRUSH CONTROL PANEL** is one place where you can control size and hardness.

Figure 2.27

The **BRUSH PANEL** contains many more variables for customizing brushes.

The second icon on the **OPTIONS BAR** opens the **BRUSH CONTROL PANEL** for adjusting the size and hardness of the brush. The third icon toggles open and closed the **BRUSH PANEL** where you can make more refined adjustments to a brush style. This panel can also be accessed from the vertical bar on the right side of the screen and is similar to Painter's **BRUSH CONTROL PANEL**. For more information about Photoshop's **BRUSH PANEL**, go to the Photoshop instructions in Chapter 8. In addition to the **OPACITY SLIDER** on the **OPTIONS BAR**, these brush panels also include a drop-down menu for **MODE**, which corresponds to Painter's **COMPOSITE METHOD** located in the **LAYERS PANEL** (see Chapter 4).

The panels on the right side of the default workspace in Photoshop include a **COLOR SELECTOR**, **ADJUSTMENTS** and **STYLES PANEL**, and the **LAYERS PANEL**. The **COLOR PANEL** has two tabs, one for picking a color off the **COLOR SCALE** or adjusting the **RGB** sliders and the other tab for

Figure 2.28

The **COLOR SLIDER PANEL** and the **COLOR SWATCH PANEL**.

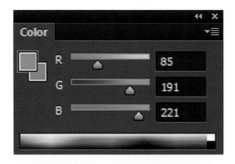

selecting individual **COLOR SWATCHES**. Photoshop also has an **EYE-DROPPER** tool in the **TOOLS PANEL** for sampling colors from an image. One thing to pay attention to in Photoshop are the two small squares of color in the **COLOR SCALE PANEL** which are also located on the bottom of the **TOOLS PANEL**. These two squares indicate a **FOREGROUND** color and a **BACK-GROUND** color. In the **TOOLS PANEL** it is possible to quickly switch between two colors or to go back to the default black and white.

Continue with Exercises 2-A and 2-B. Choose the **PENCIL** tool from the **TOOLS PANEL** and select the **2B PPENCIL** brush preset. Keep in mind that the **SELECT > ALL** and **EDIT > CLEAR** functions work the same in Photoshop.

Options Bar in Detail

Begin by opening the new document in Exercise 2-C. Some procedures that are part of the **PROPERY BAR** in Painter may not be executed the same way in Photoshop. For example, the process for painting straight and curved lines in Photoshop does not have anything to do with the **OPTIONS BAR**, but the explanation is included here to correspond with the Painter text. In order to paint a straight line, click at the beginning of the line then hold down the **SHIFT** key and click on the ending point. Once the **SHIFT** key is released you can go back to painting a freeform curved line.

Size, Opacity, and Grain

As mentioned before, the size of the brush can be adjusted in the **BRUSH CONTROL PANEL.** This panel includes sliders to control the size as well as the hardness of the tool, and small thumbnails showing different brush tip shapes. The **OPACITY** icon on the **OPTIONS BAR** has what Photoshop refers to as a "scrubby slider," which means that you can simply click on the word "opacity" and move the cursor back and forth to activate the slider.

Photoshop does not treat grain as something inherent in the painting surface but more as a texture added onto an image through filters. The variety of filters available is extensive. For the purposes of this introduction, the suggestion of paper grain will be achieved in a slightly different way. In Exercise 2-D, use the **MIXER BRUSH** in the **TOOLS PANEL** and select the **PASTEL** preset from the **BRUSH PRESET PICKER**. To increase the grain of the stroke, adjust the **FLOW** slider on the **OPTIONS BAR**.

Figure 2.29

The **MIXER BRUSH** tool and the **PRESET MENU** opened from the **OPTIONS PANEL**.

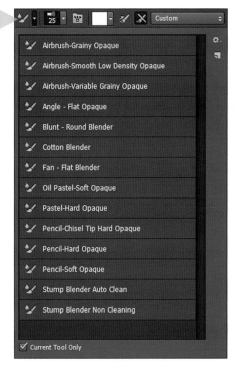

Figure 2.30

The three kinds of **ERASER** tools in the **PAINTING TOOLS** section on the **TOOL PANEL**.

Figure 2.31

The **HISTORY PANEL** shows each step in a drawing or can capture a single stage of the drawing as a **SNAPSHOT**.

Erase and Undo

Photoshop also has an **ERASER** tool in the **TOOLS PANEL**. This tool is grouped with a **BACKGROUND ERASER** and a **MAGIC ERASER**. The **BACKGROUND ERASER** samples the color where you click in the image and turns those pixels transparent, keeping the edges soft. The **MAGIC ERASER** also samples the color when you click in an image and changes all similar pixels to the background color. You can control the **BRUSH TIP SHAPE**, **SIZE**, and **HARDNESS** in the **BRUSH CONTROL PANEL**.

Using **CTL+Z/CMD+Z** in Photoshop only gives you one undo step. Clicking **CTL+Z/CMD+Z** again replaces what you just undid. Instead, Photoshop provides a **HISTORY PANEL** at the top of the vertical menu bar on the right of the workspace. The default setting in the **HISTORY PANEL** is to display the last 20 steps that were used to alter an image with the oldest version at the top of the list and most recent alteration at the bottom. By clicking on one of these steps you can revert the image back to a previous state and all other steps below that point will be discarded. Clicking on the small camera icon at the bottom of the **HISTORY PANEL** makes a **SNAPSHOT** of an image. This **SNAPSHOT** is listed at the top of the **HISTORY PANEL**. At any time you can go back and compare the image in

a previous state before determining which steps to undo. In order to keep the steps organized, you can change the name of the **SNAPSHOT** by double-clicking on the name of the **IMAGE** in the **HISTORY PANEL** and typing in a new name.

Navigation Tools

The **GRABBER** or **HAND** tool works the same in Photoshop, but the **MAGNI-FIER** or **ZOOM** tool is a little different. Once **ZOOM** is selected, simply click and drag to the right to zoom in and drag to the left to zoom out. If you want to zoom in to a specific area, you need to go to the **OPTIONS BAR** when the **ZOOM** tool is selected and uncheck the box next to **SCRUBBY ZOOM**. This allows you to make a marquee around the specific area that you want to magnify. Toggle buttons for **FIT TO SCREEN** or **FILL SCREEN** also are located on the **OPTIONS BAR**. There is a **NAVIGATION PANEL** that can be opened under the **WINDOWS** tab, but it is not part of the default workspace. This panel offers a visual representation of which portion of the image is being magnified. Once this panel is opened, an icon will be added to the vertical menu bar on the right of the workspace to make accessing this panel quicker and easier.

Underneath the **GRABBER** tool is the **ROTATE** tool, which can be used to turn the image. As with Painter, the **OPTIONS BAR** will change. This becomes particularly useful when using the **ROTATE** tool in the event that you want to bring the image back to 0°.

Complete Exercise 2-E. Practice using the **HISTORY PANEL** and the **NAVIGATION PANEL** in order to gain familiarity with these features.

Media Selector Bar

There is no **MEDIA SELECTOR** bar in Photoshop, but it is important to note that there is a **GRADIENT** tool in the **TOOLS PANEL**. Clicking on this tool and dragging in the image will fill the image with a gradient. Hidden under the **GRADIENT** tool is the **PAINT BUCKET** tool as well as a **3-D FILL** tool. See Chapter 3 about working with **GRADIENTS** and the **PAINT BUCKET** tool.

Figure 2.32

The **GRADIENT TOOL** menu is in the **PAINTING TOOLS** section on the **TOOL PANEL**.

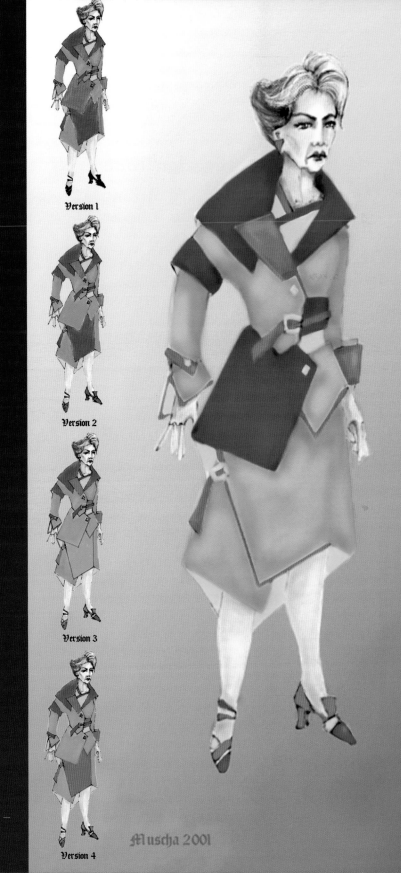

Version 1

Version 2

Version 3

Version 4

Muscha 2001

Chapter 3

Color

- Color Mixer Panel
- Color Set Libraries
- Paint Bucket Tool
- Using Gradients
- Photoshop Notes

Design by Colleen
Muscha. Frauline Doktor
Mathilde Von Zahnd in
The Physicists, Asolo
Conservatory, Sarasota,
Florida, 2001. Sketch
executed in Painter.

Color Mixer Panel ⓟⓢ

In Chapter 2 you were introduced to the color wheel. For most designers, this is a sufficient method for choosing and manipulating colors. Some, however, will miss the ability to mix custom colors, as when using traditional paint. Painter offers the **COLOR MIXER PANEL** as a means to blend your own colors. The panel is one of the tabs in the **COLOR PALETTE**. If it is not open, you can go to **WINDOW** on the top menu bar and select **COLOR PANELS > MIXER**.

Across the top of the **COLOR MIXER PANEL** are **COLOR SWATCHES** of primary hues as well as black, white, and a pale gray. Below is an open space, the **MIXER PAD**, where you can blend the colors. Across the bottom are various brush icons for applying and mixing colors as well as **ZOOM** and **PAN** buttons. The slider at the bottom changes the size of the brush on the **MIXER PAD**.

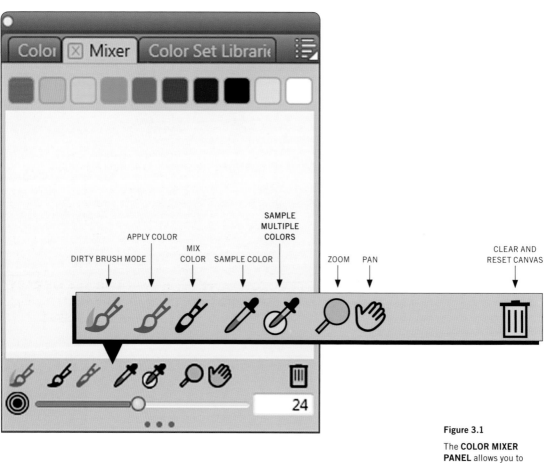

Figure 3.1

The **COLOR MIXER PANEL** allows you to mix custom colors as you would when using traditional media.

Note

In the default settings for Painter, the **COLOR MIXER PANEL** may already have colors blended in the **MIXER PAD**. See instructions below for clearing and resetting the **MIXER PAD**.

Figure 3.2

Blue and yellow have been mixed together using the **COLOR MIXER PAD**.

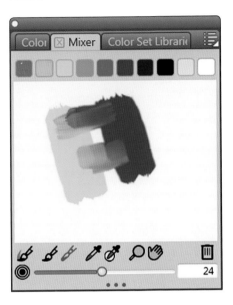

The second brush icon, **APPLY COLOR**, acts like a brush loaded with paint. Use this brush to apply paint to the **MIXER PAD**. Select another color and apply it to the **MIXER PAD**. You can now blend the two colors together using the **APPLY COLOR** brush, which is loaded with the last color you selected, or use the **MIX COLOR** brush, which functions like a clean brush and simply mixes the paint already on the **MIXER PAD** without adding more of either color. If you want to mix colors that are not represented by the **SWATCHES**, you can select a particular color either from the **COLOR WHEEL** or in the **COLOR SET LIBRARY** and then apply that color to the **MIXER PAD**. To clear the **MIXER PAD**, simply click on the trashcan icon in the lower right corner, **CLEAR AND RESET CANVAS**.

When you begin painting on your rendering, your brush will be loaded with the last primary hue that you selected before you mixed the new color. For this reason, you first need to pick up the new color you have created by selecting the **SAMPLE COLOR** eyedropper icon in the **MIXER PANEL**. Some brushes, such as the watercolor variants, can use multiple colors. If you select one of these brushes, you can also sample multiple colors by using the last eyedropper icon, **SAMPLE MULTIPLE COLORS**. Use the **ZOOM** and **PAN** buttons on the **COLOR MIXER PANEL** to zoom in close to the **MIXER PAD** so you can sample specific

color areas. To zoom out, hold the **CTL/CMD** key while clicking on the magnifier icon.

When using traditional paints, there are many times when an artist wishes to save the wet paint on the palette to avoid having to go to all the trouble of mixing the colors again. Now with digital media, it is possible to save all the variations on the **MIXER PAD**.

In the top right corner of the **COLOR PALETTE** is the **OPTIONS BUTTON**. This button will open a menu of different options for each of the three-color panels. In this case, open the options for the **MIXER PAD** and select **SAVE MIXER PAD**. In the dialogue box, give the file a name and choose a location where you will be able to find this file again. The file has its own extension (*.MXS) and can only be opened by Painter. Once it has been closed, you can reopen the file by going to the **OPTIONS BUTTON > OPEN MIXER PAD**, and find the location where you saved the file.

Another function you can find in the **OPTIONS** menu is the command to change the background color of the **MIXER PAD**. By clicking on this item, a color dialogue box will open. You can select a hue or basic white black or gray. This is particularly helpful if you want to do your renderings with a colored background. Keep in mind that if you change the background to white, you cannot see any distinction when you blend with the white paint. For this reason, the light gray background is a better choice.

Figure 3.3

The **OPTIONS** menu changes depending on which color panel is open.

Figure 3.4

You save a **MIXER PAD** the same way you save any file. Notice that the file type is distinctive.

EXERCISE 3-A

Using the Color Mixer Panel ⓟⓢ

1 Open the file *Miss Gerard* and zoom in to a close-up of her face.

2 Go to the **COLOR MIXER PANEL**. Using the **APPLY COLOR** tool, blend two or three colors together to create a rich skin tone to use as a base color on the face.

3 Switch to the **SAMPLE COLOR** tool and pick a portion of your blended color that you think is appropriate.

4 Apply this color to the sketch. A **DIGITAL AIRBRUSH** works well.

5 Adjust the opacity of the color on the **PROPERTY BAR** at the top of the screen.

6 Go back to the **MIXER PANEL** and add black or one of the dark colors to your blend to create a shadow color.

7 **SAMPLE** this new color and use it to shadow the nose, cheekbones, and under the chin.

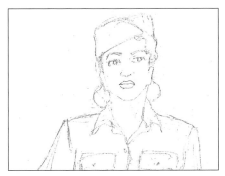

Figure 3.5

Zoom in close to *Miss Gerard*'s face to do Exercise 3-A. Sketch by Kristine Kearney.

Figure 3.6

The colors on the **MIXER PAD** were used to paint Miss Gerard's face.

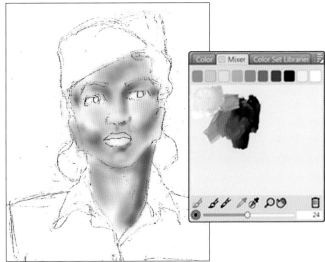

8 Repeat this process to create a highlight color.

9 Click on the **OPTIONS BUTTON** and select **SAVE MIXER PAD**. Select a folder into which you can save the file and name it *Skin Tone 1*.

10 Once the **MIXER PAD** file is saved, click on the **CLEAR AND RESET CANVAS** icon (the trashcan).

11 **SAVE** your work as a **JPEG**.

Color Set Libraries 🄿🅂

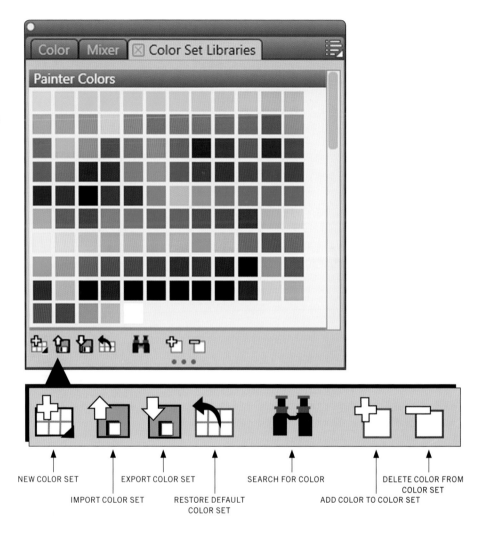

NEW COLOR SET

IMPORT COLOR SET

EXPORT COLOR SET

RESTORE DEFAULT COLOR SET

SEARCH FOR COLOR

ADD COLOR TO COLOR SET

DELETE COLOR FROM COLOR SET

Another method for using color is through **COLOR SET LIBRARIES**. This option is the third tab in the **COLOR PALETTE**. When the **COLOR SET LIBRARIES PANEL** is open, you will see an array of small swatches of individual colors. Each has a name that is revealed as you slowly move your cursor over the colors. To select a color simply click on it. Notice that the color you selected appears at the bottom of the **TOOLBOX**. If you want to adjust the value or intensity of the color, go back to the **COLOR WHEEL** tab and refine the color. In addition to being able to select colors very specifically, the advantage of using a color set is that you can create your own libraries and add colors that you use frequently.

Figure 3.8

There are many options for creating new **COLOR SETS**.

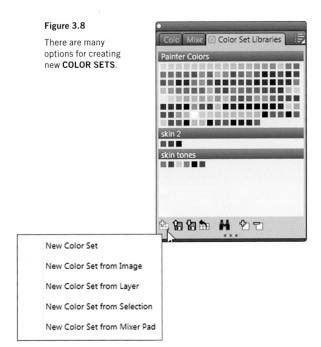

New Color Set
New Color Set from Image
New Color Set from Layer
New Color Set from Selection
New Color Set from Mixer Pad

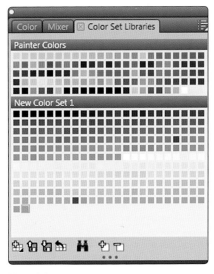

Figure 3.9

Max color slider.

There are several ways of creating new color sets based on the colors already existing in an image by selecting the **NEW COLOR SET** icon, the first icon on the bottom of the **COLOR SET LIBRARIES PANEL**. In the drop-down menu there are options for capturing all the colors in the image, just the colors in a specific layer, or the colors on the **MIXER PAD**. You can also build your own library by individually selecting specific colors. One thing to keep in mind is that no color in Painter is a simple color. The eye may see only three colors in a part of an image, but when you create a color set from even a part of an image, the library will include all nuances and variations of those colors. The new library will be a lot bigger than you might imagine. For this reason, I suggest that you reduce the **MAX COLOR** slider (found only in Painter X3) or create your custom libraries by selecting individual colors.

EXERCISE 3-B

Working With the Color Set Library

1 Go back to *Miss Gerard*'s face.

2 Open the **COLOR SET LIBRARY** tab in the color palette.

3 Select a dark brown color to use to outline the eyes and eyebrows.

4 Pick a contrasting color to give her some eye shadow.

Figure 3.10

Notice that the color set created from all the colors in the image is much larger than expected.

Figure 3.11

Once you select **NEW COLOR SET** from the menu, you can give your custom library a distinctive name.

5 Once the eyes are complete, click on the **NEW COLOR SET** icon and choose **NEW COLOR SET FROM IMAGE**.

6 Scroll down the color set library and you will see heading for **NEW COLOR SET 1**. Below this heading are swatches of all the colors in the sketch including the smudges on the bottom of the drawing. This is probably more than you need in a custom color library.

7 **SAVE** your work as a **JPEG**.

A better way to create a customized color library is to go to **NEW COLOR SET**, and choose **NEW COLOR SET** again from the menu. In the dialogue box give the new library a distinctive name. A swatch of whichever color was selected last is now showing in the new library. To add more colors, use the **EYEDROPPER** tool in the **TOOLBOX** to sample a color from your rendering, the **COLOR WHEEL**, or the **MIXER PAD**. Then go back to the **COLOR SET LIBRARY** and click on the icon with the plus sign, **ADD COLOR TO COLOR SET**. Do this for each color you want to add to your custom library. If you want to remove a color from the library, click on the color then click the **DELETE COLOR FROM COLOR SET** icon. You can give each of your custom colors individual names by **RIGHT**-clicking **CTL** + click on the color and typing in the new name. Having names for colors becomes important in complex drawings. Among the icons at the bottom of the panel is a pair of binoculars. This tool enables you to search for colors

Figure 3.12

If you have named your colors based on how they are used in the drawing, it is easy to retrieve those colors by using the search function in the **COLOR SET LIBRARY** panel.

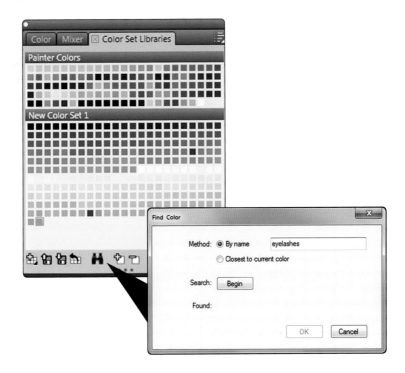

Figure 3.13

Use the **OPTIONS BUTTON** to change the size of the color swatches.

by name. Type in the name of the color you want to find and click on **BEGIN**. When the dialogue box indicates the color has been found, click **OK**. The color is now loaded on your brush and the swatch is highlighted in the color library.

Sometimes it is difficult to see which color is highlighted among all the tiny swatches. You can change the appearance of the **COLOR SET LIBRARY** by going to the **OPTIONS BUTTON** in the top right corner. When you open this menu you will see a new list of options different from those for the **COLOR MIXER** or the **COLOR WHEEL**. Scroll down the menu to **COLOR SET LIBRARY VIEW**. There you can choose to make the swatches small, medium, or large, or use just a list of color names.

Figure 3.14

Select the name of
the **COLOR SET** that
you want to export
from the drop-down
list, then click **OK**
and choose a location
to save the file.

If this library is one that you will use frequently, you can save the library by
EXPORTING it to a location on your computer. The third icon on the bottom is
the **EXPORT COLOR SET** button. In the dialogue box select the name of the
color library you want to export. Then choose the location where you want to
save the file. Notice that the **COLOR SET** files have a select file extension, **.PCS**.
Again, this type of file can only be opened by Painter.

If you are working with several color sets and you want to close one in order to
simplify the library panel, go to the **OPTIONS BUTTON** on the top right
hand corner. Select **REMOVE COLOR SET** from the drop-down menu. In the
dialogue box select the name of the library you want to remove and click **OK**.
A warning box will appear saying, "Removing the library permanently deletes the
library from Painter. Do you want to remove the selected library?" As dire as this
sounds, it just means that the library will be permanently deleted if you have
not already saved and exported the library to a location on your computer. If you
have saved the library, it can be reopened by using the **IMPORT COLOR SET**
icon at the bottom of the panel. You can then go to the location to which you
exported your color set files, select the appropriate library, and click **OPEN**. The
library will reappear in the **COLOR SET LIBRARY PANEL**.

Figure 3.15

Choose the **COLOR
SET** you want to
remove from the list.
Once selected, a
warning will appear
informing you that the
library is permanently
deleted from Painter.
If you have saved
the library on your
computer, this should
not be a problem.

EXERCISE 3-C

Creating a Custom Color Set

1 Go back to the *Miss Gerard* file.

2 Under the **OPTIONS BUTTON** choose **REMOVE COLOR SET.** Make sure **NEW COLOR SET 1** is listed in the dialogue box then click **OK**. Say **YES** in the warning box. Next you will make a more selective custom library of the facial colors used in the sketch.

3 Go to the **COLOR SET LIBRARIES PANEL** and select the **NEW COLOR SET** icon **> NEW COLOR SET**.

4 In the dialogue box give the new set the name *Skin Tone 2*.

5 Scroll down to find the new library. A swatch of the last color you used should be at the top of the library. Click to make this library active.

Figure 3.16

When the new library is created, the last color that was used appears as the first swatch.

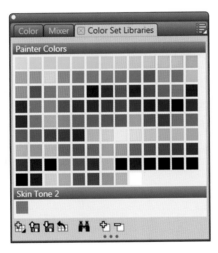

6 Pick up the **EYEDROPPER** tool from the **TOOLBOX** and select a part of the rendered face that has a medium skin tone.

7 In the **PANEL**, click on the **ADD COLOR TO COLOR SET** icon. The new color should appear next to the first color.

8 Go to the **MIXER PAD**. Click on the **OPTIONS BUTTON > OPEN MIXER PAD** and find the *Skin Tone 1* file that you saved.

9 Using the **SAMPLE** tool, select a shadow color.

10 Go back to the **COLOR SET LIBRARY** and add the shadow color to the *Skin Tone 2* library.

Figure 3.17

The **COLOR MIXER PAD** has all the skin tone colors and the **SKIN TONE 2** library has the lipstick and eye shadow colors as well as simplified swatches of skin color.

11 Click on the first color in the library set then select the **DELETE COLOR FROM COLOR SET** icon. A dialogue box will open asking if you are sure you want to delete the selected color. Just click **YES**.

12 Go to the **COLOR WHEEL PANEL** and find a color to use as lipstick.

13 Add that color to the *Skin Tone 2* library. **RIGHT CLICK** (**CTL+CLICK**) on the lipstick color and select **RENAME COLOR**. Give the color a distinctive name.

14 In order to save this color set go to the **EXPORT COLOR SET** icon. Make sure that *Skin Tone 2* is listed in the dialogue box. Click **OK** and find a location in which you can save your file.

15 Finish coloring in the face.

16 **SAVE** your file as a **JPEG**.

ADVANCED EXERCISE

Try this on your own: Use your *Skin Tone 1*, **MIXER PAD**, or *Skin Tone 2* to add color to the hands and legs.

Paint Bucket Tool ⓅⓈ

One of the timesaving features of digital design is the option of using the **PAINT BUCKET** tool to quickly fill a space with color. While it is indeed a timesaving

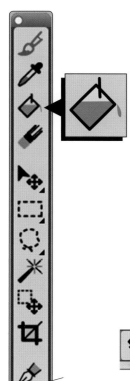

device, there are some difficulties with using this tool. The major disadvantage of this method is that the area that needs to be filled must, in most cases, be bounded by an unbroken line. For those designers who create a sketchy free-flowing figure, the effort to make a solid outline not only takes more time but also seems to destroy the life in the drawing. The other significant problem is that the color fill is flat and opaque. Although this look might be suitable is some circumstances, it does not add depth or a sense of three-dimensional contour to your sketches. There are, however some fairly simple solutions to these problems.

Stopping Leakage

When you select the **PAINT BUCKET** tool from the **TOOLBOX**, the **PROPERTY BAR** displays a box for **FILL**, which tells the program what you want the **PAINT BUCKET** to use to fill your image. The default setting is **CURRENT COLOR**. Click on the arrow in this box to see other fill choices.

Figure 3.18

The **PAINT BUCKET** too may look familiar from other programs you have used.

Figure 3.19

The **PAINT BUCKET FILL** options are located in a drop-down menu on the **PROPERTY BAR**.

Next to the **FILL** box are two popup sliders for **TOLERANCE** and **FEATHER**. Painter uses the **PAINT BUCKET** tool to fill areas based on color boundaries. When you position the **PAINT BUCKET** on your drawing, you are in effect selecting a specific pixel of one color and telling the program to fill all the neighboring pixels close to that same color with a new color. Often the color will leak beyond what you perceive as a boundary. For example, if you are working with a pencil sketch on a white background and select an area in the interior of your sketch, the paint will be stopped by the gray sketched line except in those areas where the line is too faint or there is a gap. The light gray of those faintly sketched lines is not different enough from the white color of the pixel you selected for the program to recognize it as a boundary.

The first thing you can do is zoom in close and inspect the outline of the drawing for any gaps. By nature a pencil stroke will have tiny gaps reflecting the grain of the paper, so if you are going to repair gaps in a sketch, you should use a more continuous media such as the **SMOOTH INK PEN.**

Figure 3.20

The **TOLERANCE** slider works just the same as the **SIZE** and **OPACITY** sliders on the **PROPERTY BAR**.

Figure 3.21

In the first example with the **TOLERANCE** set at the default 32, the **PAINT BUCKET FILL** color is stopped by the solid line but bleeds through the chalk line. In the second example the **TOLERANCE** has been reduced to 19 and the chalk line now contains the color.

Another technique involves tracing over the entire outline of the area you want to fill with a brush like the **SMOOTH INK PEN** or making a selection around the edge of the area to be filled. See Chapter 5 on making selections. This technique can be tantamount to redrawing the sketch and you will lose some of the loose feeling of your original drawing. In a complex, lightly sketched drawing it can be very tedious to close every single gap or redraw every outline. The most successful solution for stopping leakage is to limit the number of pixels that will be filled by the **PAINT BUCKET**. The **TOLERANCE** slider changes the degree of variance from the specific pixel you choose to fill. The default setting is 32. If you lower the **TOLERANCE** slider, you limit the number of pixels that will be filled. The paint flow will be stopped even by pale lines, thus minimizing the leakage. You may still have to go back and close more obvious gaps, but you will find that you usually do not have to redraw the entire outline.

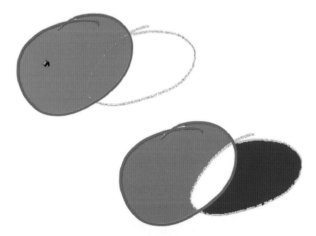

The **FEATHER** slider softens the edge of the fill. The default setting is 0. If you increase the **FEATHER** slider, the pixels just outside the tolerance range will be filled with the color at a lower intensity, making it appear that the color is gradually fading into the boundary. This can also counteract the effect of lowering the **TOLERANCE** slider, so it may take some experimentation to achieve the correct balance between these two sliders.

Figure 3.22

In the first image the **PAINT BUCKET FEATHERING** is set at 0. There is a clear distinction where the blue color is stopped by the pink chalk line. In the second image the blue color merges slightly into the pink line, creating a more subtle transition.

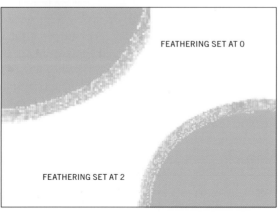

FEATHERING SET AT 0

FEATHERING SET AT 2

Filling with Current Color

Figure 3.23

The **PAINT BUCKET FILL** color is contained by the skirt outline when the **TOLERANCE** is set at 10.

1 Open the file labeled *Full Skirt*.

2 Save the file and give it a new name.

3 Use the **EYEDROPPER** tool in the **TOOLBOX** to select the beige color of the outline.

4 Click on the **PAINT BUCKET** tool and check the **PROPERTY BAR** to make sure the words **CURRENT COLOR** are in the **FILL** box.

5 Click anywhere within the outline of the skirt. Paint will flow throughout the entire drawing.

6 Click **CTL+Z/CMD+Z** to undo the **PAINT BUCKET FILL**.

7 Go back to the **PROPERTY BAR** and move the **TOLERANCE** slider to 10.

8 Use the **PAINT BUCKET** to click inside the skirt outline again. This time the paint should be contained within the outline.

9 **SAVE** your work as a **JPEG** and close the file.

Creating Contour

If you want to give your sketch the suggestion of depth and dimensionality, you can select **GRADIENT** from the **PAINT BUCKET FILL OPTIONS**. Once you select a color, notice that there are two small color circles in the corner of the **COLOR WHEEL** (These also appear at the bottom of the **TOOLBOX** to indicate what color is currently in use). Usually the back circle is white. This indicates that your gradation will be from white to the color you selected. If you want a gradation between two different colors, simply click in the white circle and select a second color. Keep in mind that the **PAINT BUCKET FILL** is opaque, so even though the color is graduated, the white area will hide anything underneath it. To control the opacity of a **FILL**, you need to work in a separate layer. See Chapter 4 on working with layers.

Using Gradients ⓟⓢ

In addition to the standard two-color gradient, there are several pre-designed gradients loaded into the **GRADIENTS LIBRARY.** You can access the **GRADIENTS LIBRARY** by going to the **MEDIA SELECTOR BAR** below the **TOOLBOX**. For this exercise, however, you will need to manipulate the standard two-color gradient, so it is necessary to open the **GRADIENTS CONTROL PANEL**. Go to the top menu bar and the **WINDOWS** tab. Select **MEDIA CONTROL PANELS > GRADIENTS**. The **GRADIENTS CONTROL PANEL** will open. Notice that it is in a **PALETTE** that also contains tabs to open the controls for **PATTERNS** and **WEAVES**.

Editing a Gradation

The **GRADIENTS CONTROL PANEL** includes a preview window as well as an icon to open the library of Painter's pre-programmed gradient designs. Below the library icon is a series of thumbnails that can change the type of gradation. You can choose from **LINEAR**, **RADIAL**, **CIRCULAR**, or **SPIRAL** and you can control the direction of the color blend. For most costume applications you will use a linear, two-point gradation. Select the **TWO-POINT** variation from the **GRADIENTS LIBRARY**, select the two colors you want to use, and then determine the direction you want the blend to flow. When you are painting a costume rendering, you usually determine a light source coming from a specific direction. The linear gradient can correspond to that light source so the angle of the shadows is consistent throughout the rendering. In some instances, you may want to select the variation that is dark in the middle and light on either side, or the inverse, which is light in the middle and dark on either side. Similar adjustments can be made with **SPIRAL** gradients.

Figure 3.24

The **GRADIENT CONTROL PANEL** sets the direction of the gradient as well as the degree of shift between colors.

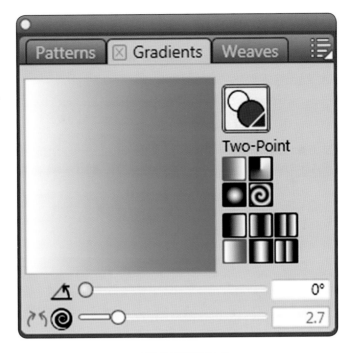

Figure 3.25

Click in the center of the gradated scale and a center triangle will apprear that can move to adjust the degree of gradation from one side to another. If you click in the window on one side or another, you can add additional color control points.

At the bottom of the **GRADIENTS CONTROL PANEL** are two sliders. The one at the top controls the direction of a linear gradation. The bottom one controls the tightness of a spiral gradation. For more advanced editing, click on the **OPTIONS BUTTON** in the top right corner to open the drop-down menu. Select **EDIT GRADATION**. Another dialogue box will open with a slider. Click in the center of the gradation strip. A center triangle will apprear that you can move from left to right to change the range of transition in the gradation.

Editing Gradients

1 Open the original file labeled *Full Skirt* again.

2 Click on the **PAINT BUCKET** icon.

3 Go to the **PROPERTY BAR**. Click the small arrow in the **FILL** box and select **GRADIENT**. Make sure the **TOLERANCE** slider is set at 10.

4 In the **GRADIENTS CONTROL PANEL** make sure the **TWO POINT** thumbnail is showing in the library window.

5 Check the **LINEAR GRADIENT** button.

6 Because the skirt is sitting at an angle on the hips, you need to adjust the angle of the gradation. Move the top slider in the **GRADIENT CONTROL PANEL** so that the darker area of the color is in the upper right corner.

7 Now fill the skirt with the **GRADIENT**.

8 **SAVE AS** a **JPEG** file and give it a new name. Close the file.

Figure 3.26

Note the transition of color across the skirt and how it corresponds to the thumbnail image in the **GRADIENT CONTROL PANEL**.

The skirt you just created now has a highlight on one side of the body. In reality each fold of the skirt would have its own highlight and shadow. The next exercise will use gradations to give the skirt more dimensions. Additional techniques for creating highlights and shadows can be found in Chapter 6 on the use of **DODGE** and **BURN** tools.

EXERCISE 3-F

Creating Multiple Dimensions

1 Re-open the original file labeled *Full Skirt*.

2 Using a **SMOOTH INK PEN** and a color that matches the skirt, extend the lines that define the folds up to the waistband. Make sure all gaps are closed.

3 Imagine that the light is coming in from the left side of the drawing.

4 Select the **PAINT BUCKET** tool and make sure the **FILL** is set on **GRADATION** and the **TOLERANCE** slider is set at 10.

Figure 3.27

The individual gradations replicate the play of light over the folds of the skirt, giving the rendering a more three-dimensional appearance.

SKIRT DIVIDED INTO SECTIONS EACH SKIRT IS FILLED WITH AN INDIVIDUALLY CALIBRATED GRADATION

5 Fill the first section on the far left of the skirt with a gradient that moves from light on the left to dark on the right.

6 Using the lower set of buttons on the **GRADIENTS CONTROL PANEL**, change the type of gradient to one that is light in the middle and dark on the sides. Use this to fill the second section of the skirt. You may have to adjust the angle slightly (you can type 3° into the box by the slider).

7 For the third section of the skirt change the **FILL** in the **PROPERTY BAR** to **CURRENT COLOR**. This section is completely in shadow so it is filled with a solid color.

8 The next section is filled with a gradient that is light in the middle and dark on the sides. Adjust the angle to about 10°.

9 Use a gradient that is dark on the left and light on the right for the next section.

Figure 3.28

Finished coloring the skirt.

The definitions between each section of the skirt have been blended to create a smoother effect from one color to another.

THE EDGES OF EACH SECTION ARE BLENDED
USING A SOFT BLENDER STUMP AND AN AIRBRUSH

10 Fill the last section with **CURRENT COLOR**.

11 Go to the **BLENDERS** brush category and select **SOFT BLENDER STUMP**. Use this brush to smooth out the hard edges at the top of the skirt. You can also use an **AIRBRUSH** or other soft-edged media to refine the transitions into the folds of the skirt.

12 **SAVE** your file as a **JPEG** with a new name.

ADVANCED EXERCISE

Continue on your own: The character *Miss Gerard* is an army WAC. Mix a range of color from dark to light khaki using the **MIXER PAD** to apply to *Miss Gerard's* dress. By sampling the colors in the **MIXER PAD**, you can create a gradient of highlights and shadows to use with the **PAINT BUCKET** tool to paint *Miss Gerard's* dress. Create and export a **COLOR SET LIBRARY** of only the colors in the dress.

Figure 3.29

Sketch by Kristine Kearney. Miss Gerard in *Mr. Roberts* for Cincinnati Playhouse-in-the-Park, Cincinnati, Ohio, 2004.

Photoshop Notes

Color Panels

To select a color from the **COLOR SLIDER PANEL** you first click on the scale at the bottom to get into the general color range you desire. Then move each of the **RED, GREEN,** or **BLUE** sliders to refine the color more carefully. Another way to select a color is to click on the color swatches at the bottom of the **TOOLS PANEL**. This will open a **COLOR PICKER** dialogue box where you can adjust the value and intensity of the color chosen or move to a different hue.

Figure 3.30

The **COLOR SLIDER PANEL**. Basic hues can be selected from the bar at the bottom and tints and shades can be created by moving the RGB sliders.

Figure 3.31

The **COLOR PICKER** dialogue box is opened by clicking on the color swatches at the bottom of the **TOOL PANEL**.

Instead of a separate **COLOR MIXER PANEL**, Photoshop uses a **MIXER BRUSH** located with the **BRUSH** tool in the **TOOLS PANEL**. The **MIXER BRUSH** tool allows you to mix paint directly on the canvas. The **MIXER BRUSH** loads one color onto the brush and, depending on different settings, will then mix with a color that is already on the canvas. An alternative way to use this tool is to open a new document to use as a palette and mix your colors in that document.

The new colors can then be sampled and applied to your painting. The practice file can be saved as a **PSD** file so the colors remain wet and can be picked up again at a later time. Individual colors can be saved in the **COLOR SWATCH PANEL**.

In order to use this brush more effectively, it is important to understand the **OPTIONS BAR** for this tool. In addition to the standard brush control icons, there is a color swatch showing what color is loaded onto the brush.

Figure 3.32

The **OPTIONS BAR** when the **MIXER BRUSH** is selected.

There are also percentage slides to adjust the way the paint interacts with the color on the canvas.

- **WET** determines the wetness of the paint on the canvas not on the brush. The higher the percentage, the more the colors will flow together.

- **LOAD** determines how much paint is loaded onto the brush. If less is loaded, the brush will dry out after making only a few strokes. Note that there is a toggle button that can be set to load the brush after each stroke.

- **MIX** refers to the amount of paint that is mixed from the canvas. If the number is high, less of the paint on the brush will be mixed with the color on the canvas.

- **FLOW** can determine how well the color flows over the canvas surface.

Figure 3.313

CUSTOM is the default setting for the **MIXER BRUSH** but there are many other presets that can be accessed from the **OPTIONS BAR**.

In addition to these individual settings, there is a drop-down menu with brush setting presets. These are convenient if you do not want to adjust each of these settings every time you want to mix colors. Use the Photoshop **COLOR PANEL** to select and refine colors for Exercise 3-A. Explore one of the **AIRBRUSH** tools under the **MIXER BRUSH** to replicate the exercise.

Figure 3.34

The **COLOR SWATCH PANEL** showing the drop-down **OPTIONS MENU**.

Color Swatch Panel

The **COLOR SWATCH PANEL** is very similar to the **COLOR SET LIBRARY** in Painter. This panel has two icons at the bottom, one for saving a color that has been sampled from an image and the other for deleting a swatch. The major difference in the **COLOR SWATCH PANELS** is the number of preloaded swatch libraries and the manner in which custom libraries are created. In the drop-down **OPTIONS MENU**, opened with the button in the top right corner, you will find many more preset color libraries and options. Some of the options are:

- **RESET SWATCHES** switches back to the default colors.

- **LOAD SWATCHES** adds a new swatch library from your saved files to the existing swatches.

- **SAVE SWATCHES** creates a new library and saves it with a distinct **.ACO** file extension.

- **REPLACE SWATCHES** replaces the existing color library with another from your saved files.

When you select **SAVE SWATCHES**, the new library will contain all the swatches that are visible, not just the new colors you have added. After giving the library a new name and saving it, you can then add or delete colors to configure the library to your liking. To go back to the default colors, select **RESET SWATCHES** from the **OPTIONS** drop-down menu. A prompt will appear asking if you want to save changes before resetting back to the default colors.

Use Exercises 3-B and 3-C to explore the preset **COLOR SWATCH LIBRARIES** and create a custom **COLOR SWATCH LIBRARY**.

Figure 3.35

The icons grouped with the **GRADIENT TOOL** include the **PAINT BUCKET** and the **3-D MATERIAL DROP TOOL**.

Paint Bucket and Gradient Tools

The **PAINT BUCKET** and the **GRADIENT** tools are located stacked together towards the middle of the **TOOLS PANEL**. When the **PAINT BUCKET** tool is selected, the **OPTIONS BAR** has similar choices to those in Painter and the tool works in the same way. The **GRADIENT** tool, however, works a bit differently. To fill an area with a graduated color, you first select the tool and then drag your cursor through the painting in the direction in which you want the color to move from dark to light. Colors can be selected using the **FOREGROUND** and **BACKGROUND** color swatches in the **COLOR SELECTION PANEL**. Because you are not working with the **PAINT BUCKET** tool, the **GRADIENT** tool does not respond to pixel color. If you want to confine the **GRADIENT FILL** to a restricted area, you must first make a selection to determine the borders on the area. The most convenient method is to use the **QUICK SELECTION** tool towards the top of the **TOOLS PANEL**. Once this tool is selected, click in the area you want to fill. The program interprets the boundary of the area you have chosen. You may have to click more than once to get the entire area selected. See Chapter 5 for more on making selections. After the selection is made, click on the **GRADIENT** tool and drag your cursor inside the selection. Only that area will be filled with the gradation.

Figure 3.36

The **QUICK SELECT** and **MAGIC WAND** tools in the **SELECTION TOOL** section on the **TOOL PANEL**.

The first icon on the **OPTIONS BAR** when the **GRADIENT** tool is selected is the drop-down library of **GRADIENT PRESETS**. If you select one of these and then click in the thumbnail window, the **GRADIENT EDITOR** dialogue box will open. Here you can adjust the degree of one color in proportion to the next.

The **OPTIONS BAR** will also have buttons to select **LINEAR**, **RADIAL**, **ANGLED**, **REFLECTED**, and **DIAMOND** gradations.

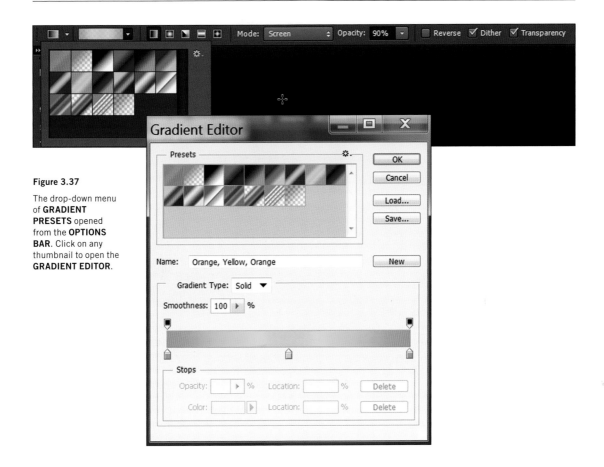

Figure 3.37

The drop-down menu of **GRADIENT PRESETS** opened from the **OPTIONS BAR**. Click on any thumbnail to open the **GRADIENT EDITOR**.

Complete the next three Exercises. In Exercise 3-E, you will need to make a selection of the outline of the skirt. In Exercise 3-F, you can eliminate the steps dividing the skirt into sections and simply select different areas of the skirt to fill. Use the **REFLECTED** button on the **OPTIONS BAR** and experiment with different ways of dragging the cursor to make the gradation align to the angle of the skirt. In any one selection you can keep making subsequent fills with the gradation until the fill looks correct.

Figure 3.38

The **GRADIENT STYLE** buttons located on the **OPTIONS BAR**.

LINEAR ANGLED DIAMOND
RADIAL REFLECTED

THE MIKADO LYRIC STAGE 2012

DIRECTED BY: SPIRO VELOUDOS, COSTUMES BY: RAFAEL JAEN

Chapter 4

Working with Layers

- Layers Panel
- Working with Watercolors
- Composite Methods
- Layer Commands: Group, Ungroup, Collapse, and Drop
- Photoshop Notes

Design by Rafael Jaen.
Katisha in *The Mikado,*
Lyric Stage Company,
Boston, Massachusetts.
2001. Sketch executed in
Photoshop.

I n addition to the array of art materials and brushes, one of the most valuable features of digital design is the layers function. You can think of layers as stacks of clear acetate that are placed over a drawing. You can change the properties of those layers to make them translucent or opaque. You can rearrange the layers in a different order to create diverse effects. Above all, the use of layers is a means by which to organize all the information in a complex drawing. For example, you might choose to put the skin color of your figure on one layer, design the skirt on another layer, and draw the blouse on a third layer. If the character will later add a coat, you can add a fourth layer and draw in the coat without having to redraw the entire sketch and or having the painting technique on the coat damage the painting on the under layers.

Layers Panel Ⓟ

In this section we will discuss how to create and name layers, rearrange layers, and lock, hide, or delete layers. Keep in mind Painter's redundant features. There is a **LAYER** tab on the top menu bar. The drop-down menu there will give you access to all of the layer commands. It is somewhat tedious, however, to constantly scroll through drop-down menus. It is far more efficient to work with the **LAYERS PANEL**. It is also important to get into the habit of checking the **LAYERS PANEL** to see which layer is active. You may think you are working on the Skin layer only to discover when you try to hide that layer that the painting you were doing actually appeared on the Blouse layer because you did not check to make sure the Skin layer was activated.

If the **LAYERS PANEL** is not open, go to **WINDOW** and make sure **LAYERS** is checked. Open a new file and put a bold mark on the page. The first layer in any document is called the Canvas layer. You should see the Canvas layer in the **LAYERS PANEL**. Now look at the row of buttons at the bottom of the palette.

The first three icons have small arrows next to them. This indicates that they will open a drop-down menu. At the moment, we will work with the third icon, **ADD A NEW LAYER**. Simply click on this button and a new layer will be added to the list in the **LAYERS PANEL**. When you paint in this new layer, you are not altering the sketch that is in the Canvas layer.

Keep in mind that the Canvas layer cannot be locked, moved, duplicated, or deleted. The techniques for manipulating the other layers utilize button icons, click and drag functions, as well as using a **RIGHT CLICK /CTL+CLICK**. In addition, there is a drop-down menu of options and commands in the upper right corner. Some of the more common applications for layers follow.

Figure 4.1

The green highlight indicates which is the active layer. The icons on the right of the layer name indicate the type of layer.

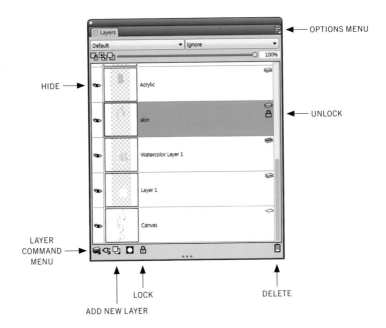

OPTIONS MENU

HIDE

UNLOCK

LAYER COMMAND MENU

LOCK

DELETE

ADD NEW LAYER

- **HIDE** a layer. Click on the eye icon to the left of the layer name. When the eye is closed the layer is hidden.

- **LOCK** a layer. Click on the small padlock icon on the bottom of the palette. Note a padlock symbol will appear to the right of the layer name.

- **UNLOCK** a layer. Click on the padlock symbol next to the layer name.

- **MOVE** a layer. Click and drag the layer either above or below subsequent layers.

- **DUPLICATE** a layer. **RIGHT CLICK** (**CTL+CLICK**) on the layer name and select **DUPLICATE** from the drop-down menu.

- **DELETE** a layer. Click on the layer you want to delete then click on the trash can symbol on the bottom of the palette.

As a drawing becomes more complex, it becomes necessary to keep track of several layers. When the list of layers gets longer than what is visible in the panel window, a scroll bar will appear to the right so that you can move up and down through the layer list. The small thumbnail next to the layer name helps to identify what is in the layer. If the sketch is just a small piece of the whole image, a piece of jewelry for example, what is drawn in the layer may not be visible in the thumbnail. It is important, therefore, that you give the layers specific names.

DOUBLE CLICK on the layer that you want to name. The **LAYER ATTRIBUTES** dialogue box will open with a space for you to type in a new name for the layer. If

Figure 4.2

In addition to naming a layer, contents can be precisely positioned or mapped with hotspots linked to websites. Both of these are advanced techniques that will not be covered in this book.

you want to change a name that you created, **DOUBLE CLICK** on the layer name and you will be able to type in a new name.

EXERCISE 4-A

Working with Layers

1 Open the file labeled *Basic Croquis*.

2 Create a new layer and name it Blouse. Use a pencil and a bold color to sketch in the blouse shape.

3 Create another new layer and change the name of this layer to Skin.

4 Use Select **AIRBRUSH > DIGITAL AIRBRUSH** from the **BRUSH SELECTOR BAR**, then choose a color to use as the skin tone from one of the **CONTROL PANELS**.

5 Adjust the size and opacity and begin filling in the head and arms with skin color.

6 Use the **ERASER** tool in the **TOOLBOX** to go back and clean up the over spray areas around the hand especially. Notice that the *Basic Croquis* image on the canvas and the lines in the Blouse layer are not affected by erasing on the Skin layer.

7 In the **LAYERS PANEL**, click on the Skin layer and **MOVE** it below the layer labeled blouse. The lines of the blouse are now clearly visible on top of the Skin layer.

8 **LOCK** the Skin layer.

9 Click on the Blouse layer and **DUPLICATE** it. Label the new layer Acrylic. On the **BRUSH SELECTOR BAR**, select **ACRYLIC** media and the variant **OPAQUE ACRYLIC**. Begin to fill in the blouse outline with color. The opaque medium will cover the blouse outline, any skin tones that are under the blouse, as well as the figure outline on the canvas.

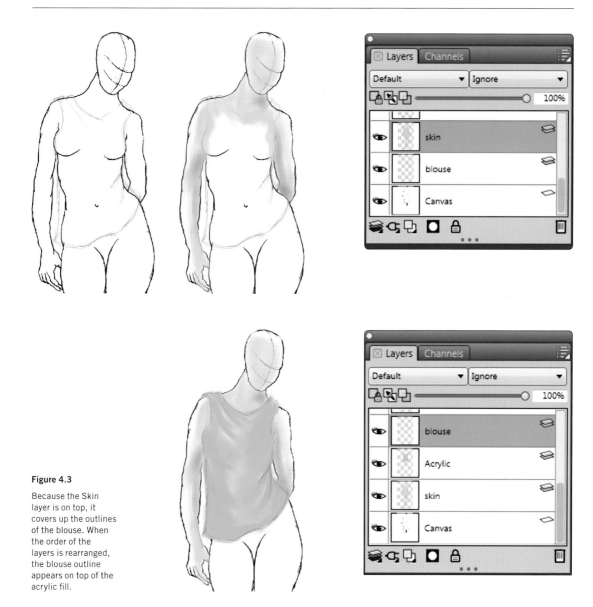

Figure 4.3

Because the Skin layer is on top, it covers up the outlines of the blouse. When the order of the layers is rearranged, the blouse outline appears on top of the acrylic fill.

10 When you have completed filling in the sketch with the paint, click on the Blouse layer and **MOVE** it above the Acrylic layer. You should now have a blouse filled with color with the outline visible and the overlapped skin tones hidden.

11 **SAVE** your work as a **RIFF** file to preserve the separate layers.

Specialized Layers

The small icon to the right of the layer name indicates what kind of layer it is. In addition to the standard pixel based layer, there are seven different kinds of layers. Certain brushes or applications require layers with specific characteristics. Some of those special layers include **WATERCOLOR LAYERS**, **TEXT LAYERS**, and **FLOATING OBJECT LAYERS**. A complete list of layer types and their icon indicators can be found in the Painter help menus. It is a good idea when exploring various brushes to keep an eye on the **LAYERS PANEL** to see if there are any automatic changes to the individual layers. Working with watercolors is a good introduction to a specialized layer.

Working with Watercolors

Because many costume designers use watercolors in their traditional rendering techniques, it is usually one of the first brushes to learn when switching to digital media. In an effort to mimic all the nuances of the watercolor medium, Painter has three different watercolor categories in the **BRUSH SELECTOR BAR**. The Painter help menu defines these three categories.

Figure 4.4

Each of the three types of watercolors has its own set of variants. Note the similarity in the identifying icons.

- **WATERCOLOR** is designed to produce natural-looking effects. Included are brush control options that allow you to control color diffusion and some water and paper interactions. The **WATERCOLOR** brushes are applied to the Watercolor layer.

- **REAL WATERCOLOR** allows you to apply pigment to the paper in a very realistic way. Included are brush control options that allow you to precisely control water and paper interactions. The **REAL WATERCOLOR** brushes are applied to the Watercolor layer.

- **DIGITAL WATERCOLOR** lets you apply watercolor effects directly to the canvas or a default layer, without the need for a Watercolor layer. However, the brush control options for **DIGITAL WATERCOLOR** are limited.

The mention of a specific Watercolor layer refers to the fact that when you begin to paint in the drawing document with either a **WATERCOLOR** brush or a **REAL WATERCOLOR** brush, a new layer is automatically created in the **LAYERS PANEL**. As a "wet" layer it allows the paint to flow, mix, and absorb into the paper.

This layer is identified as a Watercolor layer unless you give it a specific name. The icon to the right of the layer name in the **LAYERS PANEL** shows a blue layer on top to indicate a Watercolor layer. There are two important things to remember when working with watercolors. First, only watercolor brushes can be used in Watercolor layers. If you attempt to add a pencil line in that Watercolor layer, you will get an error message. Second, you need to go back to your Watercolor layer each time you pick up a **WATERCOLOR** brush. If you have moved on to a different media and then go back to using **WATERCOLOR**, Painter will continually make new wet layers each time you return to pick up the **WATERCOLOR** brush unless you make sure you are in your original Watercolor layer. **DIGITAL WATERCOLOR** differs from the other two watercolor media in that it does not create the special Watercolor layer. Consequently, you can use other dry media in the same layer where you have put the **DIGITAL WATERCOLOR**. For the purposes of costume design where speed is often a factor, using **DIGITAL WATERCOLOR** is much faster but still produces realistic watercolor effects.

The best way to gain a familiarity for watercolors is to open a blank document and simply explore the different brushes.

Figure 4.5

If you change the name of a Watercolor layer, you can use the identifying icon to keep track of which are wet layers.

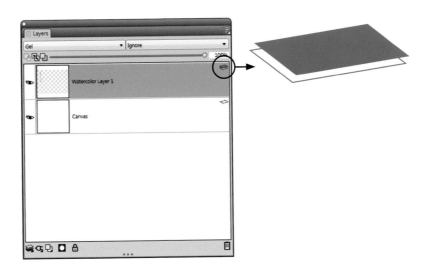

Special Layers Using Watercolor

1 Open a new blank file.

2 Lay down an area of color in the middle of the page using **WATERCOLOR > SIMPLE ROUND WASH** variant. See what happens when your brush strokes overlap. Notice that a Watercolor layer was automatically created in the **LAYERS PANEL**.

3 Change to **DRY BRISTLE** to see a different effect. Adjust the **FEATURE SIZE** on the **PROPERTY BAR** to change the spacing between the bristles. Reset the **DRY BRISTLE** brush to its default settings by using the **RESET** tool on the **PROPERTY BAR**.

4 Change to **DIFFUSE BRISTLE** and watch how the brush stroke transforms after you stop the stroke.

5 Select a different color and choose the **SOFT RUNNY WASH** variant. Place a stroke on top of one of the other brush strokes. Notice how long it takes for the stroke to finish processing. Also take a look at how the runny stroke affects the color underneath.

6 Explore the five different kinds of **ERASER** variants under the **WATERCOLOR** brush.

7 Change to the **REAL WATERCOLOR** media. Note the differences in **WET SPLATTER** and **DRY SPLATTER** variants.

8 Switch to **DIGITAL WATERCOLOR** and try the **SPATTER** variant. Did you remember to go back to the Canvas layer before using **DIGITAL WATER-COLOR**?

9 Create a new layer and, using a pencil, write down the name of the brushes and variants that you use as you continue working so you can use this document as a reference source.

10 **SAVE** your work as a **RIFF** file to preserve the Watercolor layers.

Note

Keep in mind that when working with brush stokes that have a processing time you cannot work very fast. If you try to work quickly, the computer will slow down as it tries to manipulate several brush strokes. Also, the final effect may look very different from when you initially put the paint on the paper.

Using Watercolor Layers in a Rendering

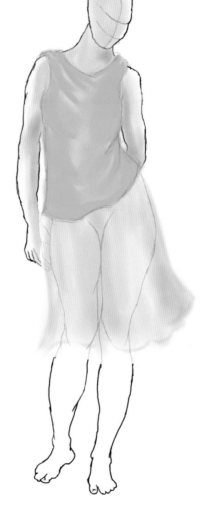

Figure 4.6

The skirt has been painted in using **WATERCOLOR** medium. By default, the skirt is now in a "wet" layer separate from the rest of the drawing.

1 Go back to the *Basic Croquis* file. Use a **WATERCOLOR BRUSH** to paint a skirt on the figure. You can overlap the color onto the blouse.

2 Notice that a Watercolor layer is automatically created in the **LAYERS PANEL**. Rename this layer Skirt.

3 Move this layer so that the Skin layer is underneath the skirt and the Blouse layer is on top of the skirt.

4 **SAVE** your work as a **RIFF** file.

Figure 4.7

Each of the
**COMPOSITE
METHODS** creates a
different effect in your
drawing. The most
useful **COMPOSITE
METHODS** for
costume renderings
are the **DEFAULT** and
the **GEL** variations.

Composite Methods

Because watercolor is a transparent medium, in Exercise 4-C the outline of the
legs is still visible. You can erase these lines on the Canvas layer but perhaps
you want to keep your base figure for another purpose. You can add a new layer
under your Watercolor layer and "paint" over the leg lines with an opaque media.
Another technique is to change the **COMPOSITE METHOD** of the layer in
the menu box on the top left corner of the **LAYERS PANEL**.

COMPOSITE METHOD refers to the way in which one layer will interact with
the layer below. The list of composite methods is extensive. The Painter help
files define and give examples of each of these composite methods. The **GEL** and
DEFAULT methods will be discussed here.

Because watercolor is a transparent media, the Watercolor layer that is automati-
cally created is set to a **GEL** composite method. Consequently one can see the
lines of the image on the Canvas layer. When you switch the **COMPOSITE
METHOD** to **DEFAULT**, the Watercolor layer becomes opaque. You can then use
the **TRANSPARENCY** slider, located directly below the **COMPOSITE METHOD**
box in the **LAYERS PANEL**, to control the overall transparency of the image in
that layer.

EXERCISE 4-D

Changing Composite Methods

1 Create a new layer and label this Blue Skirt. Use an opaque medium to paint a pale blue skirt over the watercolor skirt, covering up the lines of the legs.

2 Move the Blue Skirt layer below the Watercolor layer.

3 Go back to the Watercolor layer and change the **COMPOSITE METHOD** to **DEFAULT**.

4 Use the **TRANSPARENCY** slider to adjust the transparency of the Watercolor layer so that some of the blue skirt shows through.

5 **SAVE** your work as a **RIFF**.

Figure 4.8

The opaque blue skirt covers up the lines of the legs. The painting can be done quickly and without consideration of the lines of the blouse because when the layer is moved below the Blouse layer, the overlapped paint will be hidden.

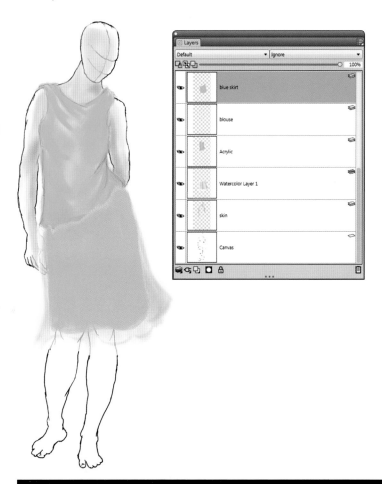

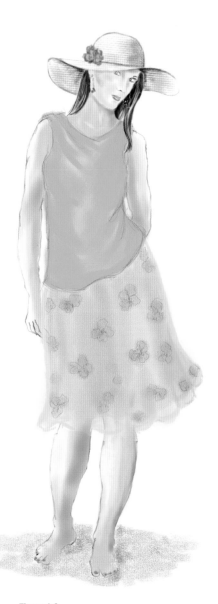

Figure 4.9

The completed image for Exercise 4-D. Your final image should look like this.

Layer Commands: Group, Ungroup, Collapse, Drop Ⓟ

As we have discussed, the order in which you stack your layers can be extremely important. There are times, however, when you would like to have layers work together. The first icon in the bottom left corner of the **LAYERS PANEL** is the **LAYER COMMANDS** and it will open a drop-down list that includes the following options.

Figure 4.10

Most of the items in this menu will not be highlighted unless two or more layers are selected.

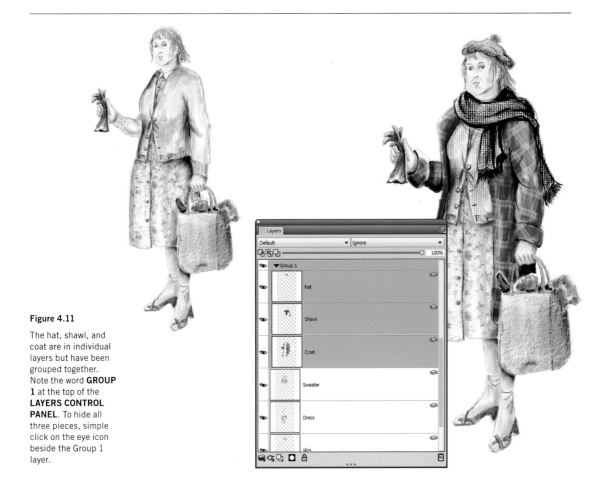

Figure 4.11

The hat, shawl, and coat are in individual layers but have been grouped together. Note the word **GROUP 1** at the top of the **LAYERS CONTROL PANEL**. To hide all three pieces, simple click on the eye icon beside the Group 1 layer.

- **GROUP** is used when you want to keep layers separate but still be able to move, hide, or reveal several layers together. A good example of this is if you have a character with a base costume and you want to add a coat and scarf for a scene change. By keeping the scarf and coat in two separate layers you can show either the completely rendered coat or the scarf. Because the coat and scarf are used for the same scene, it might be a good idea to **GROUP** those two layers so that during a discussion with a director, you can quickly show the costume change. If the director decides against the scarf, you can still delete that one layer without having to redo the painting on the coat.

- **UNGROUP** is used to separate layers that you have previously grouped together.

- **COLLAPSE** is used when you no longer need two layers separated and want to have all operations affect both layers together. Perhaps you want to investigate different lapel styles for the coat. Add a new layer on which to sketch a new lapel style so that you can erase and redraw until you get the look you want without disturbing the original drawing. Once you have achieved the look you want,

it is a good idea to **COLLAPSE** the coat and lapel layers together. This reduces the size of your layer list. If you want to apply some kind of effect, such as adjusting the overall color, you only have to work within one layer.

Figure 4.12

A redesigned lapel is in its own separate layer. Both the Lapel layer and the Coat layer have been highlighted and will be collapsed into one layer.

- **DROP** is for when you want to drop a layer down to the canvas. If you want to apply an effect or an overall texture to your drawing, you will need to have all the layers merge with the canvas layer.

In order to select multiple layers, click on the first layer then hold down the **SHIFT** key and click on however many subsequent layers you want to select. When you **GROUP** layers together, they will be called **GROUP 1** but the name can be changed in **LAYER ATTRIBUTES**. To open or close a **GROUP**, click on the small arrow in the thumbnail box. The original names of the separate layers will still be there.

Note

GROUPED layers should be closed together before **UNGROUPING** them.

When you **COLLAPSE** two or more layers, the new layer will have the name of whichever layer was on top of the stack. If you decide to **DROP** a layer onto the canvas, you need to consider your layer order and make sure that an effect will not be lost once a layer is dropped. It is important to note that you can only **UNDO** each of these commands until your document is saved. After a **SAVE**, **COLLAPSED** and **DROPPED** layers cannot be undone. **GROUPS**, however, always have the option to **UNGROUP**.

EXERCISE 4-E

Layer Commands

1 Open the file named *Frank's Face*.

2 Create a new layer and name it Skin. Using an **AIRBRUSH**, spray a skin color over the face and neck. Reduce the size of the brush, choose a shadow color, and add depth around the eyes and under the cheekbones. Notice some of the features on the pencil sketch have been covered up.

3 Because you do not want to disturb the highlights and shadows, create a new layer and label it Eyes, Nose, Mouth. Using a pencil and a dark color, sketch in the facial features more clearly. To make the eyebrows and hair, go the **PEN** brush and select the **BARBED WIRE** variant. Adjust the size and opacity to get the effect you want.

Figure 4.13

There will be some overspray when painting the face. The features can be accented using pencil media.

4 The facial features and the skin tone will probably always work together. If you want to blend some of the lines on the facial features with the skin tone, you will need to merge these two layers so that your brush will pick up both the color of the skin tone as well as the pencil strokes on the Eyes, Nose, Mouth layer. Select both the Skin layer and the Eyes, Nose, Mouth layer then go to the **LAYER COMMAND** button and select **COLLAPSE**.

5 Create a new layer, name it Hat and add color to the cowboy hat. Experiment with the **CHALK** brush using a **BLUNT CHALK** variant. Move the **GRAIN** slider to increase the visibility of the grain in order to achieve the texture of a straw hat. Open the **PAPER PALETTE** in the **TOOLBOX** to find a texture that might enhance the look of woven straw. Review Chapter 2 and the section on the **PAPER LIBRARY**.

Figure 4.14

Because the hat and sunglasses are going to be worn at the same time, they need to be grouped into one layer.

6 The director has decided that she wants this character to have sunglasses. Create a new layer and label it Glasses. Tint the lenses and select an opaque medium to create the highlight.

7 In this production, the hat and the glasses will always be worn at the same time. Select both the Hat and Glasses layers and **GROUP** them. Rename this layer Hat & Glasses.

8 **SAVE** your work as a **RIFF**.

ADVANCED EXERCISE

Continue on your own: During the production this character goes through a transformation from being down and out with a baseball cap to clean cut with the cowboy hat. Use the different layer functions to create two different illustrations for Frank in a manner that you can quickly toggle back and forth between the two looks. Explore a variety of media to create beard stubble. Remember to adjust **SIZE**, **OPACITY**, and **GRAIN**. Some brushes to try are: **BLUNT CHALK** on **SANDY PASTEL PAPER**; **AIRBRUSH** with a **PIXEL SPRAY** or a **PEPPER SPRAY** variant; **FAIRY DUST** variant under the **FX BRUSHES**. Determine how to hide the cowboy hat in the rendering with the baseball cap.

Photoshop Notes

Figure 4.15

The Photoshop
LAYERS PANEL.

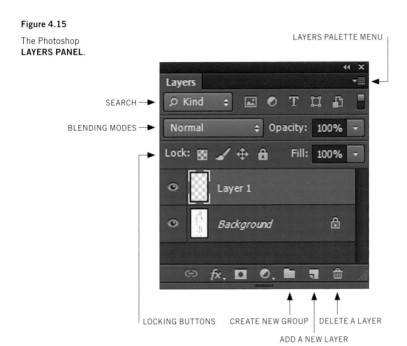

LAYERS PALETTE MENU

SEARCH

BLENDING MODES

LOCKING BUTTONS CREATE NEW GROUP | DELETE A LAYER

ADD A NEW LAYER

Layers Panel

The **LAYERS PANEL** in Painter was modeled after the one in Photoshop, so the icon buttons, functions, and properties are very similar between the two programs. Photoshop uses the term Background layer instead of Canvas layer for the first layer in the document. The icons at the bottom of the **LAYERS PANEL** are slightly different. The **ADD NEW LAYER** button is the second from the right next to the **TRASH CAN** icon or **DELETE BUTTON.** Common applications, such as hiding or locking a layer, listed in the Painter chapter apply to Photoshop as well. One distinct difference is, unlike the Canvas layer in Painter, the Background layer in Photoshop can be unlocked so that it becomes a regular layer that can be moved, duplicated, or deleted. Simply click on the Background layer then click on the small padlock at the right and drag it to the **TRASH CAN**. This unlocks the Background layer and it becomes Layer 0 unless you give it a distinct name. **DOUBLE CLICK** on the layer name and type in a new name. The point of Exercise 4-A is to gain familiarity with layers. The type of brushes you choose to complete the exercise is not as significant as the action of creating, naming, moving, and locking layers.

Figure 4.16

Clicking in the **SEARCH** window in the **LAYERS PANEL** reveals the many ways you can find a specific layer.

Specialized Layers

Photoshop does not have watercolors per se, or specialized watercolor layers. You can complete Exercises 4-B, 4-C, and 4-D by adjusting the **OPACITY** slider in the **LAYERS PANEL** and exploring the various blending techniques in the drop-down menu in the box to the left of the panel under the word **NORMAL**. Look for **BLENDING MODES** in the Photoshop help menus. **BLENDING MODES** are the same as **COMPOSITE METHODS** in Painter. This is also an opportunity to explore more **BRUSH PRESETS** and **TIP SHAPES**.

One unique aspect of Photoshop's **LAYERS PANEL** is the **SEARCH** feature at the top of the panel. If you click the arrow, a menu will open to define your search.

You can search layers by **NAME**, or **KIND** of layer among other things. Click **NAME** and type in the name of the layer you are looking for in the text box.

> **Note** This feature seems to have been deleted in Photoshop 7.

Layer Commands

Most of the **LAYER COMMANDS** in Photoshop are located in icons instead of drop-down menus. At the top of the layers list is a series of icons for different locking mechanisms.

- **LOCK TRANSPARENT PIXELS** prevents putting a mark anywhere except where something already exists in the layer.

- **LOCK IMAGE PIXELS** prevents putting a mark on the part of the image that is in the layer.

- **LOCK POSITION** prevents the layer from being moved.

- **LOCK ALL** locks the entire layer so that it cannot be moved or changed in any way.

At the bottom of the **LAYER PANEL** are a few new icons.

- **LINK LAYERS** links two or more layers together so they can be moved as a unit. This command is similar to **GROUPING** in Painter.

- **ADD A LAYER STYLE** adds special effects to an entire layer.

- **ADD A LAYER MASK** places a mask over everything except the portion of the layer that you have selected.

- **CREATE NEW FILL OR ADJUSTMENT LAYER** creates a layer that lets you adjust tone or color without disturbing the pixels in the layers underneath.

- **CREATE A NEW GROUP** creates a layer labeled **GROUP**. You can move whichever layers you want to include into that **GROUP** layer.

The other commands are found in the **LAYER OPTIONS** drop-down menu accessed in the upper-right corner of the panel. **MERGE A GROUP** corresponds to **COLLAPSE** in Painter. **FLATTEN AN IMAGE** corresponds to the **DROP** command in Painter. To **UNGROUP** layers in Photoshop, simply drag them out of the group layer and place them back into the layers list.

Complete Exercise 4-E using Photoshop's layer commands.

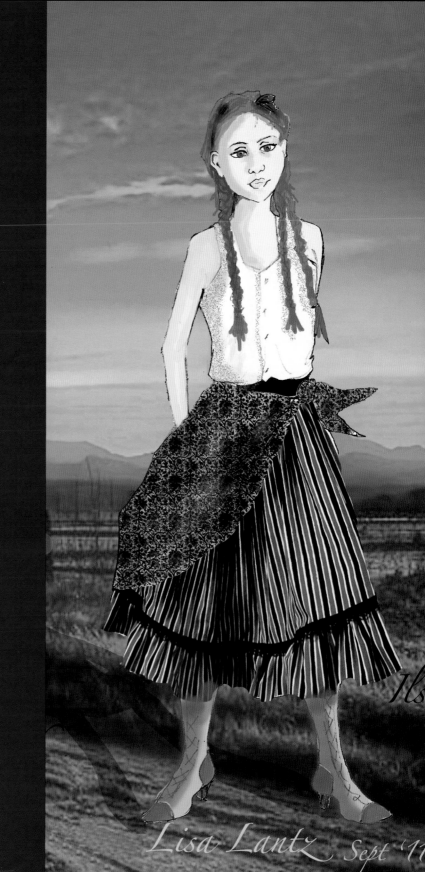

Chapter 5

Selections and Transformations

- Making Selections: Rectangular Selection, Lasso Tool, and Magic Wand
- Working with the Magic Wand
- Invert Selection
- Transform Tools: Move, Scale, Rotate, Skew, Distort, and Perspective Distortion
- Moving Between Two Documents
- Photoshop Notes

Design by Lisa Lantz.
Ilse in *Spring Awakening*,
Luther College, Decorah,
Iowa 2011. Sketch
executed in Photoshop.

Most designers have ideas churning in their heads all the time. In order to capture the process, thumbnail sketches are often jotted down on napkins, scraps of paper, or on the back of production notes. Facility with a traditional pencil and paper remains a valuable skill. Digital software, however, offers powerful tools for isolating an area of a drawing that needs to be altered or capturing thumbnail sketches and transforming them into final renderings. The techniques of selecting, moving, and transforming an image can also be used to acquire research images, textures, or design ideas and apply them to your digital rendering.

Painter has three tools for selecting an area of an image. Once the selection has been made, you can add color or other effects, float the selection and move it around, or place it onto its own layer.

Making Selections: Rectangular Selection, Lasso Tool, and Magic Wand 🅿

RECTANGULAR AND OVAL

LASSO AND POLYGONAL

THE MAGIC WAND

Figure 5.1

The **OVAL** selection tool is hidden under the **RECTANGULAR** tool. The **POLYGONAL** selection tool is hidden under the **LASSO**.

You have previously used the **SELECT** tab on the top menu bar to select the entire canvas. Now we will look at the more precise selection tools located in the **TOOLBOX**.

- **RECTANGULAR** or **OVAL** selection tool is used to click and drag around the area you want to select. The oval selection tool is hidden under the rectangle.
 If you want to select a perfect circle or a square instead of a rectangle, hold down the **SHIFT** key while dragging over the selection.

- **LASSO** allows you to make a freehand selection around an area. On a complicated object, it is sometimes difficult to maintain pressure on the stylus until you complete the selection using the **LASSO** tool.

- **POLYGONAL**, which is hidden under the **LASSO** tool, can be more precise because it allows you to click on specific points along the edge of the area you want to select. The program will connect straight-edged line segments between the points until the selection is complete.

- **MAGIC WAND** makes selections based on the color of the pixels. You can control the range of color to be selected, and it is also possible to select pixels that are not adjacent to each other. For example, if you want to change

Figure 5.2

The **SELECTION ADJUSTER** tool is located in the **TOOLBOX** just below the **MAGIC WAND**.

all the red areas on a complex design, you can use the **MAGIC WAND** to select all those areas just by clicking on one of them.

Once the selection boundary appears, you can reposition it by clicking in the center of the selection and dragging it to the new position. Notice the **PROPERTY BAR** also changes when a selection tool is chosen. The properties for the **RECTANGULAR** and **LASSO** tools include a **RESET** button as well as toggles to quickly change from one selection method to another. After making the initial selection, you can dynamically scale the area larger or smaller by choosing the **SELECTION ADJUSTER** tool in the **TOOLBOX** directly below the **MAGIC WAND** and clicking and dragging one of the handles of the bounding box that will appear. Keep in mind that this action only adjusts the identifying outline of the selection and does not change the drawing at all. Make sure that your selection boundaries are accurate before adding color or altering the selection in any way.

Note

Be careful, the icon for the **SELECTION ADJUSTER** tool looks very much like the **LAYER ADJUSTER** tool. Make sure you click on the appropriate icon.

To quickly add to or subtract from a selection, use the **PROPERTY BAR**. Click on the icon with a "plus" sign, **ADD TO SELECTION**, or a "minus" sign, **SUBTRACT FROM SELECTION,** and use your mouse or stylus to encircle the area you want to add to or subtract from your selection. You can also combine selection methods in order to select irregularly shaped areas.

Figure 5.3

The **LASSO** tool properties showing the **ADD TO** and **SUBTRACT FROM** icons.

ADD TO SELECTION SUBTRACT FROM SELECTION

Figure 5.4

A selection made by using the **RECTAN- GULAR** selection tool twice, the **OVAL** tool, and a freehand selection with the **LASSO** tool.

For more precise modifications of a selection, go to the **SELECT** tab and choose **MODIFY**. The drop-down menu includes the following modifications: **WIDEN**, **CONTRACT**, **SMOOTH**, and **BORDER**. All of these options except **SMOOTH** open a dialogue box where you can specify the number of pixels with which to adjust the selection. The **BORDER** option creates an edge of a specific width around the perimeter of the selection. The **SMOOTH** option softens sharp corners. Continue clicking the **SMOOTH** option until the selection is the desired shape. Please refer to the Painter help menu for good visual examples of these modifications.

To deselect an area, again go to the **SELECT** tab and choose **NONE**. This is another instance when the keyboard command seems to be more efficient. When an area in a drawing is selected, hit **CTL+D/CMD+D** to deselect that area.

EXERCISE 5-A

Making Selections

1 Open the file named *Rose*.

2 Use the **RECTANGULAR** selection tool and select the figure's brown paper bag. Use any media you want to create a logo on the bag.

3 Hit **CTL+D/CMD+D** to deselect the paper bag.

4 Zoom in on the skirt and change to the **OVAL** selection tool.

5 Hold down the **SHIFT** key and select one of the buttons on the skirt. Reposition if necessary.

6 Go to the **SELECT** tab and choose **MODIFY > CONTRACT** to adjust the size of the selected area to conform to the button more closely.

7 Use the **PAINT BUCKET** to change the button to a dark color. Repeat on the other two buttons then deselect all of the buttons.

8 To change the color of the socks but not alter the shoes, use the **LASSO** selection tool to select the top area of one sock.

9 Go to the **PROPERTY BAR** and choose the **ADD TO SELECTION** icon.

10 Continue using the **LASSO** tool to outline all visible areas of both socks.

11 When the socks are completely selected, avoiding any part of the shoes, use any media you want to change the color of the socks. There is no need to be careful about staying within the lines.

12 Deselect the socks.

13 **SAVE** your file as a **RIFF** with a new file name.

Figure 5.5

The **LASSO** selection tool and the **ADD TO SELECTION** property was used to isolate the socks.

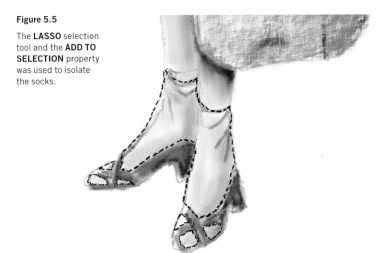

Working with the Magic Wand 🅟🅢

The **MAGIC WAND** has a distinctive set of properties on the **PROPERTY BAR**. The black and white icon with the plus and minus sign is not a toggle switch; it merely identifies the scale slider next to it as a **TOLERANCE** scale. This is similar to the **TOLERANCE** scale discussed in relation to the **PAINT BUCKET** tool in Chapter 3. When you touch the **MAGIC WAND** to an image, the tool selects a single pixel of color as well as all pixels that are adjacent to that color within a specific color range. The **TOLERANCE** slider controls the amount of variance in

Figure 5.6

You can add to or subtract from **MAGIC WAND** selections as well as adjusting the **TOLERANCE**. The **CONTIGUOUS** icon restricts the selection to just those pixels that are touching each other.

TOLERANCE SLIDER CONTIGUOUS

ANTI ALIAS

color from the original pixel selected. The higher the number the more pixels in a wider range of color will be selected. Conversely, when you lower the number, only those pixels closest in hue to the original color will be selected.

If you want to select an even wider color range, you can drag the **MAGIC WAND** across the drawing to collect a variety of colors. For example, you might want to select all the variations in skin tone on a face. In this case you would drag the **MAGIC WAND** across the face, carefully avoiding the eyebrows or lips that may contain colors you do not want to select.

The next icon, **ANTI ALIAS**, looks like a split circle. When this icon is highlighted, the selection will have a softer looking edge, although the effect is quite subtle and

can only really be seen in a close-up view. The **CONTIGUOUS** icon, however, is much more useful. When the **CONTIGUOUS** icon is highlighted, the **MAGIC WAND** will only select pixels that are adjacent to each other. Turn off the **CONTIGUOUS** icon and all pixels of that particular color will be selected no matter where they occur in the drawing.

Invert Selection

Once an area of a drawing has been selected, the border of the selection will prevent you from making a mark outside that specific area. As a result you can change the color, draw a design, or sketch in details with relative freedom of movement without being concerned that your brush strokes might inadvertently spill over and mar another part of the drawing. Sometimes there is a need to isolate an area of a drawing to protect it while you add color or effects around the exterior of the selection. In this case it is necessary to use **INVERT SELECTION.**

After selecting the area you want to isolate, go to the **SELECT** tab on the top menu bar and choose **INVERT SELECTION** from the drop-down menu. Now everything except the area you isolated is selected and you can sketch anywhere on the page except in the area of selection.

The **INVERT SELECTION** tool particularly comes in handy when you want to precisely cut a figure out from the background. The **RECTANGULAR** or **OVAL** selection tools pick up too much of the background, and it is tedious to use either the **LASSO** or **POLYGONAL** tool to trace the outline of a complex figure; a fully rendered design has too many colors to be able to pick up everything with the **MAGIC WAND** tool. The simplest method, particularly when there is a solid color background, is to use the **MAGIC WAND** to select the background. Adjust the selection using the **ADD TO** or **SUBTRACT FROM** functions and then, once the outline looks precise, use **INVERT SELECTION** to switch the selection from the background to just the figure.

Figure 5.7

Select **INVERT SELECTION** from the dropdown menu under the **SELECT** tab.

File	Edit	Canvas	Layers	Brushes	Select
All					Ctrl+A
None					Ctrl+D
Invert Selection					Ctrl+I
Reselect					Ctrl+Shift+D
Float					
Stroke Selection					
Select Layer Content					
Select Group Content					
Auto Select...					
Color Select...					
Feather...					
Modify					▸
Convert To Shape					
Transform Selection					
Hide Marquee					Ctrl+Shift+H
Load Selection...					Ctrl+Shift+G
Save Selection...					

Figure 5.8

The only way to see if a selection is inverted is to look at the edge of the drawing. In the first image the white background was selected and there is a dashed border around the edge of the picture. In the second image the selection has been inverted and the dashed line is gone from the edge of the picture and just appears around the figure.

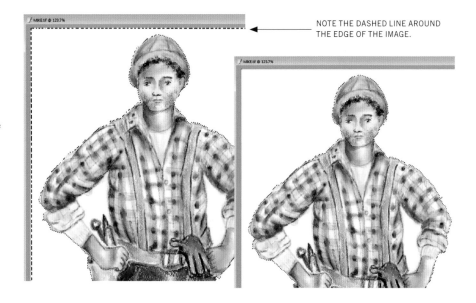

NOTE THE DASHED LINE AROUND THE EDGE OF THE IMAGE.

EXERCISE 5-B

Using the Magic Wand Selection Tool with Invert Selection

1 Go back and open the file named *Rose*.

2 Zoom in on the skirt area of the sketch. You want to change the colors of the flowers but it is too tedious to outline each one. Go to the **MAGIC WAND** selection tool and click in the bright center of one large flower.

3 If only one flower is selected, go to the **PROPERTY BAR** and make sure the **CONTIGUOUS** icon is turned off.

4 Select the flower again. If you want to expand the selection to include some of the subtle variations in the flower's color, go to **ADD TO SELECTION** on the **PROPERTY BAR** and click on another part of the flower.

5 Zoom out to see all the areas that have been selected. Use the **RECTANGULAR** selection tool and the **SUBTRACT FROM** property to remove any areas that have been selected above the hem of the sweater and below the hem of the skirt.

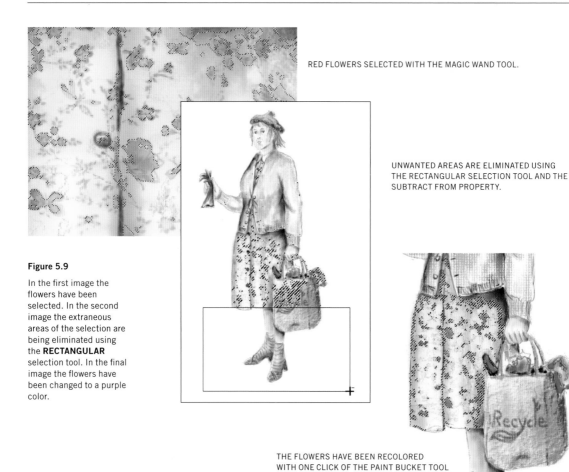

RED FLOWERS SELECTED WITH THE MAGIC WAND TOOL.

UNWANTED AREAS ARE ELIMINATED USING
THE RECTANGULAR SELECTION TOOL AND THE
SUBTRACT FROM PROPERTY.

Figure 5.9

In the first image the
flowers have been
selected. In the second
image the extraneous
areas of the selection are
being eliminated using
the **RECTANGULAR**
selection tool. In the final
image the flowers have
been changed to a purple
color.

THE FLOWERS HAVE BEEN RECOLORED
WITH ONE CLICK OF THE PAINT BUCKET TOOL

6 Use the **LASSO** selection tool with the **SUBTRACT FROM** property to remove
the selections in the brown paper bag.

7 When you have selected just the flowers in the skirt, use **A DIGITAL WATER-
COLOR** brush to paint with broad strokes across the whole skirt. Only the
selected flowers will change color.

8 If you want to change the background of the skirt but not the color of the flowers,
go to the **SELECT** tab and choose **INVERT SELECTION.**

9 Now pick up an **AIRBRUSH** tool and spray over the area of the skirt with a new
color. The background will change without altering the flowers.

10 Deselect everything to see the final result.

11 **SAVE** your file as a **RIFF**.

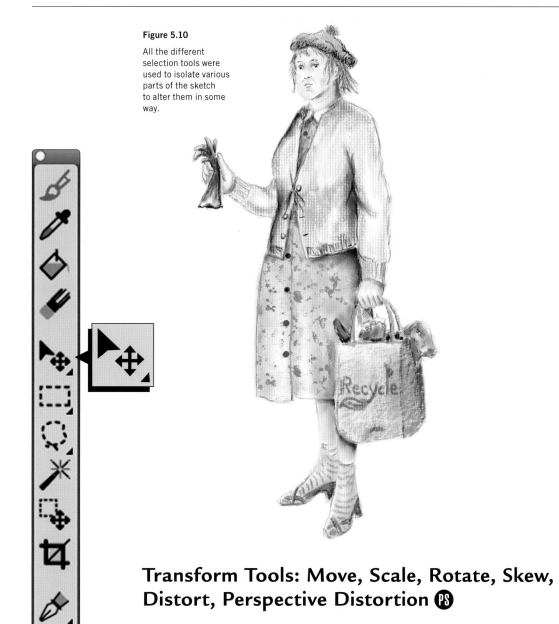

Figure 5.10

All the different selection tools were used to isolate various parts of the sketch to alter them in some way.

Figure 5.11

The **LAYER ADJUSTER** tool is located just above the **RECTANGULAR SELECTION** tool. Notice how similar this icon is to the **SELECTION ADJUSTER** icon located below the **MAGIC WAND**.

Transform Tools: Move, Scale, Rotate, Skew, Distort, Perspective Distortion 🅿️

Immediately above the **RECTANGULAR SELECTION** tool in the **TOOLBOX** is the icon for the **LAYER ADJUSTER**. If the area that is selected is on the Canvas layer, use the **LAYER ADJUSTER** to move what you have selected onto a separate layer. If the area that is selected is already in a layer, using the **LAYER ADJUSTER** will result in a **FLOATING OBJECT** that can be moved around within the layer but does not put the selection into its own discreet layer. In order to make a portion of a layer into a new layer, it is best to **CUT** (**CTL+X/CMD+X**) and **PASTE** (**CTL+V/CMD+V**) the selection. This will automatically create a new separate layer containing only the area that was selected.

Figure 5.12

The **TRANSFORM** tool is hidden behind the **LAYER ADJUSTER** tool.

Beneath the **LAYER ADJUSTER** tool is the **TRANSFORM** icon. When you click on this icon, the boundary box of your selection will change to one that has handles at each corner and in the center of each side. Clicking in the center of the selection allows you to move the part of the drawing that has been selected, not just the boundary box. If you click on one of the handles, you can scale the selection. There are several other **TRANSFORM** functions that appear on the **PROPERTY BAR**.

Figure 5.13

The **TRANSFORM** tool **PROPERTY BAR** shows six different ways to adjust a selection.

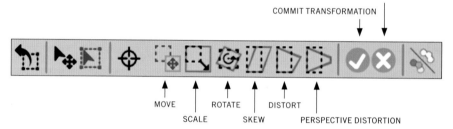

- **MOVE**. Click and drag a selection to another part of the drawing. **MOVE** is the default setting for both the **LAYER ADJUSTER** tool and the **SELECTION ADJUSTER** tool, but you can also access the **MOVE** command from the . **PROPERTY BAR**.

- **SCALE**. You can scale in one direction by clicking and dragging on one of the handles in the middle of one side. By clicking and dragging on one of the corner handles, you can scale in two directions. If you want to maintain the aspect ratio, you should hold down the **SHIFT** key as you are dragging the corner handle.

- **ROTATE**. Click and drag on one of the corner handles to rotate the selection.

- **SKEW**. You **SKEW** a selection by clicking and dragging one of the center handles. This angles the shape of the selection while keeping the sides of the bounding box parallel.

- **DISTORT**. This transformation allows you to completely change the selection. Manipulate one of the corner handles to achieve the desired distortion.

- **PERSPECTIVE DISTORTION**. Use **PERSPECTIVE DISTORTION** to add depth to a selected object. Click and drag a corner handle.

Once you have transformed a selection, you need to click the ✓ icon on the **PROPERTY BAR** to **COMMIT TO THE TRANSFORMATION** or click the **X** if you want to cancel the changes you have made to the selection. A reminder will pop up if you neglect to perform this extra step. The last button is the **FAST**

PREVIEW MODE which changes the image to grayscale during the transformation in order to speed up the process in complex drawings.

Using the Transform Tools

1 Open the file labeled *Thumbnails*. These are rough sketches done on blue-lined paper.

2 Zoom in close (about 200%) on the drawing so you can see one of the blue lines clearly.

3 Click on the **MAGIC WAND** and make sure the **CONTIGUOUS** icon is turned off.

4 Click one of the blue lines. All the blue lines should be selected.

5 On the **TOP MENU BAR** click on the **EDIT TAB** and select **CLEAR**.

6 **DESELECT** the lines. Most of the blue lines should now be gone from the drawing, leaving only the pencil sketches and notes.

7 Use the **LASSO** to make a freehand selection around one of the sleeve styles. Use the **LAYER ADJUSTER** tool to move the sleeve to another bodice. Notice that a new layer has been created in the **LAYERS PANEL**.

8 Go back to the Canvas layer.

Figure 5.14

Use the **LAYER ADJUSTER** tool to put the sleeve into its own layer and move it to one of the other bodices.

9 Use the **RECTANGULAR SELECTION** tool to make a selection around the red bow at the bottom.

10 Use the **LAYER ADJUSTER** to move the bow to the shoulder of the bottom sketch. A second layer will be created in the **LAYERS PANEL**.

11 Notice that some of the white area around the bow covers up the neckline of the dress. Select the **MAGIC WAND**, turn on the **CONTIGUOUS** function, and touch the white area outside the bow.

12 Go to the **EDIT** tab on the **TOP MENU BAR** and choose **CLEAR** from the drop-down menu. The white area should now disappear and the lines of the neckline are revealed underneath. The interior of the bow should remain opaque.

13 Click and hold on the **LAYER ADJUSTER** until the **TRANSFORM** icon appears. The bow is now bounded by a box with handles.

14 Click and drag on one of the corner handles around the bow in order to scale it down to a smaller size. Remember to hold down the **SHIFT** key if you want to scale the image proportionally.

15 On the **PROPERTY BAR**, use the **ROTATE ICON** to align the bow with the neckline. Use the **MOVE OPTION** to reposition the bow.

Figure 5.15

On the left, only the white background in the Bow layer has been selected. The image at right shows how the background has been cleared.

Figure 5.16

The bounding box shows how the bow has been rotated and repositioned using the **TRANSFORM** tools.

16 When you have the bow sized and aligned the way you want it, make sure you click on the **CHECK** button to commit to the transformation.

17 **SAVE** your file as a **RIFF**.

Moving Between Two Documents PS

Often a designer will find a piece of research that he or she wants to use in a rendering but it is either too complicated and detailed to redraw, or the image is not aligned to fit the pose of the figure in the rendering. Using selections and transformations can overcome these obstacles.

Both the rendering file and the file containing the image you want to capture need to be open. If the image file is a **JPEG** with only a Canvas layer, it is a simple matter to use the **LAYER ADJUSTER** to click and drag the selection into the rendering file. If you are taking a selection from a file with layers, it is best to use the **COPY** and **PASTE** functions to move the selection into the rendering file. In either case, a new layer will automatically be created in the rendering file. The goal of the following exercise is to use the graphic on the advertisement for a T-shirt in the *Charlie* rendering.

Figure 5.17

The goal is to use the T-shirt graphic on the sketch of *Charlie*.

Moving Selections Between Two Documents

1 Open the document named *Charlie* and the one named *Grunge T*.

2 Click on the T-shirt image to make it the active document. Use the **LASSO** to make a freehand selection around the graphic. If you do not capture all of it the first time, use the **ADD TO** or **SUBTRACT FROM** icons on the **PROPERTY BAR**.

3 Use the **LAYER ADJUSTER** to click and drag the selection into the *Charlie* image.

4 The *Charlie* image should now be the active document with a new layer containing the T-shirt graphic.

5 Use the **LAYER ADJUSTER** to **MOVE** the image into position.

Figure 5.18

The graphic image was selected and moved into the *Charlie* rendering. The Graphic layer is made transparent to reveal the lines of the jacket underneath.

Figure 5.19

The **PERSPECTIVE DISTORTION** tool was used to align the graphic to the figure.

6 Change to the **TRANSFORM** tools and use **SCALE** to fit the graphic to Charlie's T-shirt. In order to see the space between the edges of Charlie's jacket, you may have to make the Graphic layer transparent by moving the **TRANSPARENCY** slider on the **LAYERS PANEL**. Once the graphic is in place you can put the opacity back to 100%.

7 In the *Grunge T* image, the graphic is foreshortened because the mannequin is turned to one side. Use the **PERSPECTIVE DISTORTION** and pull on one of the lower handles to bring the graphic into a straight alignment to match Charlie's pose.

Figure 5.20

The completed image
with the graphic centered
under the jacket.

8 You can use the **ERASER** to get rid of the part of the graphic
that would be under the sweatshirt.

9 Select the **MAGIC WAND** and click on the grayish area
around the graphic selection.

10 Use the **EDIT > CLEAR** function to get rid of the excess
white area. You may have to make more than one selection in
order to capture all the shades of gray around the image.

11 **SAVE** your file as a **RIFF**.

When a working on a show with costumes that are going to be purchased as
opposed to built, you may rely on photographs of actual garments instead of
making hand-drawn renderings. As a communication tool, however, these
photographs do not always capture character. The selection and transformation
tools provide a way in which the photographs of actual garments can be can
be used in renderings. This technique can also be used to add photographs of
the actor's faces to a rendering.

EXERCISE 5-E

Working with Research Photographs

1 Go back and open the *Charlie* sketch on which you have put the T-shirt graphic and also open the file labeled *Jeans*.

2 Using the **MAGIC WAND**, drag across the blue jeans. Try to go over all shades of blue in the image.

3 Look at your selection. Switch to the **LASSO** tool to add to or subtract from your selection.

4 Once the jeans are captured, drag the selection to the *Charlie* image.

5 Make the new layer 50% transparent and scale the jeans to approximately fit the sketch.

6 Use the **DISTORT** function to reshape the jeans to fit the figure. You may have to make several different adjustments and switch back and forth between the different **TRANSFORMATION** tools.

Figure 5.21

Several **TRANSFORM** tools were used to align the photographic jeans with the pose of the sketched figure.

Figure 5.22

On the left leg the Jeans layer is being erased to more closely align with the sketched pencil lines. On the right leg the pencil lines on the Canvas layer are being erased so that the actual jeans leg will look more natural.

7 When you are satisfied, even if some parts of the jeans do not align perfectly, **COMMIT** to the transformation.

8 Erase the areas that are covered by the shirt and hand.

9 Make the jeans layer opaque and view your results.

10 On the Canvas layer, erase your original pencil lines; on the Jeans layer, erase areas of the jeans that extend beyond the line to refine your results.

11 **SAVE** your file as a **RIFF**.

ADVANCED EXERCISE

Try your own research: Find an image of a hooded sweatshirt to use in this sketch. Transfer the image to the sketch as a new layer. Use the **TRANSFORM** tools to align the sweatshirt to the figure. You may have to select portions of the sweatshirt such as the lower part of the sleeve and manipulate just that part of the image to match the sketched figure's pose. Erase the inside of the hood to show the face and the front of the sweatshirt to show the T-shirt underneath.

Photoshop Notes

Making Selections

Photoshop has the standard **RECTANGULAR** and **OVAL** or **ELLIPTICAL** selection tools in the **TOOLS PANEL**. These are called **MARQUEE** tools and are all located at the top of the **TOOLS PANEL** under the **RECTANGULAR MARQUEE** icon.

Figure 5.23

Several square selection tools are grouped under the **RECTANGULAR MARQUEE** on the **TOOLS PANEL**.

Figure 5.24

The **LASSO** tool is stacked with the **POLYGONAL LASSO** and the **MAGNETIC LASSO** on the **TOOLS PANEL**.

Underneath the **LASSO** tool is a **POLYGONAL LASSO** as in Painter as well as a **MAGNETIC** lasso. The **MAGNETIC LASSO** is similar to the **POLYGONAL LASSO** in that you click on selected points on the border of what you want to select, but instead of connecting these points with straight lines, the **MAGNETIC LASSO** conforms to the edges of the defined area in an image. This tool is particularly useful when your image is against a high contrast background. The third selection icon on the **TOOLS PANEL** is one of the most useful selections tools found in Photoshop but not in Painter. This is the **QUICK SELECTION** tool and underneath it is the **MAGIC WAND** tool. The **QUICK SELECTION** tool interprets the pixels in the image and makes a selection outline based on where you click your cursor.

Figure 5.25

Icons for **MAGIC WAND** and **QUICK SELECT** are grouped together on the **TOOLS PANEL**.

INTERSECT WITH SELECTION

MAKE A SELECTION SUBTRACT FROM SELECTION

ADD TO SELECTION

Figure 5.26

Once a selection tool is chosen, the **OPTIONS BAR** changes to show the **ADD TO**, **SUBTRACT FROM**, and **INTERSECT WITH SELECTION** buttons.

All of these selection tools have the same **ADD TO** and **SUBTRACT FROM** function buttons on the **OPTIONS BAR** as well as an **INTERSECT WITH SELECTION** button that captures the area where two selections overlap. To quickly toggle back and forth between the **ADD TO** and **SUBTRACT FROM** functions, hold down the **ALT** (**OPTIONS**) key. To reposition an entire selection, first click on the **NEW SELECTION** button on the **OPTIONS BAR** and then click inside the selected area to drag it to the new position.

Another button on the **OPTIONS BAR** that is unique to Photoshop is the **REFINE EDGE** button. This button opens a dialogue box and the selection is seen in the document window against a white background. If you click on **SMART RADIUS** and then stroke the cursor along the edge of the selection you can remove any of the stray background that you do not want. By adjusting the sliders, you can indicate where you want the edge of the selection to be hard, and where you want it to be soft.

Figure 5.27

The dialogue box for **REFINE EDGE** lets you make very specific adjustments to a selection.

For further modifications of a selection, open the drop-down menu under the **SELECT** tab at the top of the workspace. These menu items are similar to those in Painter. Choose **DESELECT** when you want to let go of a selected area. Complete Exercise 5-A using a variety of selection tools.

Working with the Magic Wand

The **MAGIC WAND** tool in Photoshop functions the same as in Painter and the controls on the **OPTIONS BAR** are the same as those in the **PROPERTY BAR** in Painter. The term for inverting a selection in Photoshop is **INVERSE** under the **SELECT** tab. Complete Exercise 5-B using the **MAGIC WAND** tool.

Transform Tools

To **MOVE** an area of a painting that you have selected to a different part of the page, use the **MOVE** tool, which is located at the top of the **TOOLS PANEL**. The other **TRANSFORM** commands are located under the **EDIT** tab on the top menu bar. There are two transformation commands, **FREE TRANSFORM** and **TRANSFORM**, which opens a drop-down menu of choices. **FREE TRANSFORM** is a quick way to **SCALE** a selection. The menu under **TRANS-FORM** includes **SCALE**, **ROTATE**, **SKEW**, **DISTORT PERSPECTIVE**, and **WARP** as well as items for rotating by specific degrees or flipping horizontally or vertically. The most distinctive transformation is the **WARP** tool. This places a grid over the image and allows you to push or pull any part of the image in any direction. In Exercise 5-C, use the **WARP** transformation to make one of the sleeves curve out to the side.

Moving Between Two Documents

The default setting in Photoshop is to stack multiple image documents on top of each other. You can click and drag a selection from one document to the other by using the **MOVE** tool. The major difference from Painter is that you will click and hold the mouse key down while you drag up to the tab with the name of the second document. **KEEP THE MOUSE KEY DOWN** as the new document opens, then continue to drag into the new image. As in Painter, a new layer will be created automatically. If you want to make both images visible side-by-side, go to the **WINDOWS TAB > ARRANGE > TILE VERTICALLY** (or horizontally). Then you can simply drag from one image to the next. To go back to stacked images where only one is visible, go back to **WINDOW > ARRANGE > CONSOLIDATE ALL TO TABS**. The **COPY** and **PASTE** functions in Photoshop works the same as in Painter. Continue to complete Exercises 5-D and 5-E.

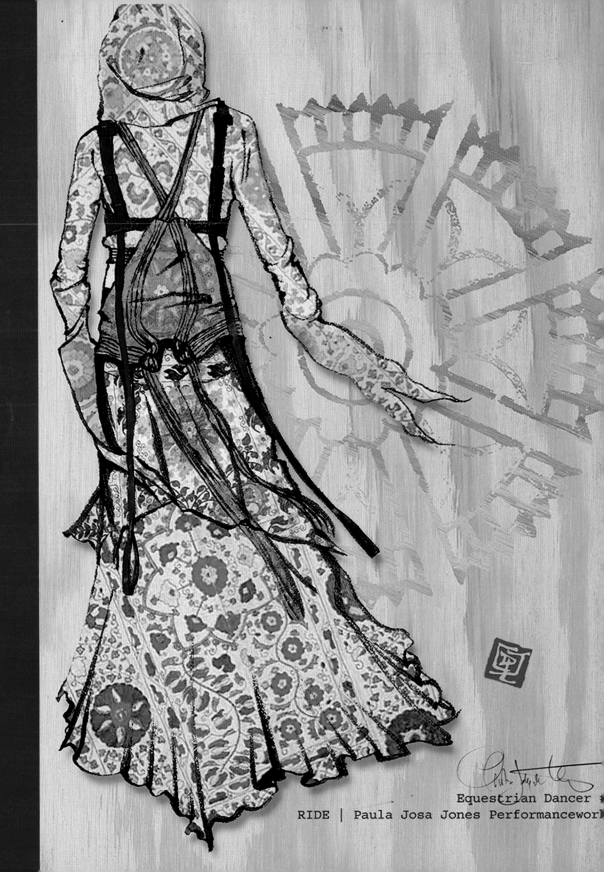

Equestrian Dancer
RIDE | Paula Josa Jones Performancework

Chapter 6

Working with Patterns

- Cloners
- Cloner Brushes
- Adding a Clone Source
- Offset Sampling
- Creating Patterns
- Dodging and Burning
- Aligning a Pattern
- Pattern Pens
- Photoshop Notes

Design by Christine Joly de Lotbinere. Equestrian Dancer #4 in *Ride,* Paula Josa Jones Performance Works, 2001. Sketch executed in Photoshop.

Remember watching cartoons and seeing Mickey Mouse dip a paintbrush into a bucket of polka dot paint and then joyfully paint the side of a barn with polka dots? That fantasy can now become a reality with the use of digital patterns. Using patterns can add intricate texture and detail to any rendering, but for costume designers the greatest advantage by far is that it gives us the ability to use scanned swatches of actual fabric in our renderings. This means that important design decisions can be made before purchasing a large quantity of fabric. Two brushes you need to be familiar with when working with patterns are **CLONERS** and **PATTERN PENS**.

Cloners 🅟🅢

CLONE is both a function under the **FILE** menu as well as a category of brushes. The **CLONE** features were originally designed to transform digital photographs into artistically rendered images. While this function may be useful to costume designers, there are other features of using **CLONERS** that really become a benefit to the design process. The **CLONER BRUSHES** can use another image or a pattern from one of the libraries as a medium with which to paint.

The process begins by opening an image and clicking on the word **CLONE** in the **FILE** menu. This action creates an exact duplicate of the original image as a new file directly on top of the old image. If you move the new image to one side you will be able to see both images. The new image has the **CLONE SOURCE** embedded in it, though it does not place it on a separate layer. To more completely understand the relationship between the new image and the **CLONE SOURCE**, you need to open the **CLONE SOURCE PANEL** under the **WINDOWS** tab on the top menu bar.

At the top of the **CLONE SOURCE PANEL** are three buttons that indicate what type of **CLONE SOURCE** is being used. The **CLONE SOURCE** can be one of the following types:

- **CURRENT PATTERN**. You can use any of the patterns loaded into the pattern library or create your own pattern from a scanned piece of fabric.

- **OFFSET SAMPLING.** The term **SAMPLING** is used in reference to the **EYEDROPPER** tool to pick up or "sample" color from an image. **OFFSET SAMPLING** means that you want to clone or copy a specific part of an image into another location.

- **IMAGE**. This refers to the original image that was cloned to create the new file or another image that has been opened.

In the lower part of the panel are a thumbnail view and the name of the **CLONE SOURCE** image. It is possible to have more than one **CLONE SOURCE**. Patterns

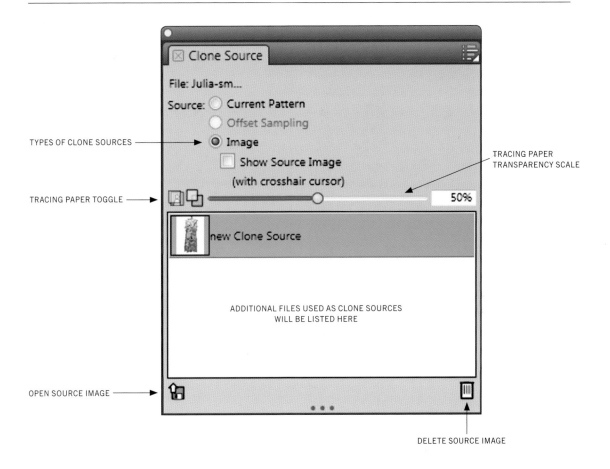

TYPES OF CLONE SOURCES

TRACING PAPER
TRANSPARENCY SCALE

TRACING PAPER TOGGLE

OPEN SOURCE IMAGE

DELETE SOURCE IMAGE

Figure 6.1

A photograph of a
dress has been cloned.
The thumbnail of
the dress file is listed
as an image source

do not show up as thumbnails, but any other images that are being used will
appear in the **CLONE SOURCE** list. To switch from one **CLONE SOURCE** to
another, click on the thumbnail as you would in the **LAYERS PANEL**.

Tracing Paper

One advantage of using the **CLONE** function is the ability to use **TRACING
PAPER**. Below the buttons showing the type of **CLONE SOURCE** is an icon that
can toggle the **TRACING PAPER** on and off and a sliding scale controlling the
degree of transparency of the **TRACING PAPER**. In order to see the effect of
TRACING PAPER more clearly, the canvas needs to be cleared, just as was done
in Chapter 1, by going to **SELECT > ALL** then **EDIT > CLEAR**. Although your
document appears to be blank, when you toggle the **TRACING PAPER** on and
off you can see that the **CLONE SOURCE** image is still embedded in the docu-
ment. If you save this document as a **RIFF** file, the **CLONE SOURCE** will remain
embedded in the document even if the second file is not open.

Figure 6.2

The first image is the original actor's photograph. The second image is a **QUICK CLONE**. The canvas has been cleared but the original image can be seen under the tracing paper.

Quick Clone

Go back to the **FILE** menu and see that there is also an option for **QUICK CLONE**. The **QUICK CLONE** function copies and embeds the existing image into a new document, clears the Canvas layer, and automatically opens the **TRACING PAPER** function, so this is a significant timesaving feature. One valuable asset for costume designers is to use the **TRACING PAPER** function to make stencils or pattern templates.

EXERCISE 6-A

Using Quick Clone and Tracing Paper

1 Open the file named *Celtic Trim*.

2 Go to the **FILE** tab and select **QUICK CLONE**. A new file should appear with a faded version of the original image.

3 The **CLONE SOURCE PANEL** should automatically open but if it does not, go to the **WINDOWS** tab and check **CLONE SOURCE**.

4 In the **CLONE SOURCE PANEL** click on the **TOGGLE TRACING PAPER** icon to turn the tracing paper off and on.

5 Select the **PENCILS** brush category and a 2B variant.

6 With the tracing paper turned on, trace around the edges of the trim. Turn the tracing paper off occasionally to check your work.

7 **SAVE** your file as a **RIFF**.

Figure 6.3

The original image was **QUICK CLONED** so the canvas was cleared. The design was traced on the **TRACING PAPER**, but when the **TRACING PAPER** is turned off, only the outline remains.

ORIGINAL FILE

TRACING PAPER

FINAL IMAGE WITH TRACING PAPER TURNED OFF

Cloner Brushes

CLONER BRUSHES use the colors in the source file and allow you to paint a replica of the original image in a variety of media. One application of this technique that could be useful for costume designers is to take a photograph of the actor's face, transform it with cloning techniques, and then copy and paste the face into the costume rendering.

The **CLONER BRUSHES** have the same properties as their counterparts in the other brush categories. This means that you can control size and opacity just as you would with a regular brush. Those brushes that respond to grain, such as the chalk variant, retain that capability when using the **CLONER** version. The **CLONE SOURCE IMAGE** can be painted onto the Canvas layer or a new layer that you created. If you want to use one of the **WATERCOLOR CLONERS,** you must first create a new Watercolor layer. There is no need to sketch in detail a complex pattern or print. Use a wide brush setting and let the **CLONER** do the work for you.

The **COLORED PENCIL** and **CHALK CLONER** variants result in a slightly blurred version of the original but can be used to pull out details. The **WATER-COLOR CLONER** is very spotty and transparent. A more useful choice seems to be the **WATERCOLOR WASH CLONER**, but keep in mind that the strokes take time to develop and look different from the time you first apply them to the paper to when they are fully dispersed. Interesting textures can be achieved using the **IMPRESSIONIST CLONER** or the more extreme **FURRY CLONER**. In the next exercise, take time to explore and have fun.

EXERCISE 6-B

Exploring Cloner Brushes ⓅⓈ

Imagine that you have pulled a dress from stock that you want to alter slightly. Now we want to make the rendering reflect how the dress will look when altered. The first step is to take a digital photograph of the dress.

1 Open the image named *Floral Dress* and make a **QUICK CLONE**.

2 Using the **COLORED PENCIL** cloner, sketch the outline of the dress, changing it to a sleeveless dress with a shorter skirt. Adjust the opacity and grain if necessary.

3 Use the **CHALK CLONER** and paint over one side of the bodice, being sure to outline the belt.

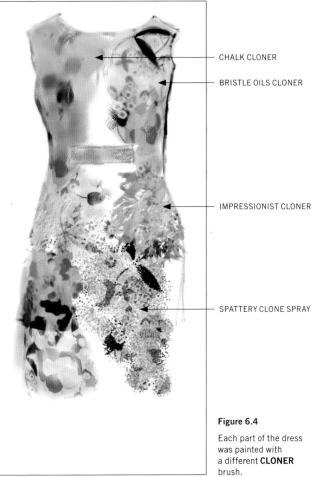

CHALK CLONER

BRISTLE OILS CLONER

IMPRESSIONIST CLONER

SPATTERY CLONE SPRAY

Figure 6.4
Each part of the dress
was painted with
a different **CLONER**
brush.

4 Turn off the **TRACING PAPER** periodically to check your results.

5 Switch to one of the **OIL BRUSH** variants and paint the other side of the bodice.

6 Go to the **LAYERS PANEL** and create a new Watercolor layer.

7 Switch to the **WATERCOLOR WASH CLONER**. Work slowly and paint in one section of the skirt. See how the brushstrokes change after you apply them.

8 Continue exploring the other **CLONER** variants including the textural variants.

9 Try different techniques on different layers and compare the results.

10 **SAVE** your file as a **RIFF** with a new name.

Adding a Clone Source Ⓟ

Often a costume designer wants to apply a scanned research image, a fabric texture, or a pattern from a completely different document onto a sketch. Using the **CLONE** or **QUICK CLONE** function is not the appropriate technique. Instead, the two different documents must be connected. First, both the sketch you want to paint and the document you want to use as a **CLONE SOURCE** must be open. With the sketch as the active document, open the **CLONE SOURCE PANEL** and select **IMAGE** as the **CLONE SOURCE** type. Click the small icon in the lower left corner, **OPEN SOURCE IMAGE**. The drop-down menu shows all the files that are open and there is a check mark by the file that is the active file, the one that the **CLONE SOURCE** will be embedded into. There you can select which image to use as a **CLONE SOURCE**. Once selected, the thumbnail view and the name of the second image will appear in the **CLONE SOURCE PANEL**.

The source image is now embedded in the sketch file and will stay there if you save as a **RIFF** file. The Canvas layer is not automatically cleared but **TRACING PAPER** can be toggled on and off to see the relationship between the sketch file and the clone source. The **CLONER BRUSHES** can now be used to apply the **CLONE SOURCE** image in the new sketch.

Note

Although the **TRACING PAPER** function is still visible, the original sketch was not cloned. Consequently, all the painting will be done on the Canvas layer in the sketch and not on a separate blank **TRACING PAPER** layer. If you want to preserve the original sketch and put the painting technique in a separate layer, you must first create a new layer. Toggling the **TRACING PAPER** on and off will still make the **CLONE SOURCE** visible, even in the new layer.

The more you paint in one area the darker and more distinct the pattern becomes. There is a variant called **STRAIGHT CLONER** that will precisely duplicate the pattern, but it creates hard sharp edges on the brushstrokes. There is a stronger sense of fabric texture and of light reflecting off fabric if you use a more transparent variant and allow some of the white paper to show through as highlights.

EXERCISE 6-C

Painting with a Source Image

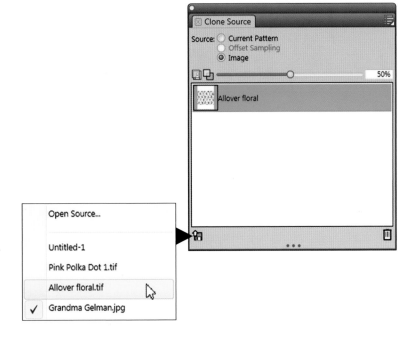

Figure 6.5

In the **OPEN SOURCE** menu the active file has a check mark by it. Choose the **CLONE SOURCE** from one of the other menu items.

1 Open the file labeled *Grandma Gelman* and the one labeled *Allover Floral*.

2 Click on the *Grandma Gelman* file to make it the active file.

3 Open the **CLONE SOURCE PANEL** if it is not already open. In the lower left corner click on **OPEN SOURCE IMAGE**. Choose *Allover Floral* from the list that appears. The Thumbnail view and name should now appear in the **CLONE SOURCE PANEL**.

4 In the **LAYERS PANEL** make a new layer and name it Skirt. Turn on the **TRACING PAPER** to see the relationship of the *Allover Floral* file to the *Grandma Gelman* sketch.

5 Open the **CLONER BRUSH** category and choose the Pencil Sketch Cloner variant. On the **PROPERTY BAR** change the size to 30, the opacity to 50% and the grain to 15%.

6 Start sketching in the skirt area of the *Grandma Gelman* sketch.

7 Create another new layer and label it Blouse.

8 Open the file named *Pink Polka Dot*.

9 In the **CLONE SOURCE PANEL** add *Pink Polka Dot* as a **CLONE SOURCE**.

Figure 6.6

With the **TRACING PAPER** turned on you can see that the *Allover Floral* file does not fill the entire image but it does cover the entire image.

Sketch courtesy of Kristine Kearney.

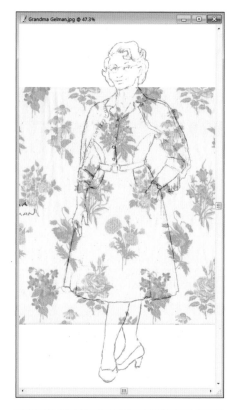

Figure 6.7

Because the *Pink Polka Dot* file is smaller than the *Grandma Gelman* file, the **CLONE SOURCE** image will not fill the collar or the right sleeve. In the next steps we will solve this.

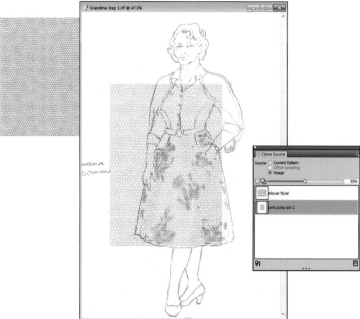

10 Toggle the **TRACING PAPER** so that you can see how the *Pink Polka Dot* file aligns with the sketch. Notice that the polka dot **CLONE SOURCE** does not cover the collar or the sleeve on the right.

11 Use the **SOFT CLONER** variant to paint the polka dot pattern on the blouse.

12 **SAVE** your file as a **RIFF**.

Figure 6.8

Use **OFFSET SAMPLING** to fill in the spaces on the collar and right sleeve that are not already covered by the **CLONE SOURCE** image.

Offset Sampling

Because the file containing the polka dot print in the previous exercise was smaller than the file of the Grandma Gelman sketch, the entire blouse could not be painted using a simple **CLONER** brush. In a case like this it is necessary to use **OFFSET SAMPLING** to pick up or "sample" an area of the **CLONE SOURCE** and apply it to a part of the sketch that is not aligned with the **CLONE SOURCE**. To do this, you have to go back to the original **CLONE SOURCE** file. With your **CLONER** brush selected, hold the **ALT/OPTION** key and click the area of the **CLONE SOURCE** file that you want to sample to set your reference point. A green marker will appear on the image to indicate the reference point. Go back to the destination image and begin painting in the area where you want to add the **CLONE SOURCE** image. As you paint, the reference point in the **CLONE SOURCE** image will also move, indicating what part of the **CLONE SOURCE** is being sampled.

Files that have more than one **CLONE SOURCE** can get very big. Once you have transferred the design into the sketch you can delete the **CLONE SOURCE** by selecting it in the **CLONE SOURCE PANEL** and then clicking on the **TRASHCAN** icon on the bottom right corner. If you need to go back and redo something, simply reopen the **CLONE SOURCE** image and re-select it in the **CLONE SOURCE PANEL**.

EXERCISE 6-D

Using Offset Sampling with a Clone Source

1 Go back to the *Grandma Gelman* sketch. Make sure the *Pink Polka Dot* file is also open and listed as a **CLONE SOURCE** in the *Grandma Gelman* sketch.

2 Hold the **ALT/OPTION** key and click in the lower center of the *Pink Polka Dot* file. Check that the green dot indicating the reference point appears.

3 Go back to the *Grandma Gelman* file and begin painting the collar and sleeve. Notice that the button for **OFFSET SAMPLING** is now highlighted in the **CLONE SOURCE PANEL**.

4 **SAVE** your file as a **RIFF**.

Figure 6.9

When the **CLONE SOURCE** image is sampled, a green dot will appear. As you are painting in the active image, the cross hairs cursor will also move in the **CLONE SOURCE** image.

Creating Patterns PS

In the last exercise you may have felt that the flowers were too big for the skirt. To change the scale of a source image, it becomes necessary to turn the **CLONE SOURCE IMAGE** into a tiled, repeating **PATTERN**. This is indeed Mickey Mouse's bucket of polka dot paint because once the image is turned into a **PATTERN**, it can be painted anywhere in your sketch without having to resort to **OFFSET SAMPLING**. More importantly, however, the pattern can be scaled to fit your rendering. Using a proportional reference object such as the size of the sketched figure's hand, you can effectively render scanned fabric in the approximate size that it would appear on an actual garment.

There are some previously created patterns already loaded into the Painter libraries. Go to the **MEDIA SELECTOR BAR** and click on the **PATTERNS** icon to see what is available. To create your own pattern from scanned fabric you need to open the **PATTERNS CONTROL PANEL**. Go to **WINDOW > MEDIA CONTROL PANELS > PATTERNS**.

The **PATTERNS CONTROL PANEL** is in a palette that includes control panels for **GRADIENTS** and **WEAVES**. The **PATTERNS CONTROL PANEL** looks similar to the **GRADIENTS CONTROL PANEL**. There is an active window that shows the size of the current pattern. On the right is a thumbnail view that when clicked will open the library of patterns available. Along the bottom are two sliders.

Figure 6.10

The **TOP** button in the **MEDIA LIBRARY PANEL** opens the **PATTERNS LIBRARY**.

Painter Patterns

The top one controls the pattern offset and the bottom one controls the scale. In the top right corner is an options menu, which includes the command for **CAPTURE PATTERN**.

Figure 6.11

The **PATTERNS CONTROL PANEL** has adjustments for scale and alignment.

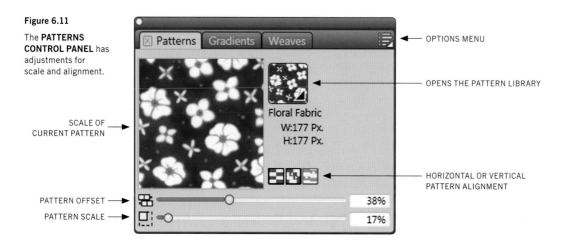

OPTIONS MENU

OPENS THE PATTERN LIBRARY

SCALE OF CURRENT PATTERN

HORIZONTAL OR VERTICAL PATTERN ALIGNMENT

PATTERN OFFSET

PATTERN SCALE

Capturing a pattern involves making a selection in the image you want to turn into a pattern and then clicking the **CAPTURE PATTERN** command. You can select the whole image or just a part of the image. The selection you made will then be repeated as square tiles to create the pattern. When you click the **CAPTURE PATTERN** command, a new dialogue box will open. At the top is a space to give the pattern a discrete name. When the **RECTANGULAR TILE** option is selected, the pattern is repeated side-by-side with no adjustment. If you want to offset the

Figure 6.12

The **CAPTURE PATTERN** dialogue box shows a thumbnail of the pattern and has sliders for adjusting the horizontal and vertical alignment.

repetition, you can select the **HORIZONTAL SHIFT** or **VERTICAL SHIFT** option and use the **BIAS** slider to offset the pattern. You will see a dynamic representation in the preview window. If you are working with a stripe or plaid fabric swatch, the **BIAS** slider can help you align the tiles to make the stripes continuous. When the pattern is set where you want it, click **OK**. The pattern is now part of the **PATTERNS LIBRARY** and should come up automatically in the **PATTERNS CONTROL PANEL**. If you want to find your pattern, simply click on the **PATTERNS LIBRARY** icon.

Because the pattern is created by repeating square tiles, the only selection tool you can use is the **RECTANGULAR SELECTION**. If you do not make your selection accurately the first time, it is better to undo and re-select rather than trying to adjust your selection in the **CAPTURE PATTERN** dialogue box. For some reason, when creating patterns, Painter recognizes when you add to a selection but not when you subtract from a selection.

EXERCISE 6-E

Capturing Patterns

1 Click on the *Allover Floral* file to make it the active document.

2 Using the **RECTANGULAR SELECTION** tool in the **TOOLBOX**, draw a selection around the cluster of small pink roses. Be careful not to select any of the other flowers

3 Go to the **PATTERNS CONTROL PANEL** and click on the options menu in the top right corner. Select **CAPTURE PATTERN**.

4 In the dialogue box that opens, name the pattern *Pink Roses*.

5 Notice how the roses are all lined up in a regular arrangement. Select either the **HORIZONTAL** or **VERTICAL SHIFT** and adjust the **BIAS** slider until the pattern is to your liking.

6 Click **OK**. Notice that the *Pink Roses* Pattern is now loaded into the **PATTERN LIBRARY**.

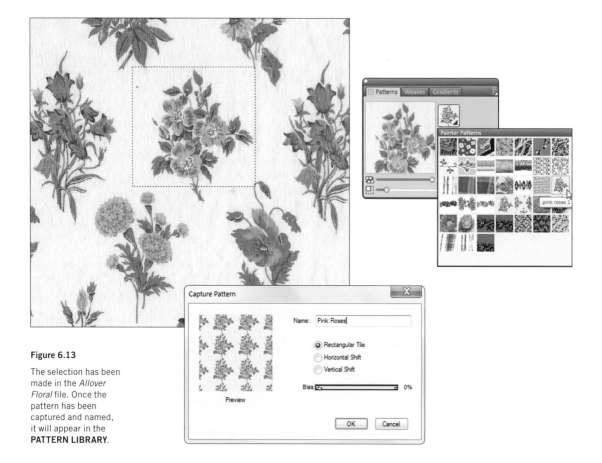

Figure 6.13

The selection has been made in the *Allover Floral* file. Once the pattern has been captured and named, it will appear in the **PATTERN LIBRARY**.

7 Repeat the process, but this time make the selection encompass the blue flowers, pink roses, orange flowers, and half of the red poppy. Check that the other half of the red poppy appears on the other side of the selection.

8 Capture the pattern and name it *Three Flowers.*

9 Because the individual flower clusters are already offset, moving the **HORIZONAL SHIFT** really does not change the pattern. Moving the **VERTICAL SHIFT**, however, distorts the way in which the two parts of the poppy match up.

10 **SAVE** your pattern by clicking **OK**.

11 Analyze the print and determine how to make your selection in order to include all the flower clusters and best represent how the pattern is repeated.

12 Name your pattern *Full Floral* and save it.

13 You should now have three new patterns in your **PATTERN LIBRARY**.

Figure 6.14

The selection was made very carefully so that the red poppies will line up once the selection has been turned into repeating tiles.

In order to paint with your pattern, you need to load the **CLONER BRUSHES** with the current pattern instead of linking them to an image. In the **CLONE SOURCE PANEL**, click the button next to **CURRENT PATTERN**. Make some test strokes in the sketch and use the **PATTERN SCALE** slider on the bottom of the **PATTERNS CONTROL PANEL** to adjust the scale of the pattern to fit the sketch. If you have the actual fabric in front of you, you can estimate the scale by looking at how the pattern compares to the size of your hand. Adjust the digital pattern to compare with the sketched figure's hand.

Applying and Scaling a Pattern

1 Open the *Grandma Gelman* sketch.

2 Hide all layers that have patterns in them. Create a new layer and name it Floral Pattern.

GRANDMA
GELMAN

Figure 6.15

A scaled-down **PATTERN** of the *Allover Floral* file has been applied to the dress and a separate *Pink Roses* pattern has been added to the sweater.

3 In the **CLONE SOURCE PANEL** make sure that **CURRENT PATTERN** is selected.

4 In the **PATTERNS CONTROL PANEL** make sure that *Full Floral* pattern is selected.

5 Use the **SOFT CLONER** variant in the **CLONER BRUSHES** category to begin painting the skirt.

6 In the **PATTERNS CONTROL PANEL** adjust the scale of the pattern to fit what you think is the scale of the rendering.

7 Continue painting the skirt and blouse.

8 In the **PATTERNS CONTROL PANEL** open the **PATTERNS LIBRARY** and select the *Pink Roses* pattern.

9 Adjust the scale and use this new pattern to paint the sweater.

10 **SAVE** your file as a **RIFF**.

ADVANCED EXERCISE

Try this technique on a previous exercise: Keep in mind that you can also fill the **PAINT BUCKET** tool with the current pattern. In Chapter 3, Exercise 3-E, the **PAINT BUCKET** tool was used to fill a skirt with a gradient. Repeat the exercise using **SOURCE IMAGE** as a fill and making sure the correct **PATTERN** is selected. Explore the **DODGE** and **BURN** tools in the **TOOLBOX** to create highlights and shadows similar to those created in Chapter 3, Exercise 3-F.

Dodging and Burning _{PS}

Two photographic techniques are also useful for creating highlights and shadows in a Painter sketch. These tools are the **DODGE** and **BURN** found one on top of the other in the **TOOLBOX**. The **DODGE** tool lightens the tones in the image while the **BURN** tool darkens the tone. Instead of trying to find an appropriate shadow color to layer over a complex pattern, the **DODGE** and **BURN** tools use the existing colors to create more natural looking highlights and shadows. These tools can also be used to give variation and depth to a solid color **PAINT BUCKET** fill. Both of these tools have **SIZE** and **OPACITY** sliders in the **PROPERTY BAR**. Simply select which tool you want to use and stroke it over the area you want to tone.

DODGE BURN

Figure 6.16
The **DODGE** and **BURN** tools are found toward the middle of the **TOOLBOX** and are stacked one on top of the other.

Aligning a Pattern _{PS}

It would be fantastic if fabric would lay flat against the body, but we all know that prints and designs shift and distort as the fabric is formed around the complex curves of the body. Costume designers must learn to convey that perception when making their renderings. Working with stripes is one of the best ways to explore solutions to this problem.

There are two approaches that can be used. The first involves creating a new document and manipulating the stripe pattern in this new document before

applying it to the sketch. In order to maintain the correct pattern scale, the new document must be the same size as the one with the sketch. To find out the size of the document you are working on, go to the **CANVAS** tab on the top menu bar and select **CANVAS SIZE** from the drop-down menu. The height and width in pixels will be shown in the dialogue box that opens. Close that box and then go to **FILE > NEW**. When the **NEW IMAGE** box opens, set the size of your new document to match the one of your sketch. Move this document so you can see both images side-by-side.

Figure 6.17

Note the size of the existing canvas at the top of the box. When you open a new document, you can make it the exact size as your sketch to keep the scale of the pattern in proportion.

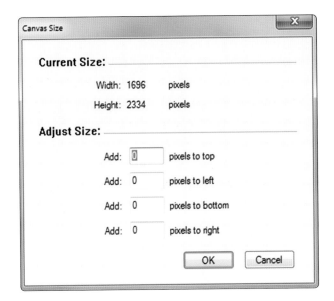

Suppose you have created a pattern that has vertical stripes and you want to apply them as horizontal stripes. First scale the pattern so it is an appropriate size for the area of the sketch you want to paint. Next, go to your new document. Use the **PAINT BUCKET** tool with a **SOURCE IMAGE** fill to apply the stripe pattern to the entire new document. Next, go to **SELECT > ALL**. Then you can use **TRANSFORM** (under the **LAYER ADJUSTER** in the **TOOLBOX**; see Chapter 5) to rotate the stripe pattern to the proper angle. Do not forget to **COMMIT TRANSFORMATION** by clicking the **CHECK** icon on the top menu bar.

When you go back to your sketch document you must use the **CLONE SOURCE PANEL > OPEN SOURCE IMAGE** to embed the stripe pattern into the sketch. Because both documents are the same size, you should be able to use a **CLONER BRUSH** to apply the stripe pattern almost anywhere in the sketch. You can go back and adjust the angle of the stripe pattern again, but each time you make a change in the **SOURCE IMAGE**, you need to re-embed the image in the sketch document.

Aligning a Stripe Pattern Using a Clone Source File

Figure 6.18

Make your selection with care so that when the stripe is converted to a repeated tile, the stripes will align.

1 Open two documents, *Operetta Dress* and *Blue Stripe*. Make the *Blue Stripe* document active.

2 Look at how the stripes repeat and carefully make a selection that will tile easily into a repeated pattern.

3 Use the **PATTERNS CONTROL PANEL > OPTIONS BUTTON > CAPTURE PATTERN** to capture the pattern. Adjust the **BIAS** slider to make sure the stripes are aligned.

4 Go back to the *Operetta Dress* file. Notice that the bodice has vertical stripes and the sleeves have horizontal stripes. With the **SOFT CLONER** variant, make a few test strokes in the margin of this document to make sure the scale of the stripe pattern is correct. Erase these test strokes when you are done. Paint vertical stripes on the bodice of the dress.

5 Go to the **CANVAS** tab on the top menu bar and select **CANVAS SIZE**. Make a note of the size of the *Operetta Dress* file and then close the dialogue box.

Figure 6.19

The stripes in the second document have been rotated to visually align with the angle on the sleeve on the upraised arm.

6 Go to **FILE > NEW** and create a document that is the same size as the *Operetta Dress* file.

7 Select the **PAINT BUCKET** tool and make sure the fill is **SOURCE IMAGE**. Fill the new document with your stripe pattern.

8 Use **SELECT > ALL** then go to **LAYER ADJUSTER > TRANSFORM > ROTATE**. Turn the stripes so that they are horizontal and in close alignment to the cuff on the upraised arm of the sketch. **COMMIT** to the transformation.

9 Now go back to the *Operetta Dress* sketch. Open the **CLONE SOURCE PANEL** if it is not open. Click on **OPEN SOURCE IMAGE** and choose the *untitled* file. Use the **SOFT CLONER** to apply the stripe to the left sleeve.

10 Go back to the *untitled* document. Click **CTL+Z/CMD+Z** (**UNDO**) until the stripe is straight again. Re-rotate it so that it aligns to the angle of the stripes on the right sleeve of the sketch. **COMMIT** to the transformation. Undoing the first rotation may be an unnecessary step, but each time the pattern is rotated, the less it fills the drawing space.

11 In the *Operetta Dress* sketch use **OPEN SOURCE IMAGE** in the **CLONE SOURCE PANEL** to re-select the *untitled* file. There will now be two *untitled* files listed in the **CLONE SOURCE PANEL**. This way you can easily switch back and forth as you paint different parts of the sketch. Continue to paint the stripes on the right sleeve.

12 **SAVE** your file as a **RIFF**.

The second approach for aligning a pattern is a bit more organic. Using layers is especially important in this technique. Use a **CLONER BRUSH** to paint the stripe pattern in a new layer over the area in which you want to apply the stripes. It is better not to be precise but to extend the pattern a little beyond the borders of the area you want to fill. Use **LAYER CONTENT** under the **SELECT** tab to capture the striped area, and then use the **TRANSFORM** tool to rotate the pattern in the direction you want the stripes to follow. Use the **DISTORT** function to make the stripes taper or spread apart. To make sure you are aligning the stripes properly, make the layer more transparent so that you can see the sketch underneath. Once you commit to the transformation, you can erase any of the excess stripe patterns.

EXERCISE 6-H

Aligning a Stripe Pattern Using Layers

1 Open the *Operetta Dress* file.

2 Create a new layer and name it Center Stripes.

3 Make sure the striped pattern is scaled appropriately for the sketch and use the **SOFT CLONER** brush to paint an area of vertical stripes over center front section of the skirt.

4 Because there is nothing else in this layer, you can go directly to **LAYER ADJUSTER > TRANSFORM** then select the **DISTORT** function from the **PROPERTY BAR**. Drag the corner handles of the selection window to compress the stripes at the waist and flare them out towards the hem.

5 **COMMIT** to the transformation.

6 Create a new layer. Using the **SOFT CLONER** brush paint an area of vertical stripes to the left of center.

7 Use the **SELECT LAYER CONTENT** to select just this area of stripes.

8 Use **LAYER ADJUSTER > TRANSFORM > ROTATE** to align the stripes to the angle of the skirt. Then use the **DISTORT** function to taper the stripes at the waist. Erase any stripes that overlap the center section.

9 Continue to fill the other sections of the skirt with stripes, angling each one to fit the curve of the skirt.

10 When the skirt is finished, all the stripe layers can be collapsed into one.

11 **SAVE** your file as a **RIFF**.

Figure 6.20

The stripes in the center section of the skirt have been tapered at the waist. Note that no attempt has been made to stay within the lines of the drawing when applying the stripes to the side section.

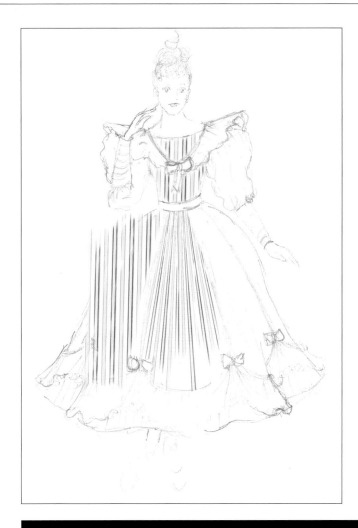

Pattern Pens

Another way to use patterns is with the **PATTERN PEN** in the **BRUSH SELECTOR BAR**. This brush takes an existing pattern or one that you create and instead of making it into an allover pattern, it creates a linear design. When you make a rectangular selection to create a pattern, the **PATTERN PEN** takes just one row of those tiles to make the linear pattern.

Figure 6.21

The **PATTERN PEN** is one of the media categories in the **BRUSH SELECTOR BAR**.

Figure 6.22

The **PATTERN PEN** variants provide a number of ways to apply a linear pattern.

- Pattern Chalk
- Pattern Marker Grad Col
- Pattern Marker
- Pattern Pen Masked
- Pattern Pen Micro
- Pattern Pen Soft Edge
- Pattern Pen Transprnt
- Pattern Pen

There are several variants of **PATTERN PENS**. Some, like cloners, emulate drawing with different media. The other **PATTERN PEN** variants control the properties of the pattern you have chosen. One of the more useful of these is the **PATTERN PEN MASKED**, which eliminates the background. In order for this pen to work, you must use a pattern that was captured without the background. To create a pattern that can be used with the **PATTERN PEN MASKED** variant you need to make your selection with the **LASSO** tool or the **MAGIC WAND** instead of a rectangular selection, eliminating as much of the background as possible. Although the background will still appear in the thumbnail in the **PATTERN CAPTURE** window, and will also appear when using the **PATTERN PEN**, the background will be removed when using the **PATTERN PEN MASKED** variant.

When you use a **PATTERN PEN** to apply a pattern to a drawing, the direction in which you stroke the pen makes a difference if you have a directional pattern. One way to see this effect is to practice with the **PATTERN PEN** variant using the pattern from the **PATTERNS LIBRARY** named *DECORATIVE GINGKO PEN* (do not use the *DECORATIVE GINGKO FILL*). When a stroke is made going down the page, the gingko shapes are facing downward, and when a new stroke is made going up the page, the pattern changes direction. As the pen moves, portions of the pattern may smear and blend, especially if the stroke is made quickly or changes direction suddenly. Changing to the **PATTERN PEN MASKED** variant will remove the blue background on the design, leaving just the gingko leaf shape.

To change the size of the pattern, it is best to use the **SIZE** slider on the **PROPERTY BAR** instead of the **SCALE** function in the **PATTERNS CON-TROL PANEL**. If you do not want to use the **PATTERN PEN TRANSPARENT** variant, you can always adjust the opacity on the **PROPERTY BAR** as well.

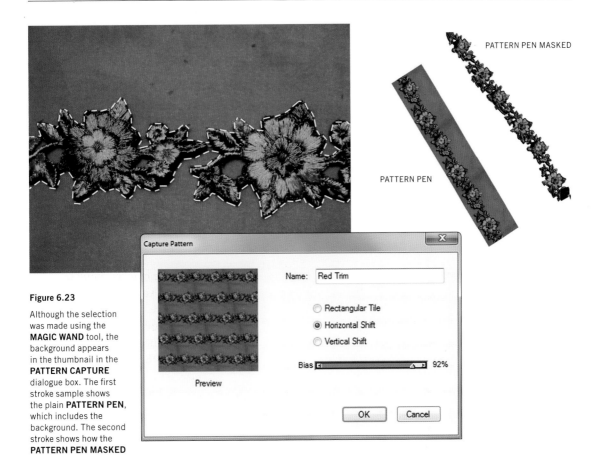

PATTERN PEN MASKED

PATTERN PEN

Figure 6.23

Although the selection was made using the **MAGIC WAND** tool, the background appears in the thumbnail in the **PATTERN CAPTURE** dialogue box. The first stroke sample shows the plain **PATTERN PEN**, which includes the background. The second stroke shows how the **PATTERN PEN MASKED** removes the background.

Figure 6.24

Notice how the *Decorative Gingko Pen* pattern changes direction and the leaf shapes become distorted when the stroke makes a tight directional change.

Working With Pattern Pens

Figure 6.25

The **CAPTURE PATTERN** panel showing the linear pattern as horizontal stripes.

1 Open the file labeled *Blue Trim*.

2 Use the **MAGIC WAND** and stroke across the white background above the trim. If the **CONTIGUOUS** button is turned on you will have to add the background below the trim to the selection.

3 Go to the **SELECT** tab on the top menu bar and choose **INVERT SELECTION.** Your selection should now be just the trim.

4 Go to the **PATTERN CONTROL PANEL**, and in the **OPTIONS MENU** select **CAPTURE PATTERN**. You should see a series of horizontal stripes made up of the trim pattern you selected.

5 Using the Horizontal Shift should not change the pattern, but using the Vertical Shift will throw the pattern out of alignment and you will not get the linear effect with the pattern pen.

6 Give the pattern a name and click **OK**.

7 Open the *Operetta Dress* file and create a new layer named Skirt Trim.

8 Select the **PATTERN PEN** and the simple **PATTERN PEN** variant and apply the trim to one of the bands on the skirt. Adjust the size of the trim by using the **SIZE** slider on the **PROPERTY BAR**.

Figure 6.26

The trim on the left of the skirt was applied using the **PATTERN PEN**. The trim on the right used **PATTERN PEN MASKED**.

9 Change to the **PATTERN PEN MASKED** variant and apply to the other band of the skirt to see the difference.

10 Continue applying the trim to the rendering wherever you think is appropriate.

11 **SAVE** your file as a **RIFF**.

Photoshop Notes

Cloners

Instead of making a **CLONE** of an image as described in the Painter instructions, Photoshop users can just use duplicate images. This process is not the same as embedding a clone source into an image but it does preserve a clean copy of the original file. Instead of working with **TRACING PAPER**, it is much easier to utilize Photoshop's versatile **LAYERS PANEL** to achieve similar results. The point of working with **TRACING PAPER** is to get an outline of a detailed image on a plain background that can be printed and used as a stencil or a guide for another application. One technique involves creating a new layer that will serve as the blank background and filling that layer with a color, usually white. Then you make the layer transparent so you can see the faint version of the original image. Next, you create a second layer on which you will draw your tracing of the image. When the tracing is completed to your satisfaction, reset the transparency of the first layer so that the original image disappears. If you save this as a Photoshop file, the original image will always be embedded into the file, just as when you use the **QUICK CLONE** in Painter. If, however, you save the file as a **JPEG** with the first layer completely opaque, you will not be able to readjust this layer to a transparent one in order to see the image underneath. Remember the layers all collapse together when the file is saved as a **JPEG**. Complete Exercise 6-A using the layer technique as tracing paper.

Exploring the Art History Brush

The **ART HISTORY BRUSH** in the **TOOLS PANEL** works a little like the **CLONER BRUSHES** in Painter in that it interprets an image and replicates it with a painterly technique that you design. As with **CLONERS**, the **ART HISTORY BRUSH** requires you to determine a source. You define the quality of the stroke and the painting technique in the **BRUSH PANEL**. Use the following steps to complete exercise 6-B:

1 Open the image *Floral Dress* and create a new layer labeled White. Use the **PAINT BUCKET** to fill this layer with white. You can adjust the opacity if you want to see your work in comparison to the original image.

2 Create another layer named Sketch and make your sample strokes in this layer.

3 Trace the outline of the dress as directed in the chapter using a **PENCIL** tool.

Figure 6.27

The **HISTORY BRUSH** and the **ART HISTORY BRUSH** are stacked together in the **PAINTING TOOLS** section on the **TOOL PANEL**.

CHECK THIS BUTTON TO SET THE ORIGINAL IMAGE AS THE SOURCE FOR THE ART HISTORY BRUSH →

PS Figure 6.28

Use the **HISTORY PANEL** to set the source for the **ART HISTORY BRUSH** by clicking on the square to the right of the name of the file or one of the iterations captured as a **SNAPSHOT**.

4 Select the **ART HISTORY BRUSH** from the **TOOLS PANEL**. Open the **HISTORY PANEL** and make sure the original image is checked on the left side as the source for the **HISTORY BRUSH**.

5 Open the **BRUSH PANEL** either from the **OPTIONS BAR** or from the icon on the right toolbar.

6 Choose the **BRUSH PRESET** tab and select a brush stroke with which to begin your work.

7 Try several brush tips. Control the **SIZE** and **OPACITY** on the **OPTIONS BAR**.

Figure 6.29

The **BRUSH PRESET** tab in the **BRUSH PANEL** showing the different stroke variations.

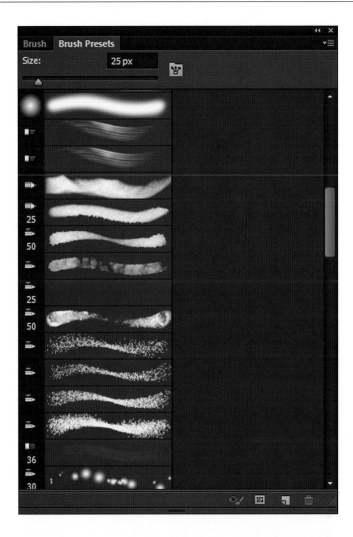

8 Open the drop-down menu on the **OPTIONS BAR** under **STYLE**. See how **LOOSE MEDIUM**, **TIGHT SHORT**, and other options change the quality of the brush stroke.

9 Open the **BRUSH** tab in the **BRUSH PANEL** and make more detailed adjustments to your brush stroke.

10 **SAVE** your work as a **PSD** file.

Adding a Clone Source

Figure 6.30

The **CLONE STAMP** tool and **PATTERN STAMP** tool grouped together on the **TOOL PANEL**.

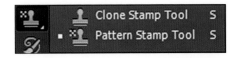

If you want to replicate an image but not alter it with a painting technique, use the **CLONE STAMP** tool in the **TOOLS PANEL**. The **CLONE STAMP** tool is paired with the **PATTERN STAMP** tool. This **CLONE STAMP** tool works the same as the **STRAIGHT CLONER** in Painter. As in Painter, you need to set the source for the **CLONE** tool. Open both documents that you want to use. Select the **CLONE STAMP** tool and click in the source document to make it the active file. Hold down the **ALT/OPTION** key and click the area that you want to copy. This is the same as **OFFSET SAMPLING** as discussed in the Painter instructions. When you go back to the document in which you want to paint, your cursor will change to a circle with a small piece of the image that you have sampled. As you move your cursor over the image, the color and pattern from the source image will appear in your drawing. You can adjust the opacity or style of the brush on the **OPTIONS BAR** or in the **BRUSH PANEL**. Complete Exercise 6-C using the **CLONE STAMP** tool and practice switching between different source documents.

Figure 6.31

The **CLONE SOURCE PANEL** is opened under the **WINDOW** tab on the top menu bar.

You may not encounter the alignment issue discussed in the Painter portion depending on which part of the polka dot pattern you choose to start the cloning process. If you sample from an area too close to the edge of the document, you may not sample enough of the pattern to fill the entire area in the sketch you want to cover. There is also a **CLONE SOURCE PANEL** in Photoshop, which can be opened under the **WINDOW** tab. In this panel you can control the X-Y offset and the height and width of the source pattern, but these controls are not as intuitive as in Painter and may take some practice to master. Complete Exercise 6-D using the **CLONE STAMP** tool and continue with **OFFSET SAMPLING**.

Figure 6.32

The **PATTERN LIBRARY** is opened by clicking on the small arrow next to the thumbnail image of the last pattern used.

Creating Patterns

The process for creating custom patterns is somewhat different in Photoshop. Use the **RECTANGULAR SELECTION** tool to select a portion of an image to use as a pattern. Go to the **EDIT** tab and choose **DEFINE PATTERN** from the menu. Give the pattern a distinctive name when the dialogue box opens. When you select the **PATTERN STAMP** tool there is an icon on the **OPTIONS BAR** that opens a library of patterns. The new pattern that was created should be listed in that library. You can then use the **PATTERN STAMP** tool to paint an area with a repeated pattern. On the **OPTIONS BAR** check the **ALIGNED** button if you want to maintain the patterns continuity no matter where you start subsequent strokes. If you uncheck the **ALIGNED** button, the pattern alignment changes every time you start a new stroke.

OPENS THE LIBRARY OF SAVED PATTERNS

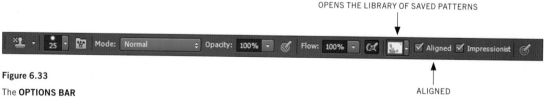

ALIGNED

Figure 6.33

The **OPTIONS BAR** showing the **PATTERN STAMP** options.

The one thing you cannot do is adjust the horizontal and vertical offset of a repeated pattern alignment. Complete Exercise 6-E to create three different patterns from the *Allover Floral* file. Because there is no **PATTERN** dialogue box, the process for scaling a pattern is also different from Painter. A pattern can be scaled if it is going to be used as a **FILL** with the **PAINT BUCKET** tool. Create a selection around the area you want to fill with a pattern. On the **LAYERS PANEL** click **CREATE NEW FILL OR ADJUSTMENT LAYER** from the buttons on the bottom of the **LAYERS PANEL**. Choose **PATTERN** from the drop-down menu. In the dialogue box that opens select the correct pattern from the thumb-

Figure 6.34

When **CREATE NEW FILL OR ADJUSTMENT LAYER** is clicked on the **LAYERS PANEL**, a drop-down menu of fill options will appear.

Figure 6.35

The **PATTERN FILL** dialogue box. To open the library of patterns, click on the arrow next to the thumbnail.

Figure 6.36

The **LAYERS PANEL** showing a Fill layer with a pattern and a mask.

nail menu. Scale the pattern to fit your selection by moving the **SCALE** slider. The area that you selected will fill with the scaled-down pattern. In the **LAYERS PANEL** you will see a thumbnail of the pattern as well as a mask over the rest of the drawing.

Look for the **CHAIN ICON** next to the thumbnail in the layer name that indicates that the mask blocking the rest of the image is linked to the to the layer content. When the **PATTERN FILL** is linked to the layer with the selection, you can move the selected area and the pattern to a different location in the drawing. If you **UNLINK** the fill layer from the layer with the selection, you can then reposition just the pattern within the selected area, but the selected area itself will not move.

You cannot use a **FILL** layer as a source for the clone brush. In order to paint with a scaled pattern it is necessary to create a new source document for the **CLONE STAMP** tool. Open a new document that is the same size as the one with your rendering. Create a new **FILL LAYER > PATTERN** and scale the pattern down in proportion to your sketch. Use the **PAINT BUCKET** to fill the new document with the scaled-down pattern. **RIGHT CLICK (CMD+CLICK)** on the fill layer and select **FLATTEN IMAGE** to merge the fill layer onto the Background layer. Pick up the **CLONE STAMP** tool, set the new document with the scaled-down pattern as the source by holding down the **ALT/OPTION** key, and proceed to paint in the rendering file with the scaled-down pattern.

In Exercise 6-F use the **ADJUSTMENT LAYER** method along with the **PAINT BUCKET** tool as well as the method for creating a new source document and the **PATTERN STAMP** to explore how to adjust the scale of the pattern within a rendering.

Dodging and Burning

These tools were first developed in Photoshop so their function and method of use is the same as in Painter.

Aligning a Pattern

Photoshop users have already explored creating a new document to use as a **CLONE SOURCE**. As in Painter, the pattern in the new document can be rotated using the **TRANSFORM** tools in the **EDIT** menu to align the stripes to different parts of the sketch. Use this method to complete Exercise 6-G. To complete Exercise 6-H, make a selection of a portion of the skirt and add an **ADJUSTMENT LAYER**. This selection can then be reshaped using some of the **TRANSFORM** tools.

The Pattern Pen

There is no tool in Photoshop that functions in the same way as Painter's **PATTERN PEN**, but it is possible to create custom brushes from images. This

process results in an outline shape from an image, which can then be applied using the various adjustments in the **BRUSH PANEL**. For greatest versatility, the source image must first be turned into a black and white image and the outline of the brush tip shape carefully selected.

When completing Exercise 6-I in Photoshop, follow these steps to create a custom brush. The way in which this brush is used will not replicate the final result in the Painter exercise but will give you an opportunity to explore ways to manipulate a custom brush.

1 Open the file labeled *Blue Trim*.

2 Use the **MAGIC WAND** tool to select the white background.

3 Add the yellow interior to the selection then go to **SELECT > INVERSE**. You should now have just the blue part of the trim selected.

4 Go to the **IMAGE TAB > ADJUSTMENTS > HUE/SATURATION** and move the **SATURATION** slider all the way to the left to turn the image into black and white. If necessary, adjust the **LIGHTNESS** slider to give a wider range of value in the image.

5 Go to the **EDIT** tab and select **DEFINE BRUSH PRESET.** Give the brush a distinctive name and make note of the number under the thumbnail. The brush should now be saved in the brush tip library.

6 Open a new document that is larger than the *Blue Trim* document by a couple of inches in either direction.

7 Select the **BRUSH** tool from the **TOOLS PANEL**. To start, choose **OIL PASTEL SOFT OPAQUE** from the **BRUSH PICKER** menu on the **OPTIONS BAR** and pick a bright foreground color.

8 Click on the **BRUSH PRESET PICKER** on the **OPTIONS BAR** and scroll down to find your new custom brush, which should be last on the list. The number will be under the icon and the name you gave the brush will appear if you hold the cursor over the icon.

9 Make some practice strokes in the new blank document. You can adjust the size of the tip in the **BRUSH PRESET PICKER**, but you cannot adjust the hardness.

10 Use the **BRUSH PANEL** to change the angle and add **TEXTURE**.

Once you have gained control over your custom brush you can continue with Exercise 6-I, starting with step 7, and apply trim to the *Operetta Dress* image.

PROGRAMME

GRAND THEATRE

OKLAHOMA

Chapter 7

Finishing Touches

- Adding Backgrounds
- Changing Canvas Size and Adding Duplicate Figures
- Special Effects
- Adding Text
- Photoshop Notes

Design by Bethann Brody.
Workshop exercise,
USITT Costume
Symposium, 2011.
Sketch executed in
Photoshop.

The ultimate goal for using digital technology may be to eliminate the use of the pencil. With all these tools at your command it should be easy to start with a blank page and create your figure directly on the digital canvas. But the truth is that most costume designers I have talked to do their initial sketching in the traditional manner with a pencil and paper and then scan the image into the computer in order to add color. Once the sketch is colored, it is time to add the finishing touches to the rendering. Digital media will give you a wealth of options for putting sketched characters into an environment that not only shows off the costume design to its best advantage, but also evokes the whole of the play with its location, time period, and mood.

Adding Backgrounds 🅿🆂

If you are going to do your entire sketch on the computer it is a good idea to keep your Canvas layer blank and begin your sketch on a new layer. In this way you can insert images, colors, or shadows behind the figure you are creating. Often a designer is in a hurry to get a rendering finished. If you find that you have completed the figure and only then decide to add a background or shadow, it will be necessary to lift the figure off the canvas and put a background behind it.

The first step is to make sure the entire figure is in one layer. It is very quick and easy to save a copy of your finished sketch as a **JPEG** file in which all the layers are merged onto the Canvas layer, but keep in mind that a **JPEG** is a compressed file. In order not to lose any detail, you should save this copy at the highest resolution. Another only slightly more tedious solution is to **DROP** all the layers onto the Canvas layer so all parts of the drawing are together. See the section in Chapter 4 on Layer Commands to review how to drop a layer.

In Chapter 4 it was pointed out that the Canvas layer cannot be duplicated. Consequently, the figure first needs to be selected and then lifted into a new layer. A quick way to do this is to use the **MAGIC WAND** to select the white background, then use **INVERT SELECTION** under the **SELECT** tab on the top menu bar to switch the selection from the white background to just the figure. Refer to Chapter 5, Selections and Transformations, to review using the **MAGIC WAND**.

Next, hold down the **CTL/CMD** key when you click on the center of the selection. A new layer is automatically created with a duplicate of the figure, leaving the Canvas layer blank. You can also **COPY** and **PASTE** the figure after it has been selected if you want retain a clean copy of the original sketch on the Canvas layer. The new layer will be created with a duplicate of the figure but no background. The original figure is still visible on the canvas layer. You can then add any number of background images behind the figure. If you want to move the figure to a different part of the canvas you can use the **LAYER ADJUSTER** in the **TOOL-BOX**. See Chapter 5 for more information about the **LAYER ADJUSTER** tool.

Figure 7.1

The **LAYERS PANEL** showing the blank canvas and the figure moved to a new layer with no background.

Lifting a Sketch and Adding a Background

1 Open the file labeled *Marge*.

2 Use the **MAGIC WAND** to select the white background.

3 Use the **ADD TO SELECTION** to also capture the white space in the crook of her arm.

4 **INVERT** the selection then hold the **CTL/CMD** key and click on the selection.

5 Check the **LAYERS CONTROL PANEL** to make sure a new layer was created. Name this layer Figure. The Canvas layer should be empty.

6 In the **LAYERS PANEL**, create a new layer and move it below the Figure layer. Name this layer Background.

7 Select colors for a two-color gradient and use the **PAINT BUCKET** tool to fill the Background layer with a gradient that gets darker toward the bottom. Remember to open the **GRADIENT CONTROL PANEL** and use **EDIT GRADIENT** in the **OPTIONS** menu. See Chapter 3 on Color for more information about editing gradients.

8 **SAVE** your file as a **RIFF**.

Figure 7.2

The completed exercise showing the figure against a gradated background. The **LAYERS PANEL** shows the separation between the figure and the background.

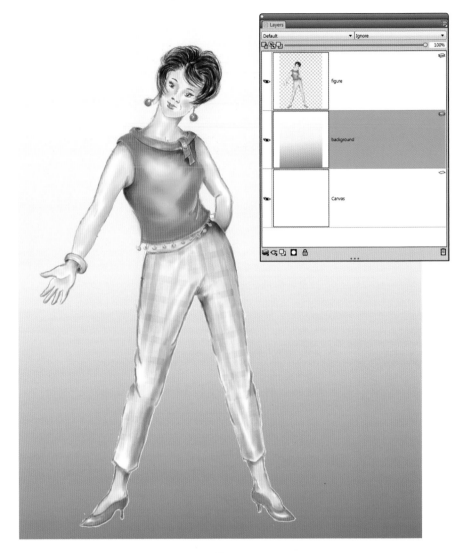

Working with Scenic Images PS

Occasionally you may want to put your figures into an image from another source. For example, it is possible to take a photograph of a scenic designer's model or sketch and place the costumed figure into that environment. It is easier to move the figure and scale it to fit the scenic design than to place an environmental image behind a figure and try to make the image look in scale with the figure. If your scenic designer has made a digital rendering, you need to get a **JPEG** of the rendering and not a three-dimensional file format.

Select the figure just as you did when moving it to a new layer. In this case you would **COPY** (**CTL+C/CMD+C**) the figure then open the new document of the

scenic sketch and **PASTE** (**CTL+V/CMD+V**) the figure into the image. A new layer is created automatically and you can use the **TRANSFORM** tools to scale and move the figure to the desired position. If you want to place a figure behind a piece of furniture, you can either erase the part of the figure that would be hidden or simply select the piece of furniture and **COPY** and **PASTE** it on top of the figure, creating yet another new layer.

EXERCISE 7-B

Adding a Figure to a Scenic Image

1 Open the file labeled *Suds Model* and the original *Marge* file. Make the *Marge* file the active file.

2 Select the figure and use **CTL+C/CMD+C** to **COPY** the selection.

3 Go to the *Suds Model* file and click to make it the active file.

4 Use **CTL+V/CMD+V** to **PASTE** the figure. Check to make sure a new layer has been created. Name this layer Figure 1.

5 Us the **TRANSFORM** tools to **SCALE** the figure to the desired size and **MOVE** the figure in front of the center washing machine. **COMMIT** to the transformation.

6 Open the file named *Dee Dee*.

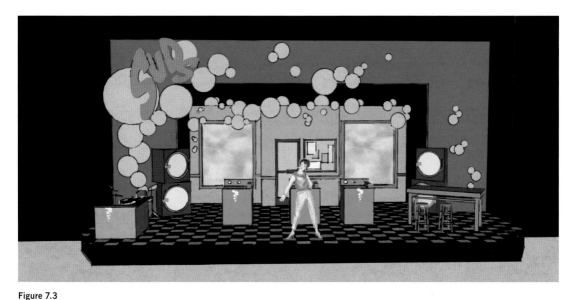

Figure 7.3

The scenic sketch showing the Marge figure inserted in front of the washing machine.

Scenic Design by Casey Kearns.

7 Select and **COPY** the Dee Dee figure into the *Suds* image. There should now be two additional layers. Label Dee Dee's layer Figure 2.

8 **SCALE** and **MOVE** the Dee Dee figure beside and slightly behind the left washing machine.

9 **HIDE** the Figure 2 layer and then click on the Canvas layer to make it active.

10 Use the **RECTANGULAR SELECTION** tool to select the shape of the washing machine that is in front of the figure.

11 Use **COPY > PASTE** to make a duplicate of the washing machine directly on top of the original image.

12 Check that a new layer has been created. Name this layer Left Machine and **MOVE** this layer on top of your Figure 2 layer.

13 **REVEAL** the Figure 2 layer by clicking on the closed eye. The machine should now hide part of Dee Dee's body.

14 **SAVE** your file as a **RIFF**.

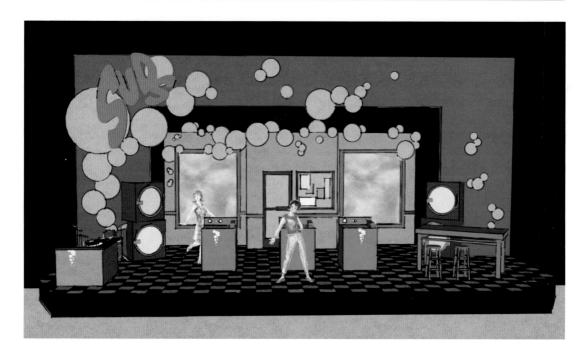

Figure 7.4

The second figure has been added and the left washing machine has been copied and placed on top of that figure.

Changing Canvas Size and Adding Duplicate Figures 🅿️🅢

Most costume renderings are created with a single figure. To demonstrate how costume groupings will work together, it is important to be able to add two or more figures to a single drawing. One technique is to open a new document sized to accommodate a number of figures and **CUT**, **PASTE**, and **SCALE** the figures to create a composition. If, however, you want to add more figures to an existing document, it may be necessary to change the size of the canvas.

File	Edit	Canvas	Layers	Brushes	Select	Shapes

Resize...	Ctrl+Shift+R
Canvas Size...	
Rotate Canvas	▶
Surface Lighting...	
Show Impasto	
Clear Impasto	
Tracing Paper	Ctrl+T
Set Paper Color	
Rulers	▶
Compositions	▶
Symmetry	▶
Guides	▶
Grid	▶
Perspective Grids	▶
Annotations	▶
Color Management Settings...	Ctrl+Alt+K
Assign Profile...	
Convert to Profile...	
Color Proofing Mode	
Color Proofing Settings...	

Resize

Current Size: 13MB

Width: 5.0 Inches
Height: 7.0 Inches
Resolution: 300.0 Pixels per Inch

New Size: 13MB

Width: 5.0 inches ▼
Height: 7.0 inches ▼
Resolution: 300.0 pixels per inch ▼

☐ Constrain File Size

OK Cancel

Figure 7.6

The **RESIZE** dialogue box allows you to adjust the height, width, and resolution in proportion to the image.

Figure 7.5

The **CANVAS** tab menu showing **RESIZE** and **CANVAS SIZE** at the top of the list.

Go to the **CANVAS** tab on the top menu bar. In the drop-down menu you will see **RESIZE** and **CANVAS SIZE**. The **RESIZE** option allows you to change the overall dimension of the canvas, keeping the figure in proportion to the overall space. In the **RESIZE** dialogue box you can also change the resolution of the sketch, which will ultimately alter the size of the canvas, but neither of these functions will give you more space on the canvas to add new figures. Instead, select **CANVAS SIZE**. In the **CANVAS SIZE** dialogue box you can effectively add to the canvas in any direction. The extra space added to the canvas will be the color of the default color of the canvas. If you started with a white canvas, the added area will be white. If you created the file with a colored canvas, the additions will be the same color. If, however, you have added color to the canvas with the **PAINT**

BUCKET, when you change the canvas size the new area will be white. The unit of measurement in the **CANVAS SIZE** dialogue box is in pixels, but with a little practice you will learn how many pixels to add to accommodate a second figure.

Note

This feature is also useful if you find that your swatches are larger than expected and you want more room on the printed page. You can change the size of the canvas and print a new page.

Once you have increased the size of your canvas, you can then duplicate the figure as many times as you want or add figures from other files. The most reliable way to duplicate a figure is to first float the figure onto its own layer so that there is no background and then duplicate the layer. Remember that the new figure will be directly on top of the original figure. Make sure you give each successive layer a new name so that you can use the **LAYER ADJUSTER** tool to move the figures around individually on the page, creating an effective rendering. Groups of figures can look larger and less homogeneous if you alter the characters' poses slightly.

One easy way to do this is to simply flip a figure from left to right. Click on the layer that contains the figure you want to flip then go to the **EDIT** tab and choose the **FLIP HORIZONTAL** function. As described in Exercise 7-B, you can always **COPY** and **PASTE** or use the **LAYER ADJUSTER** to click and drag additional figures from other files to the group document.

EXERCISE 7-C

Changing the Canvas Size and Adding Multiple Figures

1 Open the file named *Blue Coat*. Note that the figure sits close to the top of the page.

2 Go to the **CANVAS** tab on the top menu bar and select **CANVAS SIZE**.

3 Add 200 pixels to the top of the image.

4 The image width is currently 1246 pixels. If you want to add two other figures, you should add at least 1000 pixels to each side. Click **OK**. Your canvas should now be a wide rectangle with the figure centered and plenty of room on either side for additional figures.

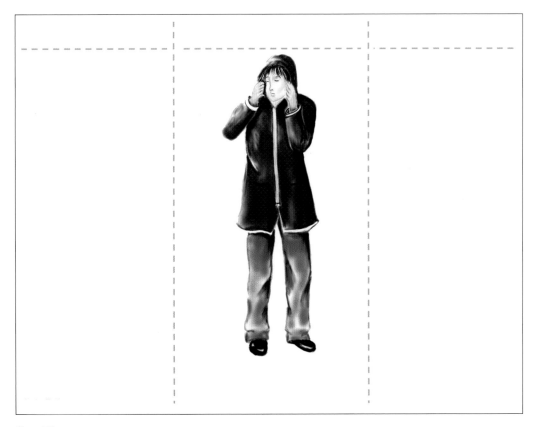

Figure 7.8

The added lines show the 200 pixels added to the top and 1000 pixels added to each side. These dashed lines do not appear when you change the canvas size.

5 Use the **MAGIC WAND** to select the white background then **INVERT SELECTION** to capture only the figure.

6 Hold the **CTL/CMD** key and click in the image to put the figure in its own layer. Name this layer Figure 1.

7 Duplicate this layer. The new figure will be directly on top of the original one.

8 Use the **LAYER ADJUSTER** to move the second figure to the left.

9 In your **LAYERS PANEL**, change the name of this layer to Left Figure.

10 Duplicate the Figure 1 layer again and move this figure to the right of the original. Change the name of the layer to Right Figure.

11 In the **LAYERS PANEL**, **MOVE** the layer labeled Right Figure below the Figure 1 layer. You should now have three figures with the left one in front, the second one in the middle, and the third one in back.

Figure 7.9

Moving the figures so they overlap each other creates a sense of depth in your rendering.

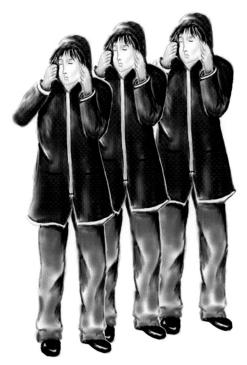

12 Duplicate the Left Figure layer.

13 Go to **EDIT** on the top menu bar and select **FLIP HORIZONTAL**. The figure should now face the other direction.

14 Position the figure slightly behind the Left Figure and change the layer name to Far Left Figure.

15 Open the file named *Blue Coat Back*.

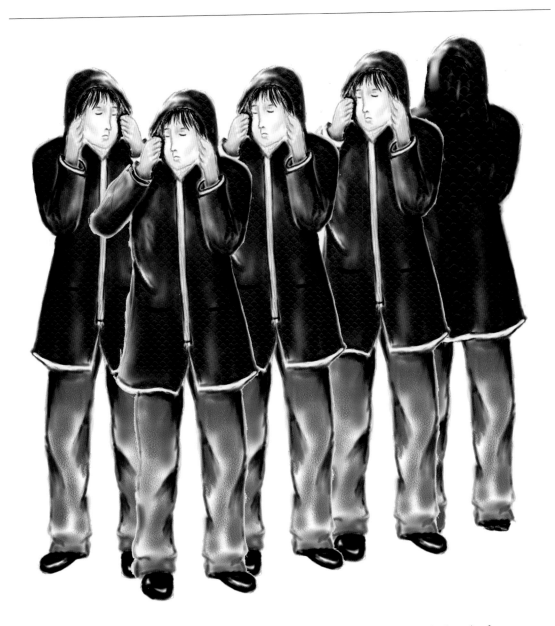

Figure 7.10

The completed exercise showing all five figures in position.

16 Use the **MAGIC WAND** and **INVERT SELECTION** to isolate the figure.

17 Use the **LAYER ADJUSTER** to click and drag the *Blue Coat Back* figure into the group drawing.

18 Move the layer behind the Right Figure layer and position the Back Figure to the far right.

19 **SAVE** your file as a **RIFF**.

Figure 7.11

The **EFFECTS**
drop-down menu.
Note that the top two
menu items can be
different depending
on which were the last
two effects used.

Figure 7.11

The **EFFECTS** drop-down menu. Note that the top two menu items can be different depending on which were the last two effects used.

Special Effects PS

The tab on the top menu bar labeled **EFFECTS** contains many special treatments that you can use to alter the look of the final rendering. The top two items in the drop-down **EFFECTS** menu change to record the last two effects that you have used. Below those are several categories of **EFFECTS**:

- **TONAL CONTROL** is where you can control the brightness and contrast of your image as well as adjusting or correcting colors.

- **SURFACE CONTROL** is where you can add lighting effects or change a photograph to look like a sketched image.

- **FOCUS** is where you can sharpen or blur an image.

- **ESOTERICA** is where you can find **MARBLING**, **MOSIAC TILE**, or other extreme special effects.

- **OBJECTS** is where you will find the **DROP SHADOW** function.

Creating a Drop Shadow PS

Adding a shadow to a figure can give a rendering more depth. Shadows also make a group sketch, such as the one in Exercise 7-C, look more dimensional and help to separate the figures so they stand out from the one behind. When you click on

> **Note**
>
> If you want to add a shadow to a figure, the figure must be in a separate layer. Keep in mind that the **CREATE DROP SHADOW** dialogue box will not open unless something in your drawing has been selected.

Figure 7.12

The **DROP SHADOW** dialogue box.

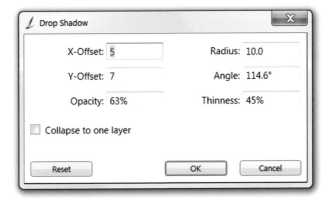

the **CREATE DROP SHADOW** menu item, a dialogue box will open containing many variables to control the location, angle, and opacity of the shadow. The shadow that is created is a full silhouette of the figure sketch.

- **X-OFFSET** determines how far to the side of the figure and the **Y-OFFSET** determines how far below the figure the shadow will extend.

- **OPACITY** controls how dense the shadow will be and how much the shadow will cover up anything that is behind your sketched figure. A lower value creates a shadow that is more transparent.

- **RADIUS** specifies the amount of blur at the edge of the shadow. If you put a zero value in this box you will create a sharp edged shadow.

- **ANGLE** specifies the direction of the blur.

- **THINNESS**, according to the Painter help menu "specifies the amount of blur applied perpendicular to the **ANGLE**". I have yet to find a need to be concerned with either **ANGLE** or **THINNESS** when working with shadows.

Once the shadow is created, it is located in a separate sub-layer that is grouped with the layer that contains the object to which you have applied the shadow. As a separate layer, the shadow can be moved, duplicated, or transformed just like any other layer. If needed, the shadow can be collapsed into the original layer so that both the sketched figure and the shadow move together. You can do that either when you are working in the **DROP SHADOW** dialogue box or by collapsing the grouped layers in the **LAYERS PANEL**.

To manipulate the shadow alone, it is important to go to the **LAYERS PANEL** and click on the arrow to open the grouped layer. Then select the individual layer that contains the shadow. It should automatically be named Shadow. Once the Shadow layer is the active layer, go to the **SELECT** tab and choose **SELECT LAYER CONTENT.** Use the **SKEW** or **DISTORT** function under the **LAYER ADJUSTER** to make the shadow appear as if it is lying on the floor and extending behind the figure. If you want to give the impression that the figure is being

Figure 7.13

The **LAYERS PANEL** showing the Figure layer and the Shadow sub-layer.

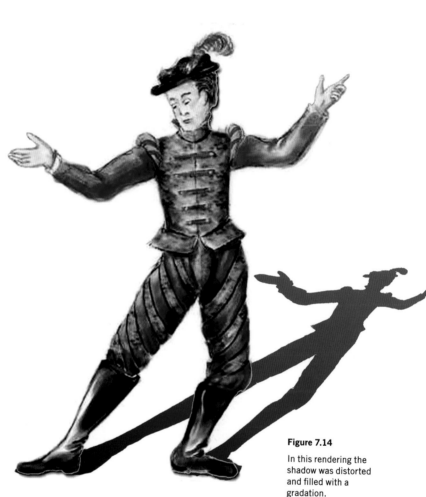

Figure 7.14

In this rendering the shadow was distorted and filled with a gradation.

illuminated with colored stage lighting, you can use the **PAINT BUCKET** tool to fill the shadow with the color of your choice. Another way to make the shadow more effective is to fill it with a gradation that gets lighter as it moves away from the figure. This fill can be added even after the shadow has been skewed into position.

Note

Depending on how the figure was completed, sometimes the Shadow layer will have a ghost outline of the figure or a faint outline of the edge of the entire drawing area. These become more apparent when the shadow is distorted. You can easily erase those extra outlines.

EXERCISE 7-D

Adding a Shadow

1 Open the file labeled *Johnny Angel*, and move the figure to a separate layer. Do not forget about the area between the legs.

2 Select the layer content then go to the **EFFECTS** tab on the top menu bar and choose **OBJECT > CREATE DROP SHADOW.**

3 Set the X and Y radius at 10 and the opacity at 50%. You can use the default settings for the other options, then click **OK**.

4 Go to the **LAYERS PANEL** and check that the Figure layer has been grouped with a Shadow layer.

5 Open the group and click on the Shadow layer to make it active.

6 Select **DISTORT** in the **TRANSFORM** tools and move the shadow so that it looks like it is lying on the floor, extending behind the front foot. **COMMIT** to the transformation.

Figure 7.15

In this image you can see the bounding box as the shadow is distorted.

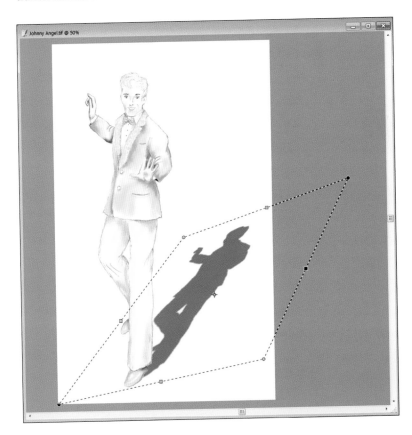

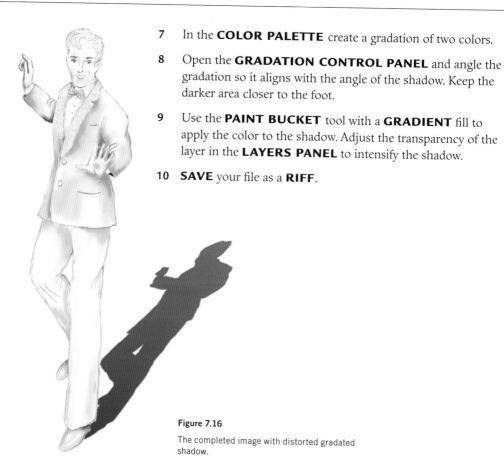

7 In the **COLOR PALETTE** create a gradation of two colors.

8 Open the **GRADATION CONTROL PANEL** and angle the gradation so it aligns with the angle of the shadow. Keep the darker area closer to the foot.

9 Use the **PAINT BUCKET** tool with a **GRADIENT** fill to apply the color to the shadow. Adjust the transparency of the layer in the **LAYERS PANEL** to intensify the shadow.

10 **SAVE** your file as a **RIFF**.

Figure 7.16

The completed image with distorted gradated shadow.

ADVANCED EXERCISE

Create your own chorus: In this production there will be a chorus of Johnny Angels. Use the *Johnny Angel* file to create a rendering in which there are multiple figures, each casting a shadow. Make the shadows fall on the ground behind the figures as well as shadowing the figure behind.

Note

Hold down the **ALT/OPTION** key while using the **LAYER ADJUSTER** tool to quickly copy a layer. This technique will also work on the separate Shadow layer. You can also **UNGROUP** the shadow from the figure.

Figure 7.17

The Johnny Angel chorus complete with multiple shadows.

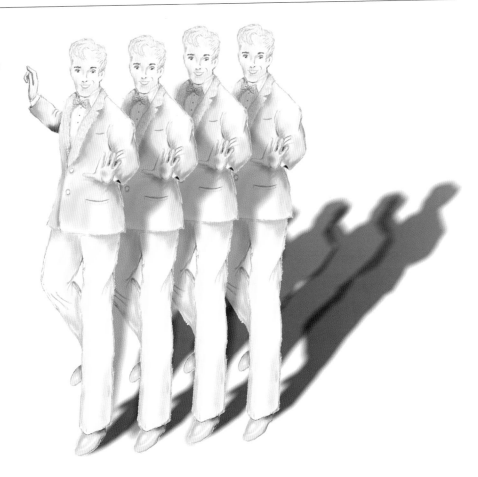

Tonal Control 🅿️

Another function under the **EFFECTS** menu is **TONAL CONTROL**. Here you can change the colors in an image. Imagine that you have a chorus all wearing the same outfit but in different colors. Instead of repainting each one, you can simply change the color on the original image. There are several different menu items under **TONAL CONTROL**. The more extreme techniques are used to apply special effects in an image. You can get very precise color correction using the dialogue box for **CORRECT COLORS**. This box involves adjusting **RGB** curves on a graph. Following are the most useful items under **TONAL CONTROL** for creating a costume rendering.

- **ADJUST COLORS** uses sliders to adjust hue, value, and intensity.

- **ADJUST SELECTED COLORS** affects only a specific range of colors.

- **BRIGHTNESS AND CONTRAST** can make an image lighter or darker or can increase or decrease the contrast between light areas and dark areas.

Figure 7.18

The most useful items in the **TONAL CONTROL** menu are **ADJUST COLORS**, **ADJUST SELECTED COLORS**, and **BRIGHTNESS AND CONTRAST**.

Figure 7.19

The **ADJUST COLORS** dialogue box. Use the sliders to adjust the colors. The results can be seen in the drawing before you commit to the change.

To change the color in a garment, the **ADJUST COLORS** function is the simplest and easiest to use and it can adjust the hue value and intensity of the colors in the whole image, on a particular layer, or in a selection. If you want to change the color of a garment but not affect the skin tone, it is best to have the garment in a separate layer and to select it without including any skin tone. At the top of the **ADJUST COLORS** dialogue box is a list of methods for adjusting the color. Using **UNIFORM COLOR** adjusts all the pixels equally. If you select **IMAGE LUMINANCE**, the pixels are adjusted proportionally as they appear in the image. For example, areas of greater luminance are adjusted more brightly than those with lesser luminance. You can get some interesting but unexpected textural effects by using **PAPER** as the method for adjusting the colors. **ORIGINAL LUMINANCE** uses the **CLONE SOURCE** as the basis for adjusting the colors.

If there is no **CLONE SOURCE**, Painter will use a pattern from the pattern library as a source. Again, you will get unexpected results so I suggest that you stay with either **UNIFORM COLOR** or **IMAGE LUMINANCE** until you fully understand the program. Once you have selected a method, you simply move the individual sliders and observe the changes in the sketch. This is another instance

Figure 7.20

These examples all began with the same sketch (center). Each one used a different method but in all of the examples the Hue was adjusted 50%.

UNIFORM COLOR

IMAGE LUMINANCE

ORIGINAL SKETCH

PAPER–USING ARTIST
CANVAS VARIANT

ORIGINAL LUMINANCE–
THE DEFAULT PATTERN
WAS A LARGE PLAID

where simple experimentation can give you good results. The good thing is that there is also a **RESET** button in the dialogue box.

The **ADJUST SELECTED COLORS** is a bit more complicated. There is a preview window in the dialogue box that opens when you choose this function. You can click in the preview image and pan around to find the specific area in the drawing where you want to see the affect of the change. The first step is to click in your drawing to select the specific color you want to change. Notice that your cursor will automatically change to the **EYEDROPPER** tool. You then can move sliders to determine the **EXTENTS** and **FEATHERING** of the hue, value, and intensity of that color.

When you pick a color to adjust, the computer will look for any instances of that color. For example, if you pick a green as the color you want to adjust, you may find that the yellows in your drawing are also adjusted because green is made up of both yellow and blue. **EXTENTS** refers to the range of colors that will be affected

Figure 7.21

The **ADJUST SELECTED COLORS** dialogue box. After setting the extents and feathering, change the color using the bottom sliders.

by the change. The higher the number, the more variations of the color pixel that you selected will be changed. If the number is lower, you will change only those pixels that are closest in hue to the pixel you selected. The **FEATHERING** function affects the softness at the edge of the selected range of colors. Controlling **FEATHERING** can make for a smoother transition from one color to the next. At the bottom are the sliders for the **HUE SHIFT**, **SATURATION**, and **VALUE**.

This is where you will actually change the color after determining the settings for the **EXTENTS** and **FEATHER**. Something to remember when using the **ADJUST SELECTED COLORS** is that the dialogue box retains the last adjustment. It is important to **RESET** the sliders between operations if you want to make multiple adjustments.

Figure 7.22

The **BRIGHTNESS/CONTRAST** dialogue box. Use the two sliders to intensify the drawing.

After the complexity of **ADJUST SELECTED COLORS**, the **BRIGHTNESS/CONTRAST** is remarkably simple. The dialogue box contains only two sliders. As you move the sliders back and forth, the results can be seen in your image. When the image is to your satisfaction, simply click **APPLY**.

EXERCISE 7-E

Adjusting Colors

Figure 7.23

The original colors in the *Dee Dee* file.

1 Open the file labeled *Dee Dee.*

2 Use the **LASSO** tool to select just the dress. Make sure you do not include any of the skin tones on the neck or arms.

3 **COPY** and **PASTE** the dress into a second layer. Label it Dress 2.

4 Go to the **EFFECTS > TONAL CONTROL > ADJUST COLORS**.

5 Using the **UNIFORM COLOR** method, move the **HUE** slider to see the effect.

6 **RESET** the controls and this time use **IMAGE LUMINANCE** as the method and compare the changes to those made by shifting the **HUE** slider.

7 **RESET** the controls and **CANCEL** the **ADJUST COLORS** operation.

8 Go to **EFFECTS > TONAL CONTROL > ADJUST SELECTED COLORS**.

9 Click in the sketch on the green background of the pattern in the dress.

10 Using the **UNIFORM COLOR** method, move the **HUE SLIDER** at the bottom and view the results in the preview window. Notice the yellow leaves are also changing color.

11 Go to the **HUE** sliders at the top and adjust **H EXTENTS** down to 8%.

12 Now move the **HUE** slider at the bottom and note the color change in the preview window. Make the background color a bright turquoise and click **OK**.

13 Reopen the **ADJUST SELECTED COLORS** dialogue box. Notice that the preview window contains your last color adjustment.

14 Click **RESET** to bring the slider controls back to their default settings.

15 Click in the image and select one of the yellow leaves.

Figure 7.24

Adjust the **EXTENTS** and use **HUE** and **VALUE** sliders to create *Dee Dee Blue*.

16 Adjust **H EXTENTS** down to 8%.

17 Move the **HUE** and **VALUE** sliders to create a pale green color in all the yellow areas.

18 Click **OK**.

19 Do a **SAVE AS** and save your file as a **RIFF** with the name *Dee Dee Blue* but do not close the file.

20 Duplicate the Dress 2 layer and continue to explore **HUE**, **VALUE**, and **SATURATION** settings to develop an entirely new look for the dress in which all the original colors have been changed to something different. Label this layer Dress 3.

21 Go back to the canvas layer and make another copy of the original dress. Label this layer Dress 4.

22 While in the Dress 4 layer, go to **EFFECTS > TONAL CONTROL > BRIGHTNESS AND CONTRAST** and use the sliders to make the entire dress a pale version of the original.

23 **SAVE** your file as a **RIFF**.

Adding Lighting Effects 🅿️

Most of the other techniques under the **EFFECTS** tab are fun to play with and explore, particularly if you are trying to design an original fabric or an unusual texture to use as a background. Once you have gained some confidence with Painter, you can take the time to investigate these techniques and really develop an understanding of their purposes. The online Painter help menu is a very valuable resource for learning about special effects and how they work. For costume renderings, however, one technique that I have found to be of value is the **LIGHTING** function.

LIGHTING effects can be applied to the whole canvas or just one layer. If you apply the effect to the canvas but have the figure in several layers above the canvas, the figure looks pasted-on and does not show the effects of the light shining on it. If you apply the effects to just one layer, only the part of the drawing that is in that layer will show the effects of the lighting. If you create a new layer and apply the lighting effects in that empty layer, no change will be seen because there is nothing in the layer to reflect the light. For this reason it is a good idea to **DROP** the layers in your drawing to the Canvas layer so that the entire image is merged.

Figure 7.25

The **EFFECTS** menu, > **SURFACE CONTROL**
> **APPLY LIGHTING**.

LIGHTING effects are under **EFFECTS > SURFACE CONTROL > APPLY LIGHTING**. The new dialogue box that opens contains a library of preset **LIGHTING** effects to get you started; use the scroll bar below the samples to see the full range. A thumbnail view of your sketch previews how a particular **LIGHTING** effect will look in your drawing. The lights are indicated in the preview image by a small icon consisting of two circles connected with a bar. The small circle is the position of the light and the larger circle shows the direction in which the light is shinning. Click and drag on the small circle and you can rotate the light to point in a new direction. Click and drag on the large circle and you can reposition the light anywhere on the drawing. The preview window is a bit sensitive. If you click anywhere in the preview window, you will add another light. To delete an unwanted light, simply click on the lighting symbol and hit the **DELETE** key.

Figure 7.26

In the thumbnail view of the **APPLY LIGHTING** dialogue box, the lights are symbolized with a large and small circle connected by a bar.

Sliders control the following properties of the lights.

- **BRIGHTNESS**. The farther to the left the brighter the light looks.

- **DISTANCE** moves the light closer or farther from the image. You can compensate for the brightness of a light that is very close to the image by adjusting the **EXPOSURE**.

- **ELEVATION**. Think of this as the angle of the light in relation to the canvas. At 90° the light is coming virtually straight down. At 1° the light is shining horizontal to the surface of the canvas.

- **SPREAD** determines the size of the cone of light.

- **EXPOSURE** is a function related to photography that controls the brightness or darkness of the image.

- **AMBIENT** refers to the overall light on the image. If you have not selected an individual light, the whole image will change when you move this slider.

Figure 7.27

To change the color of a light, click on the color swatch in the **APPLY LIGHTING** dialogue box and open the **COLOR DIALOGUE BOX**.

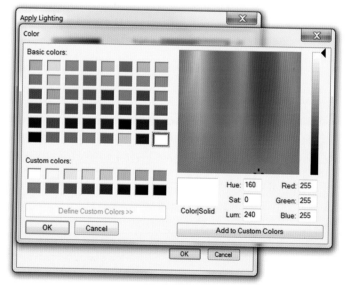

To change the color of a light, simply select the symbol of the light you want to change in the preview window. Click on the color swatch to open the **COLOR DIALOGUE BOX** and select your new color. Note that **AMBIENT** light has its own color control sample but the **COLOR DIALOGUE BOXES** are the same. Lighting effects can dramatically enhance a rendering and evoke the mood of the play if you keep them simple. I strongly suggest starting with the preset lighting effects using just one light before spending too much time trying to craft an elaborate effect of your own.

EXERCISE 7-F

Applying Lighting Effects

Figure 7.28

The resulting lighting effect gives this rendering a sense of the mood of the play.

1 Open the file labeled *Terry*. Note the direction of the shadow in the sketch.

2 Go to **EFFECTS > SURFACE CONTROL > APPLY LIGHTING**.

3 Scroll through the preset lighting options to find **SIDE LIGHTING**.

4 Click on the large circle of the lighting icon in the preview window and move the light to the upper-right corner.

5 Click on the small circle of the lighting icon and rotate the light so it is shining on the figure.

6 Adjust the **BRIGHTNESS**, **DISTANCE**, **ELEVATION**, and **SPREAD** so that the entire figure is illuminated.

7 Change the **COLOR** of the light to a very pale blue. Make the **AMBIENT LIGHT** a pale pink.

8 Check the results in the preview window. If you are satisfied, click **OK**.

9 **SAVE** your file as a **RIFF**.

Adding Text 🄿🅂

Usually the finishing touch to a rendering is to add a title, character names, and sometimes construction notes. Digital media can give you titles that capture the aesthetic of your rendering, names that are clear and accurate, and the ability to add extensive notes, sizing them to frame the rendering. The **TEXT** tool in the **TOOLBOX** is identified by a giant **T**. Click on this icon and then click in the document window and the cursor will change to a blue bounding box indicating the size of the text. You then simply type what you want the text to say. Note in the **LAYERS PANEL** that text is created in a separate Text layer.

The Text layer has special attributes that allow you to continue editing the text in many ways, but it inhibits some of the tools that are used for image layers. For example, you can move the text around by using the **LAYER ADJUSTER** tool but if you want to manipulate the layer using **TRANSFORM** tools, you must first commit to an image layer, an action that will make you lose the ability to edit the text. In a Text layer, some of the **TRANSFORM** functions can be performed with just the **LAYER ADJUSTER** tool. Clicking and dragging will **MOVE** the text and dragging a corner handle on the bounding box will **SCALE**, but to **ROTATE** or **SKEW** you have to hold down the **CTL/CMD** key while dragging a corner handle.

You can control the **FONT**, **SIZE**, **ALIGNMENT**, and **COLOR** as well as adding a **SHADOW** to the letters on the **PROPERTY BAR**. The drop-down

Figure 7.29

The **TEXT** tool is in the center of the tool bar.

FONT menu is similar to the ones you see in word documents as are the **ALIGNMENT** icons for centering the text to the right, left, or center. The sliding scale adjusts the **SIZE** of the letters, but be careful because it is very sensitive and even a small adjustment can make a big difference. The **COLOR** icon will open a swatch list of colors that you can scroll through or you can always select your color from the **COLOR WHEEL**. All the words you type in one text layer will be the same color. If you want individual words or letters to be different colors, you must commit the layer to an Image layer then fill the letters using the **PAINT BUCKET**. Additional tools are located in the **TEXT PANEL**.

Figure 7.30

The **PROPERTY BAR** showing the properties of **TEXT**.

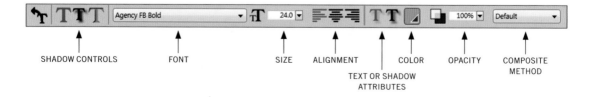

SHADOW CONTROLS FONT SIZE ALIGNMENT COLOR OPACITY COMPOSITE METHOD

TEXT OR SHADOW ATTRIBUTES

EXERCISE 7-G

Adding Text

1 Open a new file that is 5 × 7 inches.

2 Select the **TEXT** tool from the **TOOLBOX** and click in the document window to determine the size of your text.

3 Adjust the size, change the font, and choose a color then type a few sample words.

4 Check the **LAYERS PANEL** to see how the new layer was created.

5 Go to the **COLOR PALETTE** and change the text color there.

6 Go back to the Canvas layer and click anywhere in the document to write a new line of text.

7 Pick up the **BRUSH** tool and try to draw a line under your second line of text.

8 When the **COMMIT TO IMAGE** box opens, just select **CANCEL**.

Figure 7.31

This warning box will open if you try to use drawing tools in a specialized Text layer.

9 Draw the line on the Canvas layer.

10 Go back to the layer containing your first line of text. Notice that you need to reselect the **TEXT** tool to open the **PROPERTY BAR** with the text controls.

11 Change the Font.

12 **SAVE** your file as a **RIFF**.

The Text Panel (PS)

Open the **TEXT PANEL** under the **WINDOWS** tab. The **TEXT PANEL** contains all the options for changing the font and size, aligning the text, and adding a shadow that are also located in the **PROPERTY BAR**. In addition, there are sliders to give you greater refinement for spacing letters as well as tools for aligning the text to a curve. At the bottom of the **TEXT PANEL** are controls for adjusting the appearance of the shadows and the text.

Figure 7.32

The **TEXT PANEL** has the same functions as the **PROPERTY BAR** but offers more refinement for spacing and aligning the text.

Adjusting Shadows and Composite Methods

Here again, because of the special properties of a Text layer, it is possible to **SELECT LAYER CONTENT**, but the **ADD DROP SHADOW** function under the **EFFECTS** menu is disabled. To add a shadow to text you can use either the **PROPERTY BAR** or one of the three buttons at the top of the **TEXT PANEL**. The first button is **NO SHADOW**; the second is **EXTERNAL SHADOW**, which places the shadow slightly offset behind each letter; the third button is **INTERNAL SHADOW,** which places the shadow inside the outline of the letter. According to Painter's help menu, this function is designed to look like a cut-out letter that is casting a shadow on a background of the same color as the letter. This is easiest to see when you move the shadow independently.

Figure 7.33

The Scottish Play has an **EXTERNAL SHADOW** that has been moved above and to the right of the letters. Midsummer has an **INTERNAL SHADOW**. When the shadow is moved it acts like a black cut-out hovering over the colored letters on the back-ground.

The Scottish Play

Midsummer

After applying shadows to text, they do not exist as a separate layer as in an Image layer but instead are incorporated into the Text layer. You can move the shadow independently, however, by using the **LAYER ADJUSTER** tool and zooming in close to the text to make sure that you select just the shadow. Unfortunately, you cannot use this method to **ROTATE**, **SCALE**, or **SKEW** the shadow alone. To do that you would have to convert the Text layer to the default Image layer and you would lose the ability to edit the text. The important point is to make sure the content of your text is accurate before adding decorative effects.

The shadows are opaque and hard-edged unless you adjust the **OPACITY** and the **BLUR**. The two T's in the center of the **TEXT PANEL** determine if you are going to make adjustments to either the text or the shadow. Here you can also adjust the **COMPOSITE METHOD** from a drop-down menu or control the degree of transparency and blurring using sliders.

Kerning and Leading

Two important terms to learn when dealing with text are **KERNING** and **LEADING**. **KERNING** refers to the space between the letters. Painter adjusts the space equally across the text. You can make it wider or narrower by moving the **KERNING** slider in the **TEXT PANEL.** What you cannot do is to alter just one space between two letters without changing the space between the other letters.

Note

Although you can change text into individual shapes and alter each letter separately, that is tedious and time consuming. For that degree of sophisticated editing I usually create the text in a program such as Illustrator. Once the Illustrator document is saved as a **JPEG** the text can be pasted into a Painter document as a new layer. The text in this layer cannot be manipulated with the **TEXT PANEL** but you can still **MOVE, SCALE, ROTATE, SKEW,** and **DISTORT** the entire layer.

LEADING refers to the space between lines of text. Here again the **LEADING** slider in the **TEXT PANEL** adjusts those spaces equally among the lines of text. You cannot change the space between just two lines and not affect other lines in the same Text layer. The way to work around this is to type individual parts of your text in separate Text layers. Then you move the individual layers to achieve the variety of **LEADING** that you want.

EXERCISE 7-H

Adding Text with a Shadow

Figure 7.34

The letters in the title were degraded using the **DISSOLVE COMPOSITE METHOD**. The text shadow was blurred in the **TEXT PANEL**.

1 Open the file named *Arlequino*.

2 Click on the **TEXT** tool in the **TOOLBOX** then click in drawing where you want the title to be.

3 Use the slider on the **PROPERTY BAR** to determine a font and an approximate size for the text and a color then type "Love and War," adding a **RETURN** between each word so that you have three lines of text.

4 Open the **TEXT PANEL** and align the text in the center.

5 Use the **KERNING** and **LEADING** sliders to adjust the spaces in the text

6 In the **TEXT PANEL** click on the center **T** icon at the top of the **TEXT PANEL** to give the text an external shadow. Then click on the second **T** in the middle of the panel to select **SHADOW ATTRIBUTES**.

7 Move the **BLUR** slider to soften the shadow.

8 Next, click on the first **T**, **TEXT ATTRIBUTES** in the center of the panel and change the **COMPOSITE METHOD** to **DISSOLVE**. Move the opacity slider to the left to see the different degrees of dissolve.

9 **SAVE** your file as a **RIFF**.

Aligning Text to a Curve

You cannot draw a freestyle curve with one of the traditional drawing tools and then expect the text to automatically align to that curve. The data in a Text layer is simply different from the data in the Image layer where you drew the curve. Instead there are tools that you can use to give the appearance that the text is aligned with a freehand curve.

Once the text has been created, click on one of the **CURVE STYLE** icons in the center of the **TEXT PANEL**. You have a choice of several icons.

- **CURVE FLAT** reverts the text back to a straight line.

- **CURVE RIBBON** keeps all the letters upright.

- **CURVE PERPENDICULAR** keeps the letters perpendicular to the line. It may cause some letters to squish together at the bottom or top depending on the direction of the curve.

- **CURVE STRETCH** changes the shape of the letters to compensate for the spaces that are created as the letters align over sharper curves.

CURVE RIBBON

CURVE PERPENDICULAR

CURVE STRETCH

Figure 7.36

The **SHAPE SELECTOR** tool is used to manipulate **BEZIER** lines in a Painter document.

You can change the **CURVE STYLE** at any time while working with text. The sliding scale below the **CURVE STYLE** buttons moves the center point of the text and changes how the letters flow along the curve. This option works best when the text is aligned in the center using the **ALIGNMENT** buttons at the top of the **TEXT PANEL**. You will see the curve represented as a blue line. This is called a **BEZIER** line and it consists of segments between anchor points. The **BEZIER** line can be reshaped by using the **SHAPE SELECTION** tool, a white arrow-shaped icon immediately below the **TEXT** tool in the **TOOLBOX**. The text will remain conformed to whatever shape you make the **BEZIER** line. Select the **SHAPE SELECTION** arrow and click on the endpoint of the **BEZIER** line.

You can drag that point to flatten out the curve or make it more extreme. You may also notice that when you click on the endpoint that an extra line, or **HANDLE**,

Figure 7.37

A **BEZIER** line with a
handle.

appears off that endpoint. If you use the **SHAPE SELECTION** arrow and click on
the end of the **HANDLE**, you can make one segment of the **BEZIER** line change
direction. The length of the **HANDLE** as well as the degree in which you rotate it
can affect how the **BEZIER** line changes.

Figure 7.38

Under the **SHAPE
SELECTION** tool is the
SCISSORS, **ADD POINT**,
REMOVE POINT, and
CONVERT POINT. The
SCISSORS can be used
to cut a **BEZIER** line.

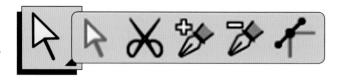

There are other tools hidden under the **SHAPE SELECTION** arrow that affect
how **BEZIER** lines can be manipulated. Probably the most useful when working
with text are the **ADD POINT** and **REMOVE POINT**. As you are manipulating
the curve, you may find that you want to make the line bend at a specific point.
Simply click on the **ADD POINT** icon and place a point on the **BEZIER** line
where you want it. You may have to zoom in close to make sure you are clicking on
the **BEZIER** line and to see that point's **HANDLES**. If you do not have experience
using **BEZIER** lines you may find this process a little awkward at first. Once the
curve is defined to your liking, use the slider in the **TEXT PANEL** to move the
text along the new curve to re-center it if necessary.

ROTATING text that is aligned to a curve seems to cause problems. If you know
the text will not be changed, you can convert the Text layer to an Image layer and
then use the **TRANSFORM** tools to do the final rotating and scaling. You do this
in the **LAYERS PANEL** by **RIGHT CLICK** (**CMD+CLICK**) on the Text layer and
selecting **CONVERT TO DEFAULT LAYER**.

Curving Text

Figure 7.39

The word on the banner was shaped to conform to the curve of the banner by using the curve methods in the **TEXT PANEL** and altering the **BEZIER** line using the **SHAPE SELECTION** tool.

1 Go back to the *Arlechino* drawing.

2 Select the **TEXT** tool and click in the empty space below the banner and type the word "Intermission."

3 If you want to change any of the text attributes such as font, size, or color, do that now either on the **PROPERTY BAR** or in the **TEXT PANEL**.

4 Use the **LAYER ADJUSTER** to move the text so it is centered on the banner. Do not **ROTATE** it.

5 In the **TEXT PANEL**, select **CURVE PERPENDICULAR** as the curve style. If your text is not centered on the curve, use the **PROPERTY BAR** to align the text in the center.

6 Go to the **SHAPE SELECTION** tool in the **TOOLBOX** and click on the end point of the **BEZIER** line. Pull the left endpoint down and the right endpoint up to begin to conform to the shape of the banner.

7 Use the right endpoint **HANDLE** to change the direction of the last half of the curve. Keep moving the **CENTERING** slider in the **TEXT PANEL** to see different effects on the text.

8 If necessary, use the **ADD POINT** tool to add another place where you might need to refine the **BEZIER** line.

9 **SAVE** your file as a **RIFF**.

Photoshop Notes

Adding Backgrounds

As explained in Chapter 4, the **LAYERS PANEL** in both Photoshop and Painter function almost identically. The process for dropping layers to the Canvas or Background layer remains the same. In addition, the selection tools for both programs also function in the same way. Under the **SELECT** tab in Photoshop there is a command for **INVERSE**, which is the same as **INVERT SELECTION**. One thing that sets Photoshop apart, however, is the ability to unlock the background layer and use **DUPLICATE**, **MOVE**, **GROUP** or any of the other layer commands. This eliminates the need to lift the sketch off the background in order to insert an image behind the figure.

Photoshop does not automatically create a new layer when a selection is moved, so it is necessary to create a new layer first, then **CUT** and **PASTE** the selection into the new layer. The **PASTE** may place the selection in the center of the image instead of directly back into the position from where it was cut. Also keep in mind that Photoshop works with a **FOREGROUND** color and a **BACKGROUND** color. These are the two swatches at the bottom of the **TOOLS PANEL** and in the **COLOR PANEL**. When a figure is **CUT** from the **BACKGROUND** or Basic layer, the **BACKGROUND** color will be revealed if it is different than what is chosen as the **FOREGROUND COLOR**. Complete Exercise 7-A by cutting and placing the figure into a new layer, leaving the background layer blank.

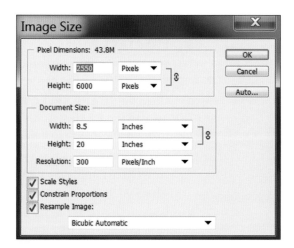

Figure 7.40

Use the **IMAGE SIZE** dialogue box to change the overall file size.

Working with Scenic Images

As mentioned in Chapter 5, the default setting for opening two different files in Photoshop is to stack the documents on top of each other. Review the process in Chapter 5 Photoshop notes for moving between two documents. Complete Exercise 7-B using the click and drag method and the **TRANSFORM** tools to **COPY** and **PASTE** figures into the scenic environment.

Changing Canvas Size and Adding Duplicate Figures

The **IMAGE** tab in Photoshop contains many of the same commands as the **CANVAS** tab in Painter. The dialogue box for the command **IMAGE SIZE** modifies the image file size proportionally in pixels or inches but does not add any extra space around the figure. To increase the size of the canvas while keeping the figure the same size select **CANVAS SIZE**. You can change the height or the width separately using pixels, inches, or other units of measurements. Adding to the **CANVAS SIZE** adds space around the figure; decreasing the **CANVAS SIZE** cuts into the image. Instead of picking from a menu to determine in which direction to add to the canvas, there is a grid with arrows in the dialogue box where you can set the anchor point. For example, if you want to add space to the right side of the image, click on the arrow in the center left grid section then change the width dimension. The added width is anchored to the left side and thus extends beyond the right edge. If the center dot in the grid is selected, the added space will be distributed evenly in all directions. You can choose whether or not to fill the added

Figure 7.41

The **CANVAS SIZE** dialogue can be used to add space around a figure within the overall drawing.

Figure 7.42

Clicking on the left arrow shows that space will be added to the right side of the drawing.

space with the **BACKGOUND** color, **FOREGROUND** color, or a custom color.
COPYING and **PASTING** the figure will automatically create a new layer.
The commands for **FLIP HORIZONTAL** and **FLIP** vertical are located under
the **EDIT > TRANSFORM**. Complete Exercise 7-C.

Special Effects

There are two places to look for the procedures that will be discussed in the next
section. For adjusting the image color and contrast, go to the **IMAGE** tab and
select **ADJUSTMENTS**. There you can open dialogue boxes for **BRIGHTNESS/
CONTRAST, HUE/SATURATION, COLOR BALANCE** and so forth.
More extreme special effects can be found under the **FILTER** tab where you will
find **BLUR** and **SHARPEN** as well as several other distortion or textural effects.

Creating a Shadow

Photoshop makes adding a shadow very easy. At the top of the **LAYERS PANEL** is
a series of icons that will create **ADJUSTMENT LAYERS**. These layers are
designed to apply some standardized photographic techniques to an image without
actually changing the image itself. One of these icons is labeled **BASIC DROP
SHADOW**. As in Painter, you must first isolate the figure into a single layer, then
click the **BASIC DROP SHADOW** adjustment layer button. Under the layer
name you will see a sub-layer with the drop shadow listed as an effect.

If you want to manipulate the shadow separately from the image, you need to
break the Shadow layer out of the Image layer as a separate object. Go to
IMAGE > LAYER STYLE > CREATE LAYERS. The shadow will now appear as
a separate layer in the **LAYERS PANEL** but will be linked to the image layer so
both the image and the shadow can still be moved together. Click on the **CHAIN
LINK** icon to link or unlink the two layers.

Once the shadow has been separated from the image you can open the **DROP
SHADOW CONTROLS** dialogue box by double-clicking on the **SHADOW
LAYER** icon in the **LAYERS PANEL**. In the **LAYER STYLE** dialogue box,
make sure **DROP SHADOW** is checked on the menu at the left. The default
BLENDING MODE is **MULTIPY**. Below that menu box is a slider for adjusting
the opacity as well as a rotating dial to control the angle of the shadow. Further
refinements can be made to **DISTANCE, SPREAD**, and **SIZE**; there is also
a box in which to change **COLOR**. Use **ADJUSTMENT LAYERS** and the
TRANSFORM tools to distort the shadow to complete Exercise 7-D. Use the
LAYERS STYLE dialogue box to change the color or quality of the shadow.

Figure 7.43

Double clicking on the Shadow layer opens the **LAYER STYLE** dialogue box. **DROP SHADOW** is checked in the menu at the left and the angle and quality of the shadow can be adjusted in the center panels.

Tonal Control

Go to the **IMAGE** tab and select **ADJUSTMENTS** to see the various ways to control color adjustments and the tone in an image. In addition to **BRIGHTNESS** and **CONTRAST**, the most useful dialogue box for adjusting existing colors in a rendering is the **HUE/SATURATION** command. You can make a selection in the image using the **MAGIC WAND** to choose a particular color to adjust. The **HUE/SATURATION** dialogue box has three sliders to adjust **HUE**, **SATURATION**, or **LIGHTNESS** (**VALUE**). In addition, there is a drop-down menu to narrow the range of colors adjusted. The default setting is **MASTER** to adjust the entire spectrum of colors. In the menu you can also select to adjust only

Figure 7.44

The **HUE/SATURA-TION** dialogue box is opened in **ADJUST-MENTS** under the **IMAGE** tab.

reds or blues, etc. This sometimes eliminates the need to select the color areas ahead of time. For example, if you have a figure wearing a blue dress and you select to adjust only blue hues, the skin tones on the figure will not change.

There is also a drop-down menu of preset color adjustments based on common photographic enhancements. Some exploration of those presets might provide interesting and quick techniques, but for more accurate control it is best to adjust the sliders to your satisfaction. Complete Exercise 7-E using the **HUE/SATURATION** dialogue box as well as the **BRIGHTNESS/CONTRAST** option.

Adding Lighting Effects

In the Painter instructions it was suggested that the lighting effects be added to the layer that contained the figure. In Photoshop, if you want to be able to go back and adjust the lighting effects at a later time, it is best to put the effects onto a separate layer. The easiest way is to duplicate the layer to which you want to add the lighting effects. Remember that if you have dropped your figure to the Background layer, simply **UNLOCK** the Background layer and **DUPLICATE** it by clicking on the **OPTIONS BUTTON** in the top right corner of the **LAYERS PANEL**. To keep the lighting controls active, you must then convert this new duplicate layer to a **SMART OBJECT**. **RIGHT CLICK** (**CMD+CLICK**) on the layer's name in the **LAYERS PANEL** and choose **CONVERT TO SMART OBJECT** from the menu.

LIGHTING EFFECTS are located under the **FILTER** tab **> RENDER**. Clicking on **LIGHTING EFFECTS** will open the image in a full-screen dialogue box where you can explore various effects before committing them to the image. The **LIGHTING PANEL** on the right contains the controls for adjusting the light. At the top is a drop-down menu for choosing the type of light.

- **POINT** refers to a light that shines in all directions such as a hanging bulb. You can control spread or intensity but not direction.

- **SPOT** is the most versatile light because you can control the direction, angle, and the spread of both the beam and hotspot.

- **INFINITE** emulates light from a distant source. You can change the intensity and color but cannot change the location or direction

Below the **TYPE OF LIGHT** menu there are sliders for adjusting the **COLOR**, **INTENSITY**, and **HOTSPOT** if a spotlight is chosen. Below that are additional sliders for **GLOSS** and **METALLIC**, which will adjust the amount of reflection off the image. For most costume design applications you would use the **COLOR**, **INTENSITY**, and **HOTSPOT** controls rather than reflected light. As you move the sliders, a preview of the final result actively appears in the document window.

Figure 7.45

The **LIGHTING EFFECTS PANEL** allows you to choose the type of light and adjust the color and intensity, as well as reflective properties.

DROP-DOWN MENU FOR CHOOSING THE TYPE OF LIGHT →

Figure 7.46

The preview window for lighting effects showing the circular controls for adjusting the **LOCATION**, **SPREAD**, **DIRECTION** and **ANGLE** of an individual light.

The **LOCATION**, **SPREAD**, and **DIRECTION** of the light is controlled directly in the document window by moving the center circle to relocate the light and grabbing one of the handles on the outer ring to change the directional angle or the spread of the beam if a **SPOTLIGHT** has been selected. On the **OPTIONS BAR** is a drop-down menu of **PRESET** lighting effects similar to those described in Painter.

Simply click on one of those options to see the results in the document window. As in Painter, many of these can provide a starting point for creating a dramatic lighting effect. To add a new light to the image, select one of the types of light icons on the **OPTIONS BAR**. The new light will be added to the list on the right. Just like layers, the lights can be given individualized names. Each light's properties can be controlled individually. When you have achieved a satisfactory look for your

image, click **OK** on the top right of the **OPTIONS BAR** The image will go back to the standard workspace view with the lighting effects applied. In the **LAYERS PANEL** you will see a sub-layer with **LIGHTING EFFECTS** listed. Double click on the **LIGHTING EFFECTS** layer to reopen the **LIGHTING CONTROL PANEL**. Complete Exercise 7-F. In addition to exploring some of the **PRESET** effects, make sure you add at least one **SPOTLIGHT** and adjust its controls to customize the overall look of your rendering.

Adding Text

The **TYPE** tool in the **TOOLS PANEL** looks the same as in Painter and functions in much the same way. Simply select the tool, click on an insertion point in the image, and begin typing. One major difference, however, is that Photoshop gives you options for choosing horizontal or vertical alignment and it also provides the ability to create a paragraph within a defined area.

Figure 7.47

Under the **TEXT** tool on the in the **DRAWING TOOLS** section of the **TOOL PANEL**, you can choose horizontal or vertical alignment.

As in Painter, a new Text layer will automatically be created when new text is added. Click on the specific text layer and reselect the **TEXT** tool to edit a line of text that has been previously created. Be careful—even if a specific text layer is actively selected, if you click anywhere else in the image while the **TEXT** tool is loaded, a new Text layer will appear so that you can start a new line of type. To edit a specific line of type you must place your cursor directly on the text. On the **OPTIONS** BAR you will find the same controls for **FONT**, **SIZE**, **COLOR**, and **ALIGNMENT**. The **MOVE** tool as well as some of the **TRANSFORM** tools under the **EDIT** tab will manipulate text just as in Painter. Complete Exercise 7- G using these common controls.

The Text Panel

There is a **TYPE** tab on the top menu bar. Click on **PANELS** and choose either **CHARACTER** or **PARAGRAPH** to open the **TEXT PANELS**. These panels are virtually identical to those in Painter. The major difference is that there is not a **COMPOSITE METHOD** menu but there are icons for selecting **ALL CAPS**, **ITALICS**, **UNDERLINE**, as well as **SUPER** and **SUBSCRIPTS** in the **CHARACTER PANEL**. There is no special method for applying a **DROP SHADOW** to text. Click on the **DROP SHADOW** icon in the **ADJUSTMENT**

Figure 7.48

The **CHARACTER PANEL** is opened from the **TYPE** tab on the top menu bar.

KERNING

TYPE STYLES

LEADING

TRACKING

LAYER PANEL and use the procedures described earlier in this chapter for creating **DROP SHADOWS** to text.

Kerning and Leading

There are a few more refinements that can be done to the **KERNING** and **LEADING** of the letters in the Photoshop **CHARACTER PANEL**. You can adjust the **KERNING** between just two letters, or if multiple letters are selected, the **TRACKING** button is highlighted to spread the adjustment out among all the letters selected. There are also sliding scales to adjust the height and width of just one letter at a time or all the text. Complete Exercise 7-H using the options in the **DROP SHADOW** dialogue box as well as the **CHARACTER PANEL**.

Figure 7.49

Under the **PEN TOOL** at the top of the **DRAWING TOOLS** section on the **TOOL PANEL** are located the icons for adding, deleting, or converting points on a **BEZIER** line.

Aligning Text to a Curve

Photoshop does not have the **CURVE STYLE** icons in the **CHARACTER PANEL**. If you want the text to conform to a curve, you must first create a **PATH**, which is like a **BEZIER** line. Select the **PEN** tool from the **TOOLS PANEL** to make a segmented line between two points or choose the **FREEFORM PEN**

tool to make a curved line. This tool can make either a line or a shape. If you are simply creating a guide on which to align text, it is important to adjust some of the options for the **PEN** tools on the **OPTIONS BAR**.

Figure 7.50

The **OPTIONS BAR** showing the adjustments for the **PEN** tool.

First there are two boxes for selecting the color of the **STROKE** and **FILL**. When each is open, there is an icon with a red line across it indicating no color. Make sure the **FILL** option has **NO COLOR**. This will keep your line from creating a shape with a fill. If you add **NO COLOR** to the **STROKE**, your line will be invisible unless its layer is highlighted. You can also change the width of the line that you draw.

Once you draw your guideline, a new layer will appear labeled Shape 1. Select the **TEXT** tool then zoom in to make sure you click on the **PATH** that you have created. Your cursor should change to an | with a curved line across it. That indicates that you have selected a **PATH** on which to type. As you type, the words will align themselves to the **PATH**.

Figure 7.51

The cursor changes when you click on a **PATH** in order to align text.

Below the **TEXT** tool in the **TOOLS PANEL** are the **DIRECT SELECTION** tool and the **PATH SELECTION** tool. Use either the **DIRECT SELECTION** tool or the **PATH SELECTION** tool and click on the text. A vertical line should appear and by moving this indicator to the left or right, you can slide the text along the line to reposition it. When you click on the **PATH** with the **DIRECT SELECTION** tool you can move the entire **PATH** to a new location. To change the curve of the path, choose the **PATH SELECTION** tool and manipulate either a line segment or one of the ending points.

Figure 7.52

The **PATH SELECTION TOOL** and **DIRECT SELECTION TOOL** are both used to adjust a **PATH** or text aligned to a **PATH**.

The line and the text remain independent of each other. To continue to manipulate each component it is important to open the **PATHS PANEL** by going to the **WINDOWS** tab. This panel is similar to the **LAYERS PANEL**. If you click on the Shape 1 layer, you will see a Work path and a Shape path in the **PATHS PANEL**. If you click on the text layer, the **PATHS PANEL** will show a Work path and the line of text. Click on the line of text in the **PATHS PANEL**, then use the **PATH SELECTION** tool to change the curve of the text. You can then go back to the

Figure 7.53

The **PATHS PANEL** is opened from the **WINDOWS** tab. The panel shows both a **WORK PATH**, which is the **BEZIER** line, and the line of text that is aligned to the **BEZIER** line.

Shape 1 layer, select the Shape 1 path in the **PATHS PANEL** and reposition the line to match the text. Complete Exercise 7-I by creating a **PATH** and aligning the text to that **PATH**.

The other option that is convenient in Photoshop is the ability to turn a selection into a **PATH**. Once the selection is made, go to the **PATHS PANEL** and click on **MAKE WORK PATH FROM SELECTION**, the fourth icon at the bottom of the panel. Click on the **TEXT** tool, position the cursor on the path, and type in the text. The text will align itself to the outer edge of the selection. Continue working on Exercise 7-I and use this method to make a selection of the banner shape and then add more text to the banner.

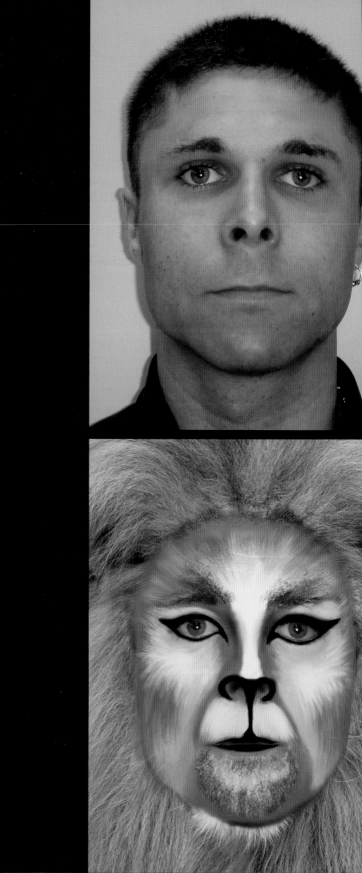

Chapter 8

Digital Makeup Design

- Cloning an Image
- Smoothing Skin Tone
- Changing Skin Color
- Creating Age Lines
- Removing or Adding Facial Hair
- Creating Hairstyles
- Photoshop Notes

Design by Annie O.
Cleveland. Beast Makeup,
*Dreams from a Summer
Night,* Colorado State
University, Ft. Collins,
Colorado, 2005.
(Anthony Cisneros,
model). Sketch executed
in Painter.

Makeup design often falls under the costume designer's purview, and there are many instances when it is effective to include a makeup design in a rendering. Having the skills to do digital makeup design is both a time-saver and an effective way to represent the specific details of the actor's face. Digital makeup design offers a dynamic perspective for the actor or the makeup artist. Traditional methods for creating makeup plots include using non-anatomically correct templates, or tracings of a photograph of an actor's face. Digital media, on the other hand, can show the makeup transformations accurately on a digital image of the actor's face. This allows for more precise placement of modeling techniques and for a stronger representation of how the makeup design will match the actor's individual features. In addition, Painter's versatile brushes can replicate some traditional makeup application techniques.

Cloning an Image **PS**

The process begins with a clear, close-up, full-face photo of the actor as well as a profile view. If possible, the actor should not be wearing makeup and should be free of facial hair. The lighting should be even without any strong shadows. To accurately represent skin tones it might be necessary to make some minor color adjustments before beginning the makeup design.

Because it is important to preserve a copy of the actor's face without makeup, the first step should be to save a copy of the image. **CLONERS** were discussed in Chapter 6 in relation to working with patterns. When you **CLONE** an image you make a duplicate of it. This can be a powerful tool for doing corrective makeup. In addition, the **QUICK CLONE** function also turns on the **TRACING PAPER** feature if you want to take a more traditional approach to makeup design. The advantage of using digital tracing paper is that you can adjust the opacity to more clearly reveal the line you are tracing. If you are going to explore the potential of digital makeup design on the actor's face, a simple **CLONE** without the tracing paper works best. It is a good idea to review the information in Chapter 6 about using **CLONER** brushes and the **CLONE SOURCE PANEL**.

Smoothing Skin Tone

Makeup application usually begins with a base. Digital makeup design starts in the same place by creating an even skin tone. The best brushes to use are the **BLENDERS** in the **BRUSH SELECTOR** bar. The **BLENDER** brushes move and mix together the colors of the individual pixels. Most of the **BLENDER** variants do not add color, so if you apply them to a blank area of the canvas, nothing happens. A few, such as the **BLENDER BRUSH** variant, will apply another layer of color and mix it with the color that is underneath. As with other brushes, you can adjust the **OPACITY** and **SIZE** of each of the **BLENDERS**

Figure 8.1

The **BLENDERS** brush category icon looks like a paper blending stump.

Figure 8.2

Each of the different blenders picks up color from where you first set down the cursor and moves the pixels to produce different effects.

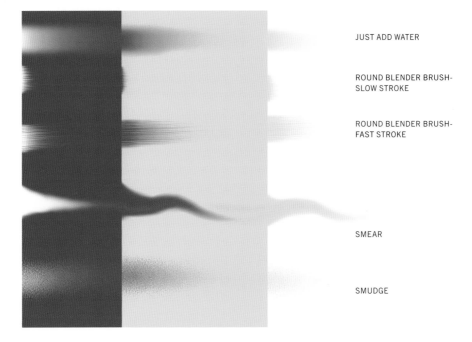

JUST ADD WATER

ROUND BLENDER BRUSH-SLOW STROKE

ROUND BLENDER BRUSH-FAST STROKE

SMEAR

SMUDGE

using the **PROPERTY BAR**. With a little experimentation you will find which variants best suit your particular makeup application techniques. Some useful variants follow.

- **JUST ADD WATER** provides a very smooth and even blend.

- **ROUND BLENDER BRUSH** gives a dry looking stroke that shows the brush bristles. This brush responds to the speed at which you place your stroke.

- **SMEAR** is an opaque blend that has a greasy consistency. The stroke merges to a point as it is extended.

- **SMUDGE** is useful for detail work. It has a dry, grainy look that reacts to paper texture.

Essentially these brushes pick up the pixels at the point where you first place the brush and then move them in the direction of your stroke, mixing them with the colors of the adjacent pixels. Although these **BLENDERS** do not add color, they will pick up the empty areas of the canvas as white. Keeping each part of the makeup application on a separate layer makes it very convenient to accurately show how highlights and shadows work together. But, if you create a new layer

on which to do your makeup, nothing but white will appear when using the **BLENDERS** because the layer is empty except in those areas where you have applied some color. To solve this issue, click on the second button next to the transparency slider in the **LAYERS PANEL**. This allows you to pick up the underlying color from the Canvas layer. That button will stay activated as you create successive layers unless you turn it off.

PICK UP UNDERLYING COLOR

Figure 8.3

Make sure the **PICK UNDERLYING COLOR** icon is highlighted if you want to blend a color in one layer with a different color in another layer. The order of your layers and the ability to lock layers becomes extremely important here.

The **JUST ADD WATER** variant is a good choice for blending the skin tone without changing color. The trick is to make sure the opacity is reduced so that the blending retains some of the skin texture and keeps the subtle highlights and shadows that make the three-dimensional facial features visible. Using short strokes and working in one small area at a time, it is possible to smooth out the entire face. If the blended stroke goes too far in one direction, you can simply reverse the direction that you move the brush. For example, if you have blended the highlight on the cheekbone too far down on the face, you can simply place your brush in the shadow under the bone and stroke upwards to correct your blend. The **JUST ADD WATER** variant is also a good way to remove beard stubble and facial hair from a photograph.

By this time you should be very versatile with the **UNDO (CTL+Z/CMD+Z)** function, but there may be times during the creation of a makeup design when you need to do an **ERASE**. If you use a traditional eraser, it will erase the photographic image, leaving a white area. This is another reason why it is important to initially **CLONE** the photograph. The **SOFT CLONER** brush can be used as an eraser to restore the image back to its original state. If you have not closed the original photograph, the clean copy of the of the actor's face may still be embedded in the document you are working on as a **CLONE SOURCE**. If you have reopened your makeup design file, remember that you must re-establish your **CLONE SOURCE**. As you use the **SOFT CLONER**, the original image will replace the area where the mistake was made.

Changing Skin Color

AIRBRUSH variants are useful for creating highlights and shadows because they create a smooth transition from dark to light. Use the **EYEDROPPER** tool to

select colors from the facial photograph to use as highlight and shadow colors. In this way you are guaranteed to have colors that are complimentary to an actor's skin tone. Remember that the **EYEDROPPER** tool selects individual pixels, so you may have to adjust the value or intensity of the color selected to make sure it is appropriate for your particular makeup design. It is also useful to scan a palette of actual makeup and select colors from that scanned image.

EXERCISE 8-A

Basic Structural Modeling

1 Open the file labeled *Face 1*.

2 Clone the image. Minimize the original image but do not close it.

3 Create a new layer and turn on the **PICK UP UNLDERLYING COLOR** button on the **LAYERS PANEL**. Name this layer Foundation.

4 On the **BRUSH SELECTOR BAR** choose **BLENDERS** and the **JUST ADD WATER** variant.

5 Reduce the opacity to 35% and change the size of the brush to make a relatively broad stroke.

6 Smooth out the skin imperfections on the cheeks.

7 Place the brush on the cheekbones and stroke up to move a lighter color into the areas of the shadow under the eye.

8 Use the **JUST ADD WATER** to remove the stray hairs falling on the forehead. Stroke towards the hairline so that you do not run the risk of pulling the darker color of the hair onto the skin of the forehead.

9 Change the shape of the top lip by blending out the two peaks.

10 Change to **CLONER > SOFT CLONER** and restore the natural lip line.

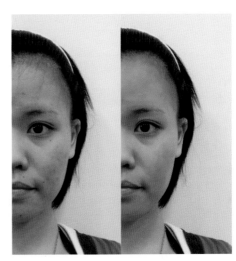

Figure 8.4

The left half of the image shows the original photograph and the right side shows the skin tone blended with the **JUST ADD WATER** blender brush variant.

11 Do a **SAVE AS** and rename the file *Face 1 Foundation*.

12 Create a new layer. Name the new layer Shadows.

13 Used the **EYEDROPPER** tool and click in the shadow area under the eyebrow.

14 Switch to an **AIRBRUSH > DIGITAL SOFT VELOCITY AIRBRUSH**. Change the opacity to 40% and add contouring shadows on the sides of the nose, at the temples, and under the cheekbones to help shape the face.

15 Create a new layer named Highlights.

16 Go back to the **EYEDROPPER** and select a highlight color. Use the **DIGITAL SOFT VELOCITY AIRBRUSH** to add highlights on the top of the cheekbones, above the eyebrows, and along the bridge of the nose.

17 Correct any areas where you have over sprayed by using either a **BLENDER** or a **CLONER**.

18 **SAVE** your file as a **RIFF**.

Figure 8.5

The completed image with highlights and shadows added.

An **AIRBRUSH** variant can also create a very smooth and even cover when you want to change the overall color of the skin. It is important to keep the application very transparent so that the makeup does not look like a mask. If you are doing extreme fantasy makeup, the application can be a bit more opaque as long as enough of the natural features are visible to act as a guide for accurate placement of the makeup. You can spray a new color evenly over the face without worrying about covering the eyes or nostrils because they can be recovered using a **CLONER**.

EXERCISE 8-B

Changing Overall Skin Tone

1 Open the file labeled *Face 2*.

2 Clone the file and **COPY** and **PASTE** the face into a new layer and name it Base Color.

3 Use **JUST ADD WATER** at a 35% **OPACITY** to remove the glare under the right eye and any skin imperfections.

4 Use the **EYEDROPPER** to select a highlight color from the area between the eyebrows.

5 Use **AIRBRUSH > DIGITAL SOFT VELOCITY AIRBRUSH** with a 25% **OPACITY** and change the overall skin tone to very pale pink as in an 18th-century makeup design. Make sure some of the natural shadows are faintly visible.

6 Lightly cover the lips so that you can change the shape. Try to retain the natural highlights on the bottom lip.

7 Use the **SOFT CLONER** to clean up any overspray along the hairline or jaw line.

8 Create a new layer named Shadows.

9 Open the file labeled *Shadow Makeup*. This is a scan of an actual pot of makeup.

10 Use the **EYEDROPPER** to select the makeup color.

Figure 8.6

Completed
18th-century
makeup design.

11 Apply this color as a shadow around the eyes and down the sides of the nose. Use both the **OPACITY** slider and minor adjustments on the **COLOR WHEEL** to make the shadow appear as lightly brushed on powder.

12 Create a new layer named Lips.

13 Change to a **PENCIL > HARD COLORED PENCIL** variant and sample one of the darker rose colors on the actress's lips.

14 Zoom in close on the lips. Use the **HARD COLORED PENCIL** to outline a new "pursed lip" look. Fill in the color with the **AIRBRUSH**.

15 Use the **SOFT CLONER** to pull some of the natural highlights on the actress's lip back into the image.

16 Do a **SAVE AS** and save your file as a **RIFF** with a new name.

If the makeup plots that you create digitally are going to be printed and used as guides for either the actor to apply his or her own makeup or a makeup crew person to do the makeup application, it is important to do a test print. You may have to make the modeling techniques more pronounced than you would normally do in order for the subtle variations of color and blending techniques to show up in printed form. If you have a screen capture program, it is a good idea to zoom in close on the principal features of the face and capture a closeup image to add to the makeup plot. All of these images can then be assembled with notes attached for clarity to give to the makeup crew head.

Creating Age Lines 🅿️

The tools for creating age lines in a digital rendering depend on the techniques used when applying the actual makeup. If you normally use an eyebrow pencil, then it might be best to start with something similar like **PENCILS > GREASY PENCIL**. If you use Richard Corson's methods of using brushes, you can choose one of the many brush variants. The **ACRYLICS > DRY BRISTLE** variant is a particularly useful brush for makeup design because the color fades out towards the end of the stroke in a fashion similar to a traditional brush loaded with cream makeup. The **DRY BRISTLE** brush's properties include **VISCOSITY**, **BLEND**, and **WETNESS**. If you reduce the percentage under the **BLEND** slider, a longer portion of the line has color before it is blended into the skin tone. For example, if you are going to do a short nasolabial fold, you might keep the **BLEND** at the default 76%. If you want a lengthy nasolabial fold, you can reduce the **BLEND** down to 50% to get a longer line. For both these techniques, the **SMEAR** brush works well as a **BLENDER** tool. A final swipe with a very transparent **SOFT CLONER** gives the makeup a more integrated look as opposed to being thickly applied.

Figure 8.7

The **ACRYLIC > DRY BRISTLE BLEND** brush variant showing the variations in blending percentages.

DEFAULT 76% BLEND

50% BLEND

90% BLEND

EXERCISE 8-C

Creating Age Lines

1 Open the file labeled *Face 3* and clone it.

2 **COPY** and **PASTE** the face into a new layer named Foundation.

3 Use **JUST ADD WATER** to smooth the skin tone and remove imperfections.

4 Create a new layer named Fold. Make sure the **PICK UP UNDERLYING COLOR** button is turned on.

5 Use the **EYEDROPPER** tool to sample a shadow color in the inner corner of the eye.

6 Select the **ACRYLICS > DRY BRISTLE** brush and make test strokes on the background of the image to determine an appropriate **SIZE** and **OPACITY** and **BLEND** for the type of line you are creating.

7 When satisfied, click **CTL+Z/CMD+Z** to remove those test strokes and then draw the nasolabial fold on the face.

8 Change to the **SMEAR** brush, adjust the size and opacity, and use it to blend the line out toward the ear using short strokes.

9 Make a final vertical stroke with the **SMEAR** brush to smooth out your short lines. This replicates a traditional makeup technique to create a line that is hard-edged on one side and soft-edged on the other.

Figure 8.8

The preliminary step in creating the nasolabial fold. Note the test strokes off to the side of the face to determine appropriate size and blend percentage.

Figure 8.9

Step 8 in creating the nasolabial fold.

Figure 8.10

The completed nasolabial fold.

10 Use the **EYEDROPPER** tool to sample a light skin tone from the nose highlight.

11 Repeat the process above adding a highlight next to the nasolabial fold line.

12 Use the **SMEAR** brush to blend across the upper lip.

Figure 8.11

Completed age makeup design by
Jen-Chun Hsu.

13 If the technique looks too opaque or greasy, change to **SOFT CLONER** and reduce the **OPACITY** to 15%.

14 Lightly stroke over the areas that are too opaque to pull in some natural skin texture.

15 **SAVE** your file as a **RIFF**.

Removing or Adding Facial Hair Ⓟ

Facial hair poses its own set of problems, whether you want to remove it from a photograph or add it to your makeup design. The **JUST ADD WATER** brush is one way to blend away facial hair, but this sometimes results in a muddy appearance in the skin tone. An **AIRBRUSH** variant can also

JUST ADD WATER TECHNIQUE

ORIGINAL IMAGE

AIRBRUSH TECHNIQUE

Figure 8.12

Above is the original image of the actor's face.
You can compare the three different methods for
covering up the beard at right.

CLONE AND OFFSET SAMPLING TECHNIQUE

be used to spray over the areas that have facial hair. Each part of the skin on the face reflects light in a slightly different manner. Therefore, to create a better representation of what the face looks like without facial hair, it is important to keep sampling colors with the **EYEDROPPER** tool of areas of skin near the facial hair that you want to cover. By working in one small area at a time you can pull out the subtle undulations of the skin surface.

The **SOFT CLONER** brush can also be used to replace facial hair by using **OFFSET SAMPLING**. Review Chapter 6 about using **CLONERS** with **OFFSET SAMPLING**. Hold down the **ALT/OPTION** key and click in an area of the face that does not have facial hair. Then use the **SOFT CLONER** to apply this area of clean skin over the facial hair. Pay attention to where the sampling reference point moves in the image so that you do not pick up facial features or areas of skin tone that are the wrong color. You can always reset the reference point.

Figure 8.13

On the left you can see the green dot showing where in the image the skin color was sampled. On the right, the round circle is the cursor of the **SOFT CLONER** brush and the + is showing the location of the color that is being sampled.

There are several brushes that can be used to add facial hair. This is a great opportunity to explore some of the more obscure brushes in Painter's brush libraries. One of the brushes that creates excellent facial hair is located under the **PENS** category and is the **BARBED WIRE PEN** variant. This brush draws a dense collection of jagged lines and responds to the speed of the stroke. The faster you draw the line, the less dense is the line. In addition to the **SIZE** and **OPACITY** sliders on the **PROPERTY BAR**, this brush has a slider for **FEATURE**, which works in proportion to the size of the brush. If you change the size of the variant, the **FEATURE** will change to a predetermined size. But you can adjust the

Figure 8.14

The **BARBED WIRE** variant in the **PEN** category.

Figure 8.15

Variations in the **BARBED WIRE PEN** brush variant showing differences in the speed of the stroke and changes in the **FEATURE** slider.

BARBED WIRE SAMPLE STROKES

SIZE 12, FEATURE 3.5, SLOW STROKE

SIZE 12, FEATURE 3.5, FAST STROKE

SIZE 12, FEATURE 10, SLOW STROKE

FEATURE without changing the size. Moving the **FEATURE** slider to the right and raising the number gives you a jagged line whose components are spaced farther apart. This is useful for adding individual hairs to a beard or mustache design. It is best to create facial hairpieces on separate layers to try out different styles.

EXERCISE 8-D

Removing and Adding Facial Hair

1 Open the file labeled *Face 4*.

2 Clone the image and **COPY** and **PASTE** the face into a new layer named Clean Skin.

3 Use the **DIGITAL SOFT VELOCITY AIRBRUSH** to remove the actor's beard on the right side of the image. Make special note of the gray highlight along the cheekbone and the darker color of the skin on the neck.

4 Switch to a **SOFT CLONER**.

5 Hold down the **ALT/OPTION** key and click in the area just under the lip on the left side of the image that is free of facial hair.

6 Use the **SOFT CLONER** to remove the beard from the left side of the face.

7 Continue to reset the **SOFT CLONER** reference point and remove the entire beard.

8 Do **SAVE AS** and label your file *Face 4 No Beard* and save the file as a **RIFF**.

9 Make a new layer and label it Mustache. Make sure the **PICK UP UNDERLYING COLOR** button is turned off.

10 Change to **PENS > BARBED WIRE** variant and a dark brown color. Set the **SIZE** at 7.0, **OPACITY** at 50%, and **FEATURE** at 5.0.

Figure 8.16

Completed 1970s mustache.

11 Use this brush to build up the actor's own mustache to make it into a fuller and longer 1970s style.

12 **SAVE** your file as a **RIFF**.

ADVANCED EXERCISE

Grow your own: This play takes place in the 1970s and the director wants to see what the actor will look like with an Afro. Find a technique for giving the actor a dense Afro but make sure the texture of the hair is still visible. Use this opportunity to explore more brush variants such as **SPONGES**, or see what changes in paper grain can achieve.

Creating Hairstyles

Creating a style for straight hair in a digital environment echoes some of the same problems encountered when rendering hair with traditional media. One brush that is particularly useful is in the **GOUACHE** category, the **FINE BRISTLE** brush. This brush creates the look of separate strands of hair when you adjust the **FEATURE** slider. By layering dark, medium, and light tones, a relatively effective hairstyle can be created. Create a part by sampling a color near the hairline using the **EYEDROPPER** tool and then applying the part where you want using an opaque media like **SHARP CHALK**, which will have a slightly grainy texture, or a narrow **AIRBRUSH** so that the line has soft edges. The hair texture can be placed

on either side of the part with the **FINE BRISTLE** brush so that it looks like the hair is growing out of the skin.

There seems to be a slight problem when using the **GOUACHE > FINE BRISTLE** brush with a digitizing pen instead of a mouse. The beginning and end of the stroke lines want to come back to a point. One work-around is to open the **BRUSH CONTROL PANELS** under the **WINDOWS** tab on the top menu bar. Scroll down the menu to **REAL BRISTLE**, and when the panel opens, click in the box marked **ENABLE REAL BRISTLE**.

Figure 8.17

The **BRUSH CONTROL PANELS** showing the checked box for **ENABLE REAL BRISTLE**.

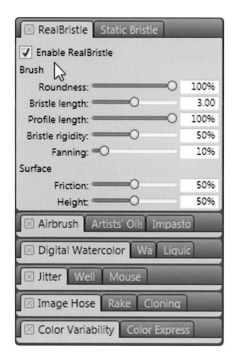

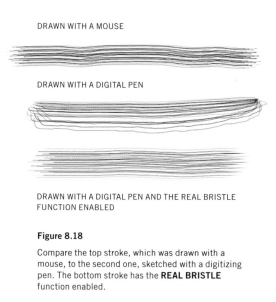

DRAWN WITH A MOUSE

DRAWN WITH A DIGITAL PEN

DRAWN WITH A DIGITAL PEN AND THE REAL BRISTLE FUNCTION ENABLED

Figure 8.18

Compare the top stroke, which was drawn with a mouse, to the second one, sketched with a digitizing pen. The bottom stroke has the **REAL BRISTLE** function enabled.

EXERCISE 8-E

Creating a Straight Hairstyle

1 Open the file labeled *Face 1 Foundation* from Exercise 8-A.

2 Create a new layer and label it Hair.

3 Use the **EYEDROPPER** to sample a dark color from the hair.

4 Select the **GOUACHE > FINE BRISTLE** brush from the **BRUSH LIBRARY PANEL**.

5 Adjust the **SIZE** to 50% and the **FEATURE** to 10%.

6 Begin by creating the overall shape of the hairstyle. Gradually layer more stokes to make the hair look dense while leaving a few open strands on the edges.

7 Use an **AIRBRUSH** to fill in the opaque areas around the neck. Because you are working in a separate layer, you can use the **ERASER** tool to remove stray strands and refine the outline of the hairstyle.

8 Use the **EYEDROPPER** tool to sample an area of color from the forehead.

9 Use the **AIRBRUSH > DETAIL AIBRUSH** variant to add a part on the top of the head. Make it a bit wider than you want.

Figure 8.19

The completed straight hairstyle.

10 Reselect the black hair color.

11 Go back to the **FINE BRISTLE** brush and add some strands to the edges of the part, directing the stroke in the direction the hair would grow.

12 Use the **EYEDROPPER** to sample a highlighted area from the top of the head. You may be surprised that the highlight has some green or unexpected colors. Make a test stroke to see if the highlight color the **EYEDROPPER** chose looks appropriate. If not, just make a selection from a slightly different place on the hair.

13 Increase the **FEATURE** property of the **FINE BRISTLE** brush to 14%. Add highlights to the appropriate areas of the hair.

14 **SAVE** your file as a **RIFF**.

Of course if you have a wig or mustache already prepared that you intend to use for the character, it is possible to cut and paste a digital image of the wig and apply it to the makeup rendering using the techniques discussed in Chapter 5 on Selections and Transformations.

Photoshop Notes

Cloning an Image

As discussed in Chapter 6, with the Photoshop **CLONE** tool there is no need to create a secondary file. Most of the exercises can be achieved using the **LAYERS PANEL** and preserving the original image in a Background layer. If necessary, the Background layer can be duplicated.

Figure 8.20

The list of **BLENDER BRUSHES** presets.

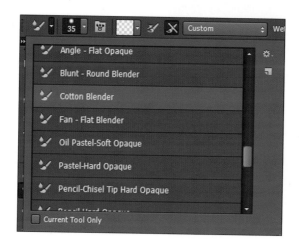

Smoothing Skin Tone

Photoshop has several blending brushes listed in the **BRUSH TOOL** menu. These include a **BLUNT ROUND BLENDER**, **COTTON BLENDER**, and **FAN FLAT BLENDER**. The **COTTON BLENDER** seems closest to the **JUST ADD WATER** feature in Painter. Each of these tools has adjustments on the **OPTIONS BAR** to control size and opacity. By experimenting with **WET**, **LOAD**, and **FLOW**, you can adjust these tools to replicate the look of actual makeup brush applications.

The **SMUDGE** tool, whose icon looks like a pointing hand, is stacked with **BLUR** and **SHARPEN** icons in the second section of the **TOOLS PANEL**. The **SMUDGE** tool comes closest to the blenders in Painter. This tool will also pick up pixels where you first place the brush and move them in the direction of the stroke. There is no way to control opacity, but you can adjust the **STRENGTH** in the **OPTIONS BAR**. Keep the **MODE** at **NORMAL** for ease of use or, if you want to have more precise control of the **SMUDGE** tool, change the **MODE** to **DARKEN**

Figure 8.21

The **SMUDGE** tool is stacked with the **BLUR** tool and the **SHARPEN** tool in the **PAINTING TOOLS** section of the **TOOL PANEL**.

Figure 8.22

The **FINGER PAINT** option is at the far right of the **OPTIONS BAR** when the **SMUDGE** tool is selected.

when smudging a dark area into a light area or **LIGHTEN** when moving from a light area into a dark area. Click the box labeled **FINGER PAINT** if you want to replicate the oily opacity of Painter's **SMEAR** tool. Complete Exercise 8-A using **BLENDER BRUSHES** and the **SMUDGE** tool.

Another tool that is effective for correcting imperfections in the face image is the **SPOT HEALING BRUSH**, which is stacked with icons for the **HEALING BRUSH**, **PATCH**, and **RED EYE** in the **TOOLS PANEL**. You may already be familiar with the technique for removing red eyes in a photograph by clicking or selecting the area of the eye that is reflecting red and letting the program replace the red with a dark color. The **SPOT HEALING BRUSH** works in a similar manner. After selecting the **SPOT HEALING BRUSH**, click on the mark or blemish in the photograph that you want to correct. Photoshop interprets the colors, textures, and values of the pixels in the surrounding area and replaces the blemish with matching skin tone. The diameter and the hardness of the **SPOT HEALING BRUSH** can be adjusted in the **BRUSH PICKER** menu on the **OPTIONS BAR**.

Figure 8.23

The **HEALING BRUSH** variations are located at the top of the **PAINTING TOOLS** section on the **TOOL PANEL**.

The **HEALING BRUSH** works in a similar fashion to Painter's **SOFT CLONER** in that you must first select an area of the face as a reference point by holding down the **ALT/OPTION** key and then applying that skin color and texture to another part of the face such as the facial hair area. The **PATCH** works very much like copying and pasting. Simply select an area on the photograph with the **PATCH** tool and click and drag it to another part of the picture. The selection

usually has a hard edge, so you may need to do some blending to make the patch integrate with the image more smoothly. An interesting aspect of the **PATCH** tool is the ability to control the source and destination points. Use the **PATCH** tool to select an area that you want to cover up but then click on the **SOURCE** button in the **OPTIONS BAR**. When you drag the selected area to the area from which you want to sample, you will see the selection change as you move over the image.

When you release the mouse button, the originally selected area is patched with the sample pixels. Complete Exercise 8-B using the **HEALING BRUSH** and other repair and restoration tools to remove blemishes, then select a varient of **AIRBRUSH** to apply color to the face.

DROP-DOWN LIBRARY OF
PRELOADED TEXTURES

Figure 8.24

Custom brushes can be created in the **BRUSH PANEL**. First select the variable from the list on the left and make adjustments in the panels on the right. The stroke on the bottom shows a visual representation of the brush you are creating.

Figure 8.25

A library of preset textures can be opened in the **BRUSH PANEL** by clicking on the small arrow next to the thumbnail. The appearance of preset textures can also be adjusted in the **BRUSH PANEL**.

Creating Age Lines

Because of Photoshop's versatility in creating custom brushes, this may be a good time to assemble a series of brushes to use for specific techniques.

First we need to take a closer look at the **BRUSH PANEL**. On the left is a list of various aspects of a brush that can be controlled. Once you select an aspect (or **OPTION SET**), the available options and controls appear in the center of the panel, depending on which option is selected. For example, if **BRUSH TIP SHAPE** is selected from the menu at the left, a library of brush tip thumbnails appear along with sliders to control **SIZE**, **HARDNESS**, and **SPACING** as well as a rotating dial to control the angle. When the **OPTION SET** for **TEXTURE** is selected, there is a drop-down library of different textures as well as several sliding controls. Consequently, defining a custom brush can be an exercise in detailed adjustments.

Once you have determined the optimum look for the brush you have designed for a specific purpose, you can save that brush in the **BRUSH PRESETS** library. Go to the **OPTIONS MENU** button on the top right of the panel and choose **NEW BRUSH PRESET** from the drop-down menu. In the dialogue box, give your new brush a specific name. Click on the **BRUSH PRESET** tab in the **BRUSH PANEL** and you will see your new **BRUSH PRESET** at the bottom of the list. When you go back to the **TOOLS PANEL** and select either the **BRUSH** or **PENCIL** tool, scroll through the **BRUSH PRESET PICKER** on the top right of the **OPTIONS BAR** to find your custom brush preset and apply the properties you defined to whatever painting tool you have chosen. Also review the section on making a custom brush from an image explained in the Chapter 6 Photoshop notes. Create a custom brush to use in Exercise 8-C. Use the **SMUDGE** tool to complete the exercise.

Removing or Adding Facial Hair

Explore the **BLENDING** tools, **AIRBRUSH** technique, and the **CLONE STAMP** tool to remove facial hair from a photograph in Exercise 8-D. To **OFFSET SAMPLE** using the **CLONE STAMP** tool, hold down the **ALT/OPTION** key and click in the area you want to sample. When the cursor is moved over the area with the facial hair that needs to be covered up, the cursor will change to a thumbnail image of the area that has been sampled.

There is no brush in Photoshop that equates to the **BARBED WIRE** tool in Painter. Exploring and adjusting some of the **BRUSH PRESETS** and the properties in the **BRUSH PANEL** can result in a custom brush that will help you replicate the look of facial hair or a straight hairstyle. Use custom brushes to complete Exercise 8-D and also to finish Exercise 8-E. Note what adjustments you make to develop your custom brushes for reference at a later time.

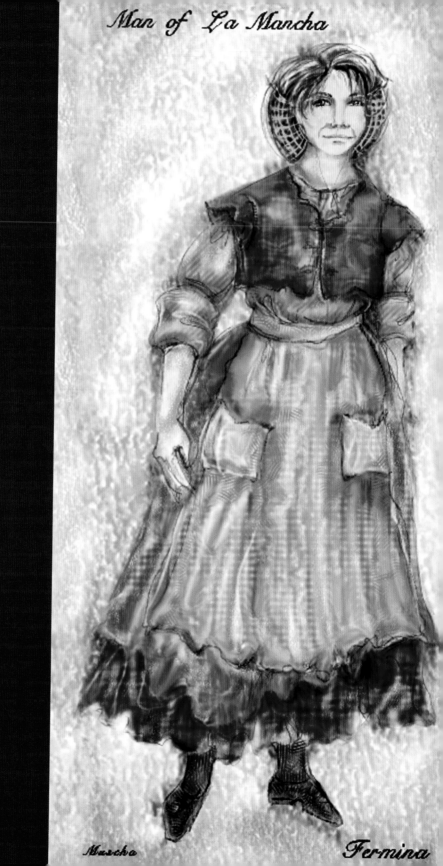

Muscha

Fermina

Conclusion

The First Step in the Journey

Will the computer replace the pencil? This question often crops up in discussions of the computer's place in the world of design. Using a computer will not suddenly give you the ability to create evocative, aesthetically pleasing costumes if you do not have a foundation in the art of costume design and have not developed some skill in sketching techniques. Arguments can still be made that nothing replaces a finely drawn sketch, delicately rendered in vivid watercolor on deliciously textured paper. Many claim that the learning curve for adapting computer techniques into the design process is just too steep and they do not have the time to devote to retraining. By the same token, not all designers can take time for making the sketches as artistically well crafted as they could be and simply settle for basic pencil sketches with a hint of color. In reality, the rendering is merely a communication tool, a single step toward the completion of the realized garments. Anything that can make that communication faster, easier, and clearer should be embraced with enthusiasm and commitment.

The argument that computers save time is a tricky one. When standing at a cutting table in a busy workroom grappling with a design change, there is nothing that takes the place of tearing a scrap of kraft paper and quickly sketching out alternative solutions. But with the coming of age of iPads and touch screen technology and ever more advanced phones, soon those spur-of-the-moment sketch ideas will be generated digitally. They can then be quickly incorporated into a finished rendering, if necessary, or disseminated immediately to a director for approval. The computer is here to stay and the hope is that the readers of this book will find a whole new design world open to them, that the learning curve has been softened just a bit, that the tools and techniques spark the imagination and generate images you had no idea how to express before, or that the desire is kindled to go deeper into the program and find even and more dynamic and elegant ways to express your design ideas. I hope the path that this book has set you upon has been inviting and the journey takes you to unimaginable design destinations.

Design by Colleen Muscha. Fermina in *Man of La Mancha,* Pennsylvania Center Stage. Sketch executed in Painter.

Appendix A: Digitizing Tablets and Pressure Sensitive Pens

The major drawback for costume designers who are trying to transition into digital design is the awkward handling of the standard computer mouse. The single most important hardware component for successfully creating digital designs is the digitizing tablet and pen. It allows users to hold a familiar tool in their hand, and to create drawing movements in a more traditional manner.

The only product I have used and feel confident about recommending is the Wacom brand of graphic tablets. The company makes several versions of digitizing tablets in a variety of sizes and price ranges. The Intuos products fulfill most of the needs of costume designers and the new line of Bamboo tablets is an affordable alternative to the more advanced digitizing tools.

The graphics tablet provides a surface on which to draw that responds to an input device such as a stylus. The digitizing pen, or stylus, has a nylon tip that glides smoothly over the tablet's surface; it is pressure sensitive so it reacts naturally to the user's individual drawing style. The image does not appear on the tablet's surface but is displayed on the computer monitor. Most of the Wacom tablets come with "express buttons" that can be configured to the user's needs. The computer mouse will also remain active even when the tablet is in use.

The most common question is, "which size tablet should I buy?" The larger tablets are heavy and awkward to hold in your lap to maintain a correct drawing posture. The smallest tablet's overall size is 8 × 12 inches and has an active drawing area that is approximately 6 × 4 inches. This may seem too small at first but the active area of the drawing surface is configured to the size of your monitor's display. Consequently, with a little practice, the smallest tablet becomes easy to use. This size is a good choice if you are equipping a computer lab and multiple tablets must be purchased.

When first using the digitizing tablet, you may find it odd to be looking at the monitor screen and not at the hand that is doing the drawing. Keep in mind that in many drawing classes, students are encouraged to look at the subject and not at the drawing. While it may seem awkward at first, in no time at all it becomes second nature to simply look at the screen.

Read the manual carefully when first setting up the tablet. Instructions are included for setting the pressure appropriate to your particular drawing style. The stylus will also respond to the particular way that you tilt it. I suggest that you hold the

There is an endless variety of Wacom tablets and other devices to suit your budget and personal preferences.

stylus as close to vertical as is comfortable. Do not lay the stylus down on the tablet when you switch to using the mouse—the tablet will continue to read the proximity of the pen's tip, so it is advisable to use the pen stand that comes with the Wacom tablets.

The digitizing pen has two additional features. First, the reverse end of the pen is an eraser. However, most of us become so accustomed to picking up tools from the tool bars on the screen that it is easy to forget about the eraser on the pen. Second, there is a rocker switch on the side of the pen's barrel that corresponds somewhat to the buttons on a mouse. If you press the upper end of the switch, you get a "double-click" function. Pressing the lower end of the switch activates a "right click." Some find this switch inconvenient and annoying while others utilize it extensively. Check the Wacom manual or Properties Dialogue Box for changing these functions to suit your own preferences or for disabling the rocker switch. The Express Keys on the digitizing tablet can also be customized. The default settings for the buttons correspond to some of the action buttons on a computer keyboard such as **SHIFT**, **CTRL/COMMAND**, **ALT/OPTION**, and **SPACE-BAR**. Again, refer to the manual to see the default settings for the express keys on your particular tablet and to see how to configure these keys to have different functions. In my case, I have chosen to ignore the express keys and simply use my keyboard commands.

Appendix B: Tools in Detail

PAINTER TOOLBOX HIDDEN ICONS

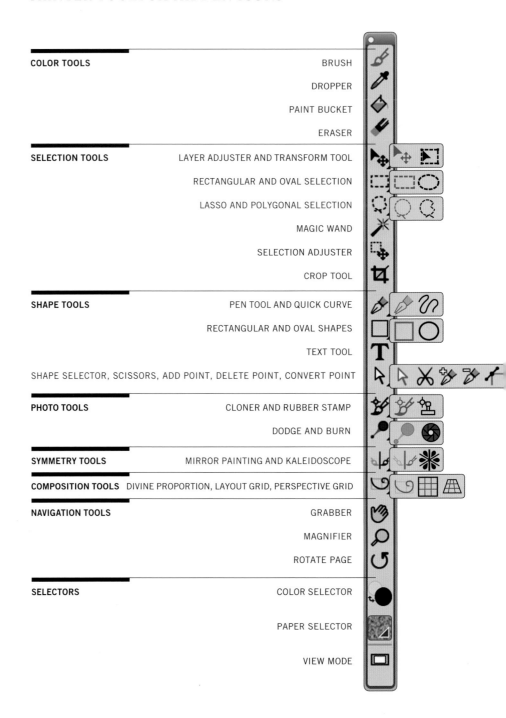

COLOR TOOLS

BRUSH

DROPPER

PAINT BUCKET

ERASER

SELECTION TOOLS

LAYER ADJUSTER AND TRANSFORM TOOL

RECTANGULAR AND OVAL SELECTION

LASSO AND POLYGONAL SELECTION

MAGIC WAND

SELECTION ADJUSTER

CROP TOOL

SHAPE TOOLS

PEN TOOL AND QUICK CURVE

RECTANGULAR AND OVAL SHAPES

TEXT TOOL

SHAPE SELECTOR, SCISSORS, ADD POINT, DELETE POINT, CONVERT POINT

PHOTO TOOLS

CLONER AND RUBBER STAMP

DODGE AND BURN

SYMMETRY TOOLS

MIRROR PAINTING AND KALEIDOSCOPE

COMPOSITION TOOLS DIVINE PROPORTION, LAYOUT GRID, PERSPECTIVE GRID

NAVIGATION TOOLS

GRABBER

MAGNIFIER

ROTATE PAGE

SELECTORS

COLOR SELECTOR

PAPER SELECTOR

VIEW MODE

PHOTOSHOP TOOLBAR OVERVIEW

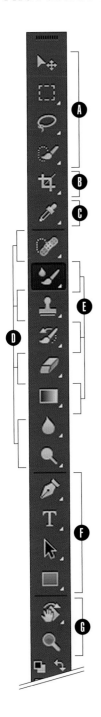

Ⓐ SELECTION TOOLS
MOVE
RECTANGULAR MARQUEE
 Elliptical Marquee
 Single Column Marquee
 Single Row Marquee
LASSO
 Polygonal Lasso
 Magnetic Lasso
QUICK SELECTION
 Magic Wand

Ⓑ CROP AND SLICE TOOLS
CROP
 Slice
 Slice Select

Ⓒ MEASURING TOOLS
 Eyedropper
 Color Sampler
 Ruler
 Note
 Count

Ⓓ RETOUCHING TOOLS
SPOT HEALING BRUSH
 Healing Brush
 Patch
 Red Eye
CLONE STAMP
 Pattern Stamp
ERASER
 Background Eraser
 Magic Eraser
BLUR
 Sharpen
 Smudge
DODGE
 Burn
 Sponge

Ⓔ PAINTING TOOLS
BRUSH
 Pencil
 Color Replacement
 Mixer Brush
HISTORY BRUSH
 Art History Brush
GRADIENT
 Paint Bucket

Ⓕ DRAWING AND TYPE TOOLS
PEN
 Freeform Pen
 Add Anchor Point
 Delete Anchor Point
 Convert Anchor Point
HORIZONTAL TYPE
 Vertical Type
 Horizontal Type Mask
 Vertical Type Mask
PATH SELECTION
 Direct Selection
RECTANGLE
 Rounded Rectangle
 Ellipse
 Polygon
 Line
 Custom Shape

Ⓖ NAVIGATION AND 3D TOOLS
3D OBJECT ROTATE
 3D Object Roll
 3D Object Pan
 3D Object Slide
 3D Object Scale
3D ROTATE CAMERA
 3D Roll Camera
 3D Pan Camera
 3D Walk Camera
 3D Zoom Camera
HAND
 Rotate View
ZOOM

Index